FANTASY

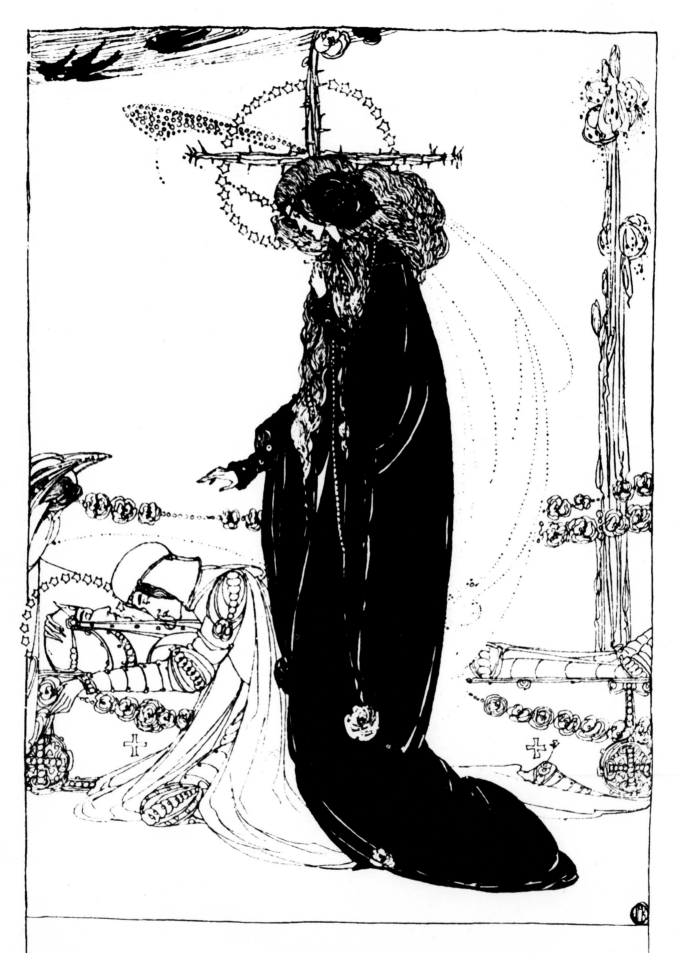

HE·DID·NOT·HEAR·HER·COMING·AS·HE·LAY·

FANTASY

THE GOLDEN AGE OF FANTASTIC ILLUSTRATION

BRIGID PEPPIN

NEW AMERICAN LIBRARY

TIMES MIRROR

NEW YORK AND SCARBOROUGH, ONTARIO

This is an authorized reprint of a hardcover edition published by
Watson-Guptill Publications.

Library of Congress Catalog Card Number: 76-41641

SIGNET, SIGNET CLASSICS, MENTOR, PLUME and
MERIDIAN BOOKS are published *in the United States* by
The New American Library, Inc.
1301 Avenue of the Americas, New York, New York 10019,
in Canada by The New American Library of Canada Limited,
81 Mack Avenue, Scarborough, 704, Ontario

First NAL printing, October, 1976

1 2 3 4 5 6 7 8 9

A Carter Nash Cameron Book
Designed by Tom Carter
Picture research by Philippa Lewis

Frontispiece
JESSIE M. KING Illustration to *King Arthur's Tomb* from
Defence of Guenevere and Other Poems
by William Morris (John Lane, 1904)

Title Page
CHARLES ROBINSON Illustration for the title page of
King Longbeard; or, The Annals of the Golden Dreamland
by Barrington MacGregor (John Lane, 1898)

Illustrations

Page numbers in italic indicate illustrations
in colour.

Alastair *176, 177,* 181
John D. Batten 19, 59
Aubrey Beardsley 15, 42-49
F. D. Bedford 91
Robert Anning Bell 94, 95
Eleanor Vere Boyle *57, 60*
René Bull *116, 117, 120, 121*
Edward Burne-Jones 39, 40
J. Byam Shaw 94
Harry Clarke 22, *160, 161, 164, 165,* 166,
 167, *168, 169,* 170, 171, *172, 173,* 174,
 175, 178, 179
Walter Crane 13, *69, 72, 73,* 82, 83, 86
Jean de Bosschère 182, 183, *184,*
E. J. Detmold *180, 181*
Gustave Doré 35-38
Richard Doyle 9, *61,* 64, *65, 68*
Edmund Dulac *124, 125, 128, 129, 132,*
 133, 136, 137, 140
H. J. Ford 19, 20, 58
A. J. Gaskin 40, 41
Vernon Hill 155, 158, 159, 162, 163
W. T. Horton 50
A. Boyd Houghton 12, 34
Laurence Housman 54, 55
Arthur Hughes 12, 13, 29
William Holman Hunt 29

A. Garth Jones 17, 67, 68
Jessie M. King 2, *112, 113,* 114, 115
Rudyard Kipling 142, 143, 146, 147,
 150, 151
Reginald Knowles *108, 109,* 110, 111
Edward Lear 25
John Everett Millais 29
H. R. Millar 139
Louis Fairfax Muckley 62, 63, 66
Harold Nelson 135, 138
Kay Nielsen *141, 144, 145, 148, 149,*
 152, 153, 154, 156, 157
J. Noel Paton 26, 27
Arthur Rackham *85, 88, 89, 92, 93, 96,*
 97, 100, 101, 102, 103, *104, 105,* 106, 107
Charles Ricketts 16, 51-53
Charles Robinson *3, 76, 77, 80, 81,*
 89, 90
Thomas Robinson 87
William Heath Robinson 17, *84,* 118,
 119, 122, 123, 126, 127, 130, 131, 134
Dante Gabriel Rossetti 11, 30
Frederick Sandys 31-33
Sidney Sime 70, 74, 75, 78
William Strang 56
E. J. Sullivan 98, 99
John Tenniel 28

Acknowledgments

Above W. HEATH ROBINSON
Endpiece to *Lacknose* from *The Giant Crab & Other Tales from Old India*, retold by W. H. D. Rouse (David Nutt, 1897).

While every attempt has been made to trace the artists' heirs or executors and the copyright holders of the illustrations reproduced in this book, the following list of acknowledgements is necessarily incomplete. Apologies are offered for any omissions which have resulted from the publication deadline of the book or from lack of sufficient evidence about the artist.

Illustrations are indicated by page number, and, where necessary, by a letter indicating the position on the page, starting from the top left hand corner.

Photographers: Ray Gardner
 Angelo Hornak
 Ian Cameron
 Sally Chappell
 Rodney Todd-White

By permission of Mrs. George Bambridge and Macmillan of London and Basingstoke 142, 143, 146, 147, 150, 151.

The British Library 2, 3, 12, 15(a)(b)(c), 17(a)(b), 19, 22, 29(c), 30(a), 34, 35, 36, 37(a)(b), 40, 41, 42, 43(a)(b)(c), 44, 45, 46, 47, 48, 49, 51, 52(a), 53, 54(a)(b)(c), 55(a)(b)(c), 56(a)(b), 57(b), 58(a)(b)(c), 59(a)(c), 60(a), 61(a)(b), 62, 63, 66, 67, 68(a)(b), 69, 70, 71, 77, 78, 87, 89, 91(a)(b)(c), 94(a)(c), 98(a)(b), 108, 109, 110, 111, 112, 114, 115, 116, 117, 120, 121, 131(c)(d), 139(a)(b), 141, 144, 145, 149, 152, 153, 154(a)(b)(c), 155, 156, 157, 158, 159, 160, 161, 162, 163, 164, 165, 166, 167, 168, 169, 170, 171, 172, 173, 174, 175, 176, 177, 178, 179, 180, 181(a)(b), 182, 183, 184.

By courtesy of the Trustees of the British Museum 64, 65, 100, 129, 132, 133, 136, 137, 140.

Given by permission of The Brockhampton Press 84, 120, 121, 124, 125, 126(a)(b), 127(a)(b)(c), 128, 129, 130(a), 131(a), 132, 133, 136, 137, 140, 141, 144, 145, 148, 149, 152, 153, 154(a)(b)(c), 156, 157, 180, 181(a).

By kind permission of Mrs. Barbara Edwards 85, 88, 89(a), 92, 93, 96, 97, 100, 101, 102, 103, 104, 105, 106, 107.

By permission of the Executors of the Laurence Housman Estate 54(a)(b)(c), 55(a)(b)(c).

By permission of the J. C. Heath Robinson Estate and The Minerva Press Ltd 118(a)(b), 119, 122, 123, 130(b)(c), 131(b)(c), 134(a)(b).

By permission of Miss Bay Robinson 76, 81, 82, 90.

By permission of Miss Bay Robinson and Gerald Duckworth & Co. 77.

By permission of Miss Bay Robinson and The Bodley Head 3.

Chas. J. Sawyer, London SW1 92, 105, 128, 148.

By permission of Miss R. Sturge Moore 51(c).

By courtesy of the Victoria and Albert Museum 13(a)(b), 31, 32, 33, 39, 72, 73, 74, 75, 76, 79(a)(b), 82, 83, 86, 94(b), 95, 101, 102, 103, 104, 106, 113, 118(a)(b), 119, 122, 123, 124, 125, 132, 133, 135, 136, 137, 138(a)(b), 140.

By permission of the Worplesdon Memorial Trustees 74, 75.

Introduction

Late Victorian and early 20th century England saw a unique flowering of book illustration as an art form. Such illustrators as Arthur Rackham, Edmund Dulac and Kay Nielsen are now recognised as remarkable artists. But perhaps their return to fashion stems less from their consummate skill than from a new, possibly more sophisticated appreciation of the fantasy elements in their work. It was in the realms of fantasy that illustration reached its highest levels, through a happy interaction of opportunity and inspiration: developments in printing and reproduction combined with the growth of the middle class audience for books and magazines to offer a perfect medium for expressing the cultural preoccupations of the era.

The ever-increasing number of books published in Britain each year during the reign of Queen Victoria included a large proportion with illustrations. The mid 19th century saw the emergence of the weekly family magazine, factual, humorous, literary or religious in content, but in every case profusely illustrated. The consequent demand for graphic work provided a new source of regular employment for many artists, assuring them of wider public exposure than was achieved by even the most successful easel painters. Consequently the various branches of illustrative work attracted many of the most gifted artists of the day.

Their talents were in demand for graphic reporting in such journals as *The Illustrated London News* and *The Graphic* until this role was taken over by photography. Humorous drawings were used in *Punch* and other satirical magazines. However, the finest opportunities for imaginative artists to explore the visionary world of dreams and fantasies came in illustrating poetry, the classics and contemporary fiction (much of which appeared in weekly instalments in periodicals like *Once a Week* and *Good Words*).

The contribution of the artist in the conceiving of a fictional or dream world necessarily varied. Some illustrators were able to realise fantasies which were specifically of their own creation: the images of Dante Gabriel Rossetti, Vernon Hill and 'Alastair' appear to spring directly from the artists' inner lives and to be connected only tenuously with the works of literature which they accompany. At the other end of the scale, Sir John Tenniel, F. D. Bedford and H. R. Millar are among the illustrators who seemed able to create images of fantasy only when inspired by a particular text. The great majority of visionary illustrators lie, predictably, between these two extremes. Of particular interest, though, are the polymaths who achieved a unique amalgam of verbal and visual imagery by illustrating their own texts. The precursor and probably the greatest of these figures was William Blake (1757–1827), whose work became a potent source of inspiration to illustrators of the late Victorian and Edwardian eras. Later artist-writers included Edward Lear, Kate Greenaway, Laurence Housman, T. Sturge Moore, W. Heath Robinson, Beatrix Potter and Jean de Bosschère. Among writers, Rudyard Kipling executed his own drawings for the *Just So Stories* but usually left the illustration of his books to others (among them his father). The boys' adventure writer R. M. Ballantyne also illustrated his own books. Less successful were Lewis Carroll's pen drawings for *Alice*, Thomas Hardy's pencil sketches to accompany his own poems, and Robert Louis Stevenson's woodcuts. Dante Gabriel Rossetti illustrated the works of other poets but not (in print) his own. The graphic artist Sidney Sime regularly published fantasy drawings (often in magazines of which he was art editor) unaccompanied by any text at all.

METHODS OF REPRODUCTION

From a technological viewpoint, English illustration of the period 1860–1920 is divided into two roughly equal periods by the introduction of photomechanical reproduction. Before about 1890 (rather earlier in Europe and America), a drawing intended for reproduction had to be engraved or etched by hand on the surface from which the print was to be made. In England, the most popular printing method was wood engraving. The surface of a block of boxwood, cut across the almost invisible grain, was coated with white paint. The artist drew his design on this in Indian ink, leaving the engraver to cut away the white areas, making a relief block and destroying the artist's original in the process. Because of the long apprenticeship required for a skilled engraver, the functions of artist and technician had tended to separate during the 19th century: wood engraving became a commercial service. The first step towards mechanical reproduction came in the 1870s when it became possible to transfer an ink drawing to the block photographically. The engraver could now reverse, enlarge or reduce the drawing before he started work; the artist's original was left intact for subsequent reference and comparison. The Dalziels (pronounced 'Dayliels'), whose firm was among the most famous and prolific engravers, at times also acted as publishers themselves, commissioning texts and illustrations on their own behalf. Charles Keene and Birket Foster were among the Victorian illustrators who started their careers as apprentice engravers; Walter Crane was apprenticed to the engraver W. J. Linton at the age of thirteen.

Colour printing from wood, with a separately engraved block for each colour, was managed with great success by Vizetelly, Edmund Evans and others, but never became widespread because of its laboriousness. The wonderfully rich effects created by Eleanor Vere Boyle ('E.V.B.') in her illustrations to Hans Christian Andersen's *Fairy Tales* (1874) and Carové's *Story Without an End* (1868) involved no less than twelve separate blocks. Edmund Evans, who was famous for his printing of Walter Crane's *Toy Books* and for his sponsorship of the children's illustrator Kate Greenaway, achieved his effects by the judicious use of considerably fewer colours. A more complex method of colour printing was chromolithography, with which effects of comparable richness could be achieved less laboriously.

The close relationship which had grown up between the engraver's workshops and the publishing houses resulted in considerable resistance to the introduction of photomechanical reproduction, which was generally accepted in England much later than elsewhere. When it eventually became popular, 'process', as it was known, had a profound effect on illustrative styles, although artists trained in the era of wood engraving often had difficulty in adapting their graphic style to the new method.

In making a wood block, the engraver inevitably tended to clarify or 'improve' on the original—surviving drawings show that substantial alterations were very often made. (Indeed, some artists would supply an engraver whom they knew well with the merest outline to follow, leaving him to supply the shading and detail.) The substance of the wood made it impossible for engravers to translate with absolute accuracy the varying weight, breadth and texture of ink or pencil lines. With 'process', on the other hand, every nuance, every dot and scribble, whether it was deliberate or accidental, was transposed mechanically and with photographic precision to the printed page, and the younger generation of black-and-white artists immediately responded by extending their range of graphic styles.

A number of different photomechanical techniques were developed more or less concurrently. In letterpress printing, line blocks gave black and white images without intermediate tones, while halftone blocks represented shading by means of a screen of dots of varying size, and various methods of screening originals were developed. Photogravure gave a shaded image which was not split into dots like a halftone. Although the technicalities of colour halftones were mastered during the 1890s, the technique did not become widely available until the early years of the 20th century.

The ease and speed of photomechanical reproduction led to a rapid increase in the number of illustrated books and magazines being produced. Many new artists were attracted to black-and-white because of the freedom of expression it now offered. Aubrey Beardsley, Charles and Will Heath Robinson, and E. J. Sullivan were among the illustrators who never had to submit to the restrictive discipline of designing within the wood engravers' capabilities; they were free to develop a completely personal style. With the introduction of the colour halftone, the emancipation of the illustrator became complete.

PRECURSORS

Illustrative drawings, destined for a wide public and usually commissioned to enhance the saleability of a book, are likely to be particularly indicative of the typical aspirations and prejudices of the age that produced them. But fantasy illustrations also involve making deeply seated and sometimes unacknowledged feelings of fear, or ecstasy, or desire, materialise as recognisable images. Their language is that of

dreams and visions, inspired by but separate from everyday existence. For this reason, the accessories of the familiar world are often abandoned in favour of those suggesting the obscure or distant past or the unknown future; the locations are likely to be the Antipodes, Mars or Fairyland. In addition, fantasy embraces the recurring or enduring symbols created by man in his unending struggle to find meaning in the world in which he lives.

Conversely, the themes and images that are repeated insistently in the works of a particular generation or individual can have their roots in current political or social conditions. In 19th century Britain, books were produced by and mostly for the upper and middle classes; they voiced the attitudes of this privileged, articulate minority. Despite the growing social conscience that found expression in the works of Charles Dickens, the early Victorian period was suffused with great optimism, even complacency, generated by the unprecedented prosperity which had followed in the wake of industrialisation. The savage social criticism of the Regency cartoonists Thomas Rowlandson and James Gillray was largely absent from the work of Gillray's successor George Cruikshank (1792–1878), whose acceptance of the existing social order was exemplified by his cartoon 'The British Beehive' with its classification of the descending levels of society from monarch to dustman. Cruikshank, who dominated both cartooning and fantasy illustration until well into the Victorian era, increasingly reserved his venom for the bottle rather than for the injustices of a society that drove men to take refuge in it. Cruikshank's fantasy was best expressed in his exuberant invention and also manifested itself in personification, seen in a remarkable cartoon of 1829 which depicted the rapid growth of London's suburbs, 'London going out of Town': horrified trees are shown fleeing from a volcanic cascade of bricks and from an army of animated chimney stacks with picks and shovels for legs. Cruikshank was equally inventive in his children's book illustrations which contain anthropomorphised plants, insects, molluscs, crockery and even letters of the alphabet.

Among the many later artists indebted to him as a source of ideas and imagery was Richard Doyle (1824–83), who reached artistic maturity in his *Punch* contributions of the late 1840s, when Cruikshank's influence was beginning to wane. As an Irishman, Doyle was well placed to take a detached view of English habits and vagaries, which form the subject of his series 'Manners and Customs of Ye Englyshe in 1849', a bird's eye view of multitudes of earnest figures, intent on society's pursuits, depicted in outline in a childlike style. His later 'Brown, Jones and Robinson' adventures were among the antecedents of the modern comic strip. He was most

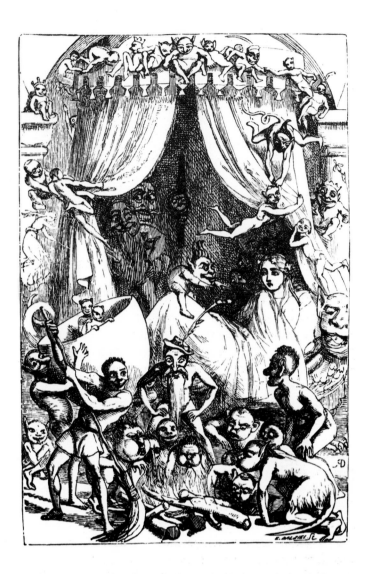

RICHARD DOYLE 'They kindled a great fire on the hearth, and placed over it a large cauldron, full of boiling water.' Illustration to *The Enchanted Crow* from *The Doyle Fairy Book*, 29 fairy tales translated by Anthony R. Montalba (Dean & Son, 1890).

popular for his fairy pictures, which were peopled by innocently mischievous elves derived from Cruikshank and presenting a somewhat bowdlerised version of the often grotesque and sometimes maleficent denizens of folk literature. Even so, these fairy pictures occasionally provided the setting for episodes with unconscious but distinct sexual implications. 'They kindled a great fire on the hearth' appears to be a bedroom comedy in which an innocent Victoria-like maiden awakes in the midst of an orgy to discover a riotous dance around a fire which is blazing in the middle of the floor; a purposeful looking gnome is squatting on her knees. (Idealised depictions of the queen recurred constantly in the iconography of the first two decades of her reign —with her respectable domestic felicity, she embodied the ideals of her subjects.)

From the extraordinarily independent mind of Edward Lear (1812–88) flowed 'nonsense' limericks, stories and drawings which have survived the test of

9

time better than many more ambitious works of the early Victorian period. By profession, Lear was a topographical watercolourist of distinction, but for his nonsense drawings he deliberately adopted a childishly naive style, with which came a child's freedom of invention. The device of enlarging the heads of his figures (an iconographic convention that he was among the first to adopt) provided a means of emphasising facial expression as well as giving his characters an infantile appearance which he accentuated with bodily gestures of astonishment or helplessness. The typical Lear nonsense figure was trapped in a preposterous situation, the inevitability and logic of which were accepted with resignation, although outsiders (often represented anonymously in the text by the pronoun 'they') might suggest remedies from the sidelines. Such fantasies are symbolic of the predicament of the small child in any society who is expected to conform to complicated, sometimes contradictory, and to him inexplicable codes of behaviour. The Victorians, who were experiencing unforeseen, often little understood technological and social changes, whose freedom of action was increasingly circumscribed by the dictates of morality and convention, may have had particular reason to welcome this form of escape.

Sir John Tenniel was the chief political cartoonist on *Punch* for over thirty years. He possessed the greatest asset of his profession, the ability to impart a sense of authority to everything he drew. His were the incarnations of Britannia, Uncle Sam and the other symbolic figures of political repertory that were accepted as authentic, and it was his caricatures that politicians usually grew to resemble. This special talent sometimes proved a hindrance in illustration: his drawings for Edgar Allan Poe's *The Raven* entirely lacked the evocative qualities demanded by the text, and his contributions to the Dalziels' edition of *The Arabian Nights* had a heaviness that placed them far below the imaginative level of Arthur Boyd Houghton's contributions to the same volumes. However, Lewis Carroll's *Alice's Adventures in Wonderland* and *Through the Looking-Glass* provided the ideal vehicle for his gifts. Carroll's fantasy was based on the logical responses of a matter-of-fact child to absurd and surreal stimuli, and Tenniel's illustrations repeat this antithesis with their authoritative depiction of dreamlike images. Tenniel was intensely irritated by Carroll's close supervision of the progress of the *Alice* illustrations, but the completed drawings, seen in the context of his work as a whole, demonstrate that he devised his most potent graphic images when he was working within closely defined limits.

Tenniel's immortal visualisation of the White Rabbit in *Alice's Adventures in Wonderland* was an early example of a figurative concept that became increasingly popular during the late 19th century and still remains in a dominant position in children's popular fantasy imagery: the anthropomorphised animal. Although animals have always figured in literature and fables, often symbolising some human or abstract quality, those of the late 19th century differed from their predecessors in being endowed with almost exclusively human characteristics. These often entirely replaced the generalised symbolic and humorous attributes that were previously their *raison d'être*—only Lear's menagerie of animals, selected for their humorous potential and the euphony of their names, seem to derive from the earlier tradition,

Among the novel features of the animal-person. the most illuminative of the period was his habit of wearing human clothes, surely as much the result of a complex moral reflex as it was a simple anthropomorphic device. If the White Rabbit was to share man's respect for time, it ought also to share his shame of nakedness. Early examples of clothed animals appear in drawings by Randolph Caldecott and Walter Crane—following Lear and Cruikshank, Crane explored the transmutation of people into animals and plants. The first specialists who systematically explored the possibilities in this area were Beatrix Potter and the obsessive (eventually mad) cat artist Louis Wain. Widespread popular approval of the clothed animal genre greeted the appearance of the children's comic strip characters Tiger Tim and the Bruin Boys in 1910. Ironically, two of Beatrix Potter's most successful stories, *Peter Rabbit* and *Tom Kitten*, are both sagas of the removal of unwanted clothing. In a recent article, Brigid Brophy has suggested an even more extreme case of subconscious rebellion in her comments on the sexual significance in the navel-downwards nakedness of Donald Duck—a mode of dress he inherited directly from Peter Rabbit and his friends.

The determination of late 19th century man to create animals in his own image may have been in part a repercussion of the impact of Charles Darwin's theory of evolution on the popular consciousness (*The Origin of Species* had been published in 1859). Once man was revealed as merely a particularly adaptive species of animal instead of a flawed replica of God, he had a motive to credit his fellow creatures with moral responses, thus opening up totally new areas for fantasy and speculation.

During the same period, Britain was being transformed into the world's first predominantly urban society. By 1851, half the population was living in cities, and by 1915, the proportion had risen to three quarters. For the first time in the history of any country, the majority of children were growing up with little direct experience of animals in their natural state and without witnessing their rearing and slaughter for food. This lack of contact with the

realities of nature, combined with the already sheltered existence led by the middle class, created a particularly receptive audience for idealised and fantastic visions of the relationship between humanity and the animal kingdom.

1860-1890

By the 1890s, it was already accepted that around 1860 illustration had emerged from its 'primitive' phase of caricature and exaggeration (exemplified by the work of Cruikshank, 'Phiz' and their contemporaries), and the writers Joseph Pennell and Gleeson White were acclaiming the Pre-Raphaelites and their followers as the founders of the modern illustrative style. Certainly the visual difference between this new style, here represented by Millais, Rossetti, Holman Hunt, Sandys, Hughes and Boyd Houghton, and the earlier one (Doyle, Noel Paton, 'E.V.B.', and, marginally, Tenniel) is enormous. In essence, a conceptual approach has been replaced by a perceptual one. The change was assisted by the emergence of wood engraving as an organised industry; the members of the Pre-Raphaelite Brotherhood were the first consciously or unconsciously to exploit the opportunities for bold drawing and chiaroscuro

DANTE GABRIEL ROSSETTI Illustration to *Goblin Market* from *Goblin Market and Other Poems* by Christina Rossetti (2nd edition, Macmillan, 1865).

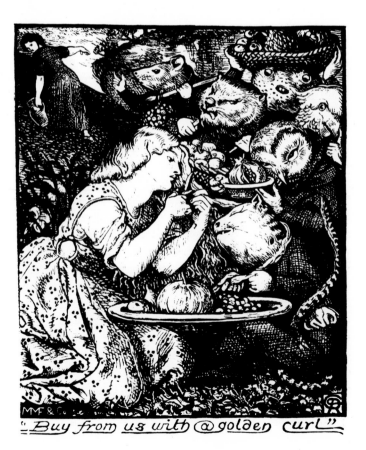

"*Buy from us with @ golden curl*"

offered by this medium. Dante Gabriel Rossetti actually experienced great difficulty in drawing on wood, and perhaps it was his very ignorance of the material that led him to make unusual demands on his engravers' skills. Whatever the cause, his drawings and those by William Holman Hunt and John Everett Millais, which appeared in a Tennyson anthology published by Edward Moxon in 1857, were outstandingly influential both in England and in Europe. One has only to compare these with any by members of the earlier generation such as Doyle or Sir Joseph Noel Paton to appreciate the originality of the Pre-Raphaelite approach. Of the original Brotherhood, Millais was the most prolific illustrator, working regularly during the 1860s for weekly family magazines—Anthony Trollope regarded him as the ideal illustrator of his work. Millais's steady decline in imaginative power after the 1850s was balanced by a spectacular rise in material and popular success. Holman Hunt was happiest working in colour and did little illustration, although he respected his graphic work enough to translate 'The Lady of Shalott' into a full-scale easel painting. Only ten of Rossetti's drawings were published as illustrations, yet his influence on the field was very great. It appeared not only through his obsessively repeated images of Elizabeth Siddall (later transmuted into the fairies and goddesses of Burne–Jones and Crane) but also through the quivering intensity in his faces and gestures and through the use of the close-up, with his figures filling or even hemmed in by the limits of the picture space.

Among the inheritors of the Pre-Raphaelite tradition prominent in the 1860s was Frederick Sandys (1832–1904). In 1857, he had published a drawing entitled 'The Nightmare' which was a parody of Millais's painting 'Sir Isumbras at the Ford' showing the critic John Ruskin as a braying ass on whose back were riding the leading members of the Pre-Raphaelite Brotherhood. Nevertheless, many of his thirty published illustrations have the mystical, evocative imagery and the illumination of detail found in the best Pre-Raphaelite work. Sandys was a remarkable draughtsman who displayed a Durer-like understanding of the problems of drawing on wood. Although his illustrations were admired and collected by discerning contemporaries, much of his total oeuvre consisted of crayon portraits that gave little indication of his imaginative gifts. 'Amor Mundi', illustrating a poem by Christina Rossetti, depicts lovers strolling happily in a meadow, oblivious of the writhing snakes and the beautiful but emaciated corpse beneath their feet. The treatment of this image of death contrasts strongly with the intensely emotional response often inspired by the subject in the hands of other artists.

Death was one of the recurrent themes that

typified Victorian art and literature. Scarcely a novel of the period was without at least one pathetic or edifying deathbed scene. Death at an early age was then sufficiently common for its frequent inclusion in fiction, poetry and the visual arts to be justifiable on grounds of realism alone; it was considered prudent to familiarise even young children with the idea through the medium of the children's book. Victorian illustrators were capable of depicting death in images of the utmost drama and pathos: 'On Her Deathbed' by George Du Maurier (published, like many of Sandys's illustrations, in *Once a Week*) showed an infant desperately embracing its dying mother, with an ancient grandmother weeping at the bedside and the sea glimpsed through an open window as a symbol of eternity. Such symbolism was particularly widespread in connection with death. 'Amor Mundi' offers another example, but is unusual for its period in the acceptance of putrefaction, an aspect which fascinated the 'decadents' of the *fin-de-*

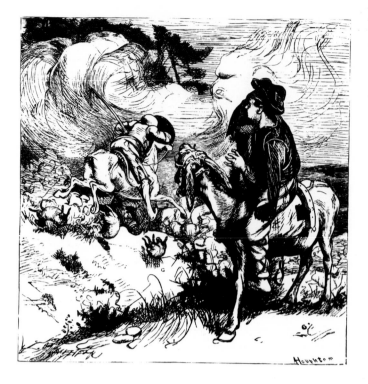

Right A. BOYD HOUGHTON 'Don Quixote goes against a flock of sheep' from *Don Quixote* by M. de Cervantes Saavedra, translated by Charles Jarvis (Frederick Warne, 1866).

Below ARTHUR HUGHES 'My Heart' which appeared in *Sunday Magazine*, 1871.

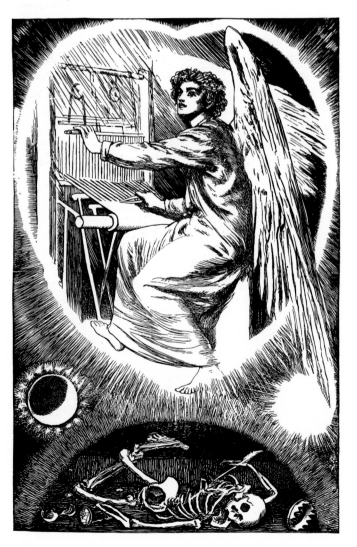

siècle period, but which the earlier Victorians preferred to overlook. The almost universal belief that judgement was followed by heavenly reward or by hellfire and damnation had traditionally offered great pictorial opportunities to artists. Gustave Doré (1833–83) conceived his illustrations of John Milton's *Paradise Lost* in the imagery of early 19th century romanticism. More typical of mid-Victorian attitudes was Arthur Hughes's 'My Heart', in which the usual white-robed angel serenely contemplates the prospect of living happily ever after.

Hughes (1832–1915), whose genre easel paintings including 'April Love' and 'Home from the Sea' embodied the quintessence of Victorian sentiment, was an evocative illustrator, producing many of his best images in response to George MacDonald's strange and powerful fantasies. A more vigorous contemporary of Hughes was Arthur Boyd Houghton (1836–75), whose claimed journeys in the Far East during childhood were supplemented by verified, extensive travel in the United States as a visual reporter for *The Graphic* magazine. His illustrations for the Dalziels' *Arabian Nights* showed a vitality and a sense of passion unequalled in the work of the period; they painfully showed up the static look of Tenniel's contributions to the same volume. (Coincidentally, both these artists were one-eyed because of accidents.) Although Houghton, like a number of the graphic innovators of the 1860s, died young, his work enjoyed renewed popularity in the 1890s after the publication by Laurence Housman of an anthology of his drawings. Housman praised his energy, his imaginative range and his economy of composition. In the extensive areas of white seen in many of Boyd Houghton's backgrounds, Housman may have noted

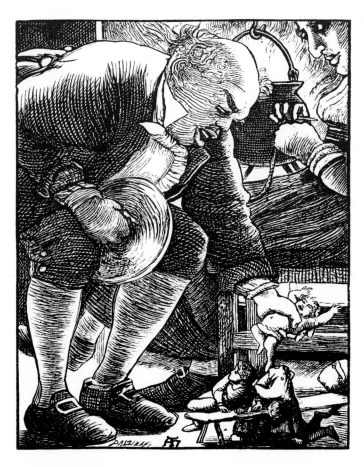

Above ARTHUR HUGHES 'Giant Thunderthump' from *Dealings with the Fairies* by George Macdonald (1869). Engraved by Dalziel Bros.

Right WALTER CRANE Endpiece to Vol. III, Book III, Canto XII of *The Faerie Queene* by Edmund Spenser, edited by Thomas J. Wise (George Allen, 1895).

an early intimation of the Japanese influence that was to emerge as a persistent iconographic source during the last three decades of the century.

A vogue for anything Japanese or indeed oriental had followed the recommencement of trade with Japan in the 1850s which had ended her two centuries of self-imposed isolation. Japanese woodcuts, defying European traditions of chiaroscuro and three-dimensional space with their insistence on linear and decorative qualities, were received with amazement by artists, many of whom were eager to assimilate this new graphic influence. Japanese art also became one of the main sources of inspiration adopted by the Aesthetic movement of the 1870s and 1880s. This movement amounted to a collective fantasy projected by artistically aware members of the middle class, an attempt to escape the ugliness and over-ornamentation then characteristic of industrial products with the creation for themselves of an environment of exotic yet pure romantic beauty. The prophet of the movement was the critic Walter Pater, who urged the cultivation of passive hyper-aesthesia in response to artistic stimuli. The Aesthetic influence was felt in every aspect of design; in

architecture and gardening, in furniture and dress, and in ideals of beauty—the pale androgynous faces created by Rossetti and Burne-Jones supplanted the royal features still admired by 'philistines'.

The movement's influence on book illustration and design was epitomised by Walter Crane, among whose earliest and most interesting projects was a series of 'toy books', the first of which appeared in 1865. In these children's illustrated versions of fairy tales and nursery rhymes which were printed in colour by Edmund Evans, Crane pioneered an awareness of book design, including the printed or hand-written text in his graphic conception and considering the double page spread as a visual unity. He acknowledged the profound influence of the Japanese print on his work: it appeared in his signature (a cartouche containing a Japanese-inspired crane symbol), in his imagery (clearly seen in the toy book *Aladdin*) and even more significantly in his visual insistence on the surface of the page. Most of Crane's illustrations stressed decoration at the expense of three-dimensional illusion; images were surrounded with an assertively ornamental border or incorporated a title or portion of text. Crane's graphic handwriting, deeply admired by his contemporaries, consisted of a graceful but rather obtuse and unvaried line. His imagery was based on a large vocabulary of motifs (many floral, including the ubiquitous 'aesthetic' sunflowers and lilies) and a limited number of human prototypes. He especially favoured an adult version of the Kate Greenaway child, languidly 'aesthetic' and completely lacking in facial variety. Crane's concept of fantasy followed his perception of the decorative potential of images, and within this limit, his work was endlessly inventive and consistently graceful. He explored the infinite

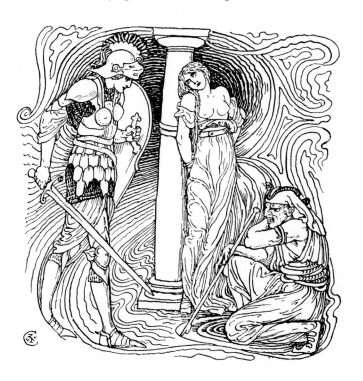

permutations of his personal kaleidoscope, rearranging his arabesques, symbols and noticeably abstract figures in compositions that were supremely decorative but curiously unemotional, seldom attempting to evoke a world of human ecstasy or terror.

Crane's illustrative work was only one aspect of a career that continued until 1915. He was the author of several books on design and illustration, as well as a designer of tiles, metalwork, fabric and wallpaper, a decorator of masques and carnivals, an art school professor, an early socialist, and successively president of the Art Workers' Guild and the Arts and Crafts Exhibition Society. These two groups formed part of the Arts and Crafts Movement, which emerged in the 1880s, inspired by the teaching of John Ruskin and by the ideas and practical achievements of Crane's hero and mentor William Morris.

The philosophy which Morris expressed in his written works, *A Dream of John Ball* and *News from Nowhere*, was of a socialist utopia in which the individual could find personal fulfilment in creative work. As a practical step towards realising his ideal, he established a company, Morris, Marshall, Faulkner & Co., later simply Morris & Co., which employed and trained skilled craftsmen to make well-designed household furnishings by traditional methods. In the last years of his life, he turned to book production, setting up the Kelmscott Press in 1891. Morris designed and engraved the exquisitely decorated borders and initials, inviting artists who were in sympathy with him, among them Crane, Sir Edward Burne–Jones and A. J. Gaskin, to create the illustrations which usually appeared as chapter headings. Kelmscott books, even more than Crane's, possessed a visual unity that did much to stimulate a new consciousness of book design. They also helped to found a tradition that was to continue well into the 20th century: small, privately owned presses publishing books designed by artists and embellished with autographic wood-engravings.

AFTER 1890

The *fin-de-siècle* period in Britain coincided with the final decade of a reign that lasted for over sixty years. The taste and the artistic development of the 1890s was shaped by second and even third generation Victorians. The Queen herself now appeared as a matriarchal figure representing the permanent supremacy of middle class moral and material values; the Prince of Wales's affaires and his enthusiastic patronage of European casinos were discreetly ignored. 'Never was there an age', writes John Rothenstein, 'when so gigantic a gulf had yawned between profession and reality. A false refinement forbade the mention of the real nature of man's instincts. His greed, his lust, and his cruelty were no longer spoken of . . . "All's well with the world" remained the order of the day'.

This hypocrisy was nowhere more evident than in sexual matters. For the brave and the highly motivated, organised vice offered a temporary escape from society's constraints: prostitutes of both sexes flourished. Yet in all spheres of middle-class life, anything to do with sex was unmentionable and almost unthinkable. Sexual fantasy had to find indirect expression in literature and art.

Almost the only illustrator able to penetrate the dense barrier of sexual evasion and euphemism directly was Aubrey Beardsley (1872–98). A consumptive spitting blood for most of his working life, Beardsley possessed a remarkably heightened perception and a recklessness arising from the knowledge that he was doomed. In five years of prodigious activity, he created a plethora of sexually ambiguous images which he included in his designs with such ingenuity and discretion that all but the highly explicit *Lysistrata* illustrations could appear in openly distributed publications. (That this was possible is indicative of public ignorance of the existence of eunuchs, hermaphrodites, transvestites or transsexuals.) Beyond his interest in sexual variety, Beardsley's awareness extended to the forbidden topic of prostitution in the highest levels of society which he revealed and embellished with a complete lack of moral indignation. He moved in the circle of Symbolists, aesthetes and wits that surrounded Oscar Wilde, and in 1893 illustrated Wilde's *Salome*. In spite of his subsequent antagonism towards Wilde, the writer's conviction for homosexual offences had enormous repercussions for Beardsley, who was popularly regarded as Wilde's equivalent in the field of illustration.

During his short career, Beardsley assimilated into his work a wide range of aesthetic sources. In his illustrations for Malory's *Morte d'Arthur* (1893), he adopted the medieval style required by the publishers J. M. Dent, who wished to produce a popular equivalent of Morris's Kelmscott editions. While Beardsley's drawings brilliantly captured the medieval manner so much admired by his contemporaries, they utterly lacked the medieval spirit that characterised the genuine Arts & Crafts production. Morris himself immediately saw them as a parody of his own work and contemplated legal action. Beardsley took a rather different view. 'The truth,' he wrote, 'is that while his [Morris's] work is mere imitation of old stuff, mine is fresh and original.' By this time, he had already absorbed the influence of Japanese art, which appeared in his often elongated formats, in his asymmetrical compositions, in his

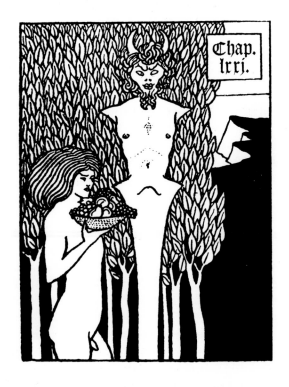

simplified backgrounds with their high horizons, and above all in his insistence on the supremacy of line and pattern. His details also showed oriental influence: in the simplified faces, Japanese in treatment though not in physiognomy, and in the flower shapes that sometimes adorned the hangings and costumes in his drawings. A third influence was the rococo style, characterised by the weightlessly delicate plant-based arabesques which began to appear in his work early in 1896. These were soon followed by the elaborately frilled and gathered costumes and the exotic coiffures found in French 18th century paintings. With the appurtenances of the rococo style came another development: the simplified motifs and patterns of Beardsley's earlier work were supplanted by much more ornate forms and by the technically and visually astonishing all-over detail of his *Rape of the Lock* illustrations. At the very end of Beardsley's life came a renewal of an early interest in Renaissance art, particularly that of Mantegna, whose grisailles and architectural themes were revived in his last works.

Symbolism, sometimes of a very personal nature, abounded in Beardsley's work. One frequently recurring image was the dwarf, either child-like or of ambiguous age and sex, sometimes mocking the central figures or at other times merely playing a supporting role. In 'The Cave of Spleen', illustrating Alexander Pope's *Rape of the Lock*, the turbaned figure of Pope himself is surrounded by a strange assortment of personalised evil qualities, including a small figure in the bottom left-hand corner facially resembling the politician Joseph Chamberlain. On its swollen belly is tattooed a diagram of the female reproductive system and a small foetus. If a likeness of Chamberlain was indeed intended, it must be almost the only example of political caricature in Beardsley's work. The adjoining figure in the design has his arm attached back-to-front; others are trapped in a cage and imprisoned in a jar. Even so, these surprising figures blend inconspicuously into the overall decorative effect.

Completely different in approach, though in his own way nearly as influential as Beardsley, was the book designer and illustrator Charles Ricketts (1866–1930), another member of Wilde's circle. Ricketts and his lifelong partner Charles Shannon (nicknamed 'Orchid' and 'Marigold' by Wilde) were at the forefront of the movement to re-establish wood engraving as an autographic medium for artists. The commercial wood engravers (now made redundant by 'process') had explored the technical but not the expressive potential of the medium in their adaptations of pen-and-ink drawings. The artist–

AUBREY BEARDSLEY Chapter headings to Vol. I, *The Birth, Life and Acts of King Arthur* by Thomas Malory (Dent, 1894).

CHARLES RICKETTS 'The Love of Venus and Anchises.'
Illustration to *Daphnis and Chloe,* translated from Longus by
George Thornley (Elkin Mathews & John Lane, 1893).

engravers, however, were determined to create works that were intrinsically expressive of the medium. Ricketts initially designed for other publishers, gaining experience by operating within whatever limits they chose to place on him, but by 1896, he and Shannon were able to set up their own publishing house, The Vale Press, and during the next ten years published some 85 books, all of which they designed entirely themselves. Like Morris, Ricketts designed a number of typefaces for use in his books, but unlike Morris, he never owned a press, preferring to turn to commercial companies for printing and binding. Morris insisted on using handmade rag paper because he hated the idea of encouraging machine production, even though many machine-made papers were better suited to the wood block process. Kelmscott books are rather uniform in conception and appearance as a result of Morris's overriding ideology. Ricketts, by contrast, approached every book as an independent design problem. Turning to the text for inspiration, he created individual formats using a wide variety of types, papers and cover materials to achieve an aesthetic unity for each title. Ricketts believed that illustration should be 'a natural and essential feature of the physical evolution of the book in the mind of the designer, and generally speaking should be used sparingly.' His own illustrations possessed an absolute timelessness with their often severely classical backgrounds and their long-haired, exquisite figures, descendants of the 'aesthetic' personae of the 1870s and 1880s, abstract rather than personalised and symbolic rather than descriptive. It was partly the evident purity of his work, its innocence of explicit sexual references, that

enabled Ricketts, who had published and illustrated several of Wilde's books, to escape the vilification that had extended to Beardsley's in the aftermath of Wilde's downfall.

Another of Rickett's friends was Laurence Housman (1865–1959), one of whose earliest undertakings was to illustrate Christina Rossetti's *Goblin Market*. This had previously been illustrated by her brother, Dante Gabriel Rossetti, with whom Housman had much in common. Both were writers as well as artists (Housman concentrated on literature after 1900 when he was forced by failing eyesight to give up illustration), both shared the ability to communicate profound emotion through their drawings. The macabre rat-faced goblins in Housman's interpretation of *Goblin Market* are derived from Rossetti's, but with the sinister addition of their Breughelesque medieval hats. Although much of Housman's illustrative work was engraved on wood by his sister Clemence, an engraver of unusual refinement, he also drew for photomechanical reproduction. His figures resembled those of Ricketts but were depicted with greater passion, with the agitated costumes and even the landscape backgrounds contributing to the emotional intensity.

In *Goblin Market*, Housman was the first to introduce the long, narrow format which, as John Russell Taylor points out, became the hallmark of the Art Nouveau book. The first recognisably Art Nouveau book design in Britain had been A. H. Mackmurdo's cover of *Wren's City Churches* in 1882. Mackmurdo was a leader of the Arts & Crafts Movement which had given birth to British Art Nouveau and almost immediately disowned it. Continental Art Nouveau was viewed by most of the English Arts and Crafts practitioners as a rather unhealthy rococo revival. Nevertheless, its sinuous plant-like forms and typical whiplash curves are identifiable in the work of a number of British illustrators. Among them was Charles Robinson (1870–1937), the elder brother of the even more famous William Heath Robinson. He was another of the small group who designed their books as a whole: he usually made a complete sketch model to demonstrate to the publisher his proposals for illustrations, endpaper and cover designs, and page layouts. In the development of his style, Robinson acknowledged the influence of Durer, Beardsley and Housman, but his pictorial language was completely his own; it had a visionary quality which was achieved through the sometimes stylised but delicate and inspired detail. The strange aura of unreality in much of his work was partly a product of the inanimate or entranced facial expressions and partly stemmed from his insistence on the decorative and graphic aspects of figuration. Later in his career, Robinson favoured evocative and nostalgic content in place of the

inventive detail that typified his early style; he took increasing pleasure in gardens and rural scenes as subject matter. The spirit of Art Nouveau appeared in his imagery, in his decorative borders and his remarkably varied page designs with their counterbalanced and intertwining areas of text and illustration. This integration was complicated to achieve in the days of letterpress but has seldom been equalled by later designers, in spite of the present-day freedom provided by offset lithography.

The influence of Art Nouveau can also be seen in the work of Alfred Garth Jones and Louis Fairfax Muckley. They were both associated with the Birmingham Guild of Handicraft under the leadership of A. J. Gaskin, a disciple of Morris who drew and engraved the illustrations for the Kelmscott *Shepheard's Calendar*. A slightly later exponent of Art Nouveau was Reginald Knowles who designed the covers and endpapers of J. M. Dent's 'Everyman' series of cheap editions from 1905 onwards. He also illustrated fairy books in partnership with his considerably less talented brother Horace.

Jessie M. King (1876–1949) was trained at the Glasgow School of Art, and her work bears the mark of the Glasgow style, a unique version of Art Nouveau developed by the architect Charles Rennie Mackintosh and his wife Margaret Macdonald; this was greatly admired in Europe but dismissed by English Arts & Crafts diehards like Crane. Jessie M. King, who also designed pottery, silver and jewellery, illustrated with Celtic delicacy which was quietly mysterious in feeling, although she later adopted the angular forms and brilliant colours of Art Deco.

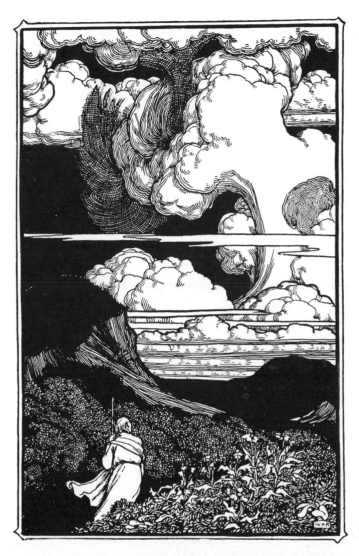

Above W. HEATH ROBINSON 'Alone' from *Poems of Edgar Allan Poe* (George Bell, 1900).

Below A. GARTH JONES Endpiece to poem from *The Minor Poems of John Milton* (George Bell, 1898).

The work of William Heath Robinson (1872–1943) was also firmly rooted in Art Nouveau. Heath Robinson, who shared many of the decorative gifts of his brother Charles, was the first illustrator to create a world of fantasy directly out of contemporary life. But then, he lived in an age which was transforming into reality many components of earlier dream worlds: self-propelling chariots, dazzling lights, heat without flame, ice-generating machines, the ability to fly and to project one's voice to the far end of the world. Earlier cartoonists, including Cruikshank and Tenniel, had incorporated such inconceivable images into science fiction cartoons. Heath Robinson, however, was able to take note of the spectacular innovations of his age. He specialised in preposterous visual hypotheses which expressed his very personal view of human motivation and were conceived with impeccable logic in terms of the technology available to the suburban home handyman. He explored the humour of his ideas with a strong sense of characterisation, peopling otherwise unbelievable situations with convincing figures whose gestures and expressions show their seriousness of purpose. Another ingredient

of the Heath Robinson world was anachronism: an knight in armour owns a coffee percolator; pterodactyls are glimpsed hovering over a golf course. The transmutability of life-forms, which had earlier been found in the work of Lear and Crane, is neatly handled by Robinson in the metaphor of a face being cultivated in a flowerpot.

Heath Robinson's early work shows an Art Nouveau feeling for eccentric and elongated compositions and for extensive areas of white. As his work developed, he increasingly crowded his pages with incident, though without ever losing his sense of design. His sensitive yet functional style of drawing contributed to the plausibility of his world.

The Symbolist movement of the 1890s extended to literature as well as visual art. Its British exponents looked for inspiration to the poems and graphic work of William Blake and to the paintings of Burne-Jones, which were visionary in a rather morbid way that harmonised with the *fin-de-siècle* spirit. Symbolism, in the words of the Symbolist writer and critic Arthur Symons, was 'a theory of life that makes one familiar with mystery', an awareness of 'the great silent conspiracy between us to forget death'. The Symbolists were preoccupied with the conundrum of existence, with birth, death and being, seeking to transcend the trivialities of everyday life, so to attain a level of heightened spirituality. (Symons, editor of *The Savoy* magazine was an associate and friend of Aubrey Beardsley during the last two years of the artist's life—Beardsley's images had from the start been conditioned by a knowledge of Symbolist thought.) In another contemporary definition, the poet W. B. Yeats described the Symbolist artist's search for forms which, unsullied by specific literary and allegorical associations, could be used to convey the 'Divine Essence', a task attempted with some technical naivety by Yeats's friend, the mystic William T. Horton (1864–1919) in his *Book of Images*.

Horton was the only illustrator who came near Yeats's ideal of a Symbolist art composed entirely of images that could be recognised as meaningful by instinct rather than because of cultural conditioning. However, Symbolist ideas appeared as an influence in the work of other graphic artists including Vernon Hill, Sidney Sime and Jean de Bosschère. Hill was primarily a wood-carver, most of whose illustrative work was done in the years 1910–12. His major achievements here were his designs for *Ballads Weird and Wonderful* and *The New Inferno*, both of which were collections of verse, the literary form most suitable for symbolic illustration. An important influence on him was Blake; it is seen in his often symmetrical compositions, the differences in scale of his figures, and their physique (which also shows Hill's feeling for sculpture). Also from Blake come a number of Hill's motifs, notably the unseeing, cataracted eyes of

the spirits in his illustration to Canto VII of Stephen Phillips's *The New Inferno* and his use of the serpent as a symbol.

The work of Sidney Sime (1867–1941) in black-and-white was published in the illustrated literary and critical magazines that flourished in the 1890s. At various times, Sime was art editor of two of these, *Eureka* and *The Idler* (which numbered Beardsley and his sister Mabel among its contributors). The fantasy drawings which were his major achievement usually appeared without any accompanying narrative or explanation beyond a title. They give the impression of belonging to a privately dreamed saga of epic dimensions. 'A Fantasy of Life' is unusually and terrifyingly explicit: a human child, trapped by hobgoblins, is about to be thrown into a subterranean kitchen where a triumphantly grinning demon in an Osiris hat presides over a boiling cauldron containing earlier victims. Sime's work often hovered between serious symbolic imagery and humour. In fact, at least half his published drawings were caricatures of theatrical personalities that were reminiscent of both 'Ape' and Sir Max Beerbohm. In both style and subject, his fantasy drawings show the influence of the Japanese print as well as that of Beardsley. Sime's only book illustrations were for a few works by Lord Dunsany, and his visualisations of these vivid and unusual adult fantasies are among his most powerfully imaginative creations.

FAIRY ILLUSTRATION

In the same period as the Symbolist movement, there was a marked increase of interest in traditional fairy stories and folklore. Collections such as *The Arabian Nights* (which had seldom been out of print since the first English translation in 1717) and *Grimms' Fairy Tales* had enjoyed continuous popularity throughout Queen Victoria's reign, but they were joined towards the end of the century by a massive influx of newly translated folk stories from all parts of the world. Their collection was made possible in part by the annexation of vast new territories, particularly in Africa, and was stimulated by a growing awareness of the threat to traditional cultures posed by the advance of industrial civilisation. This folk literature found enthusiastic readers among adults as well as among the children for whom the published anthologies were ostensibly intended. One attraction may have been the powerful sexual metaphors which permeate the imagery: the doe-princess being pierced by the prince's arrow, the frog-prince's restoration to manhood by a kiss, and so on. These fantasies could be enjoyed unselfconsciously by a generation that had not yet been alerted to sexual symbolism by the

discoveries of Sigmund Freud. Their characteristic invocation of magic to produce a happy ending might also have seemed attractively apposite to the beneficiaries of modern technological wizardry.

Two of the foremost illustrators of fairy stories in the 1890s were H. J. Ford and J. D. Batten, exact contemporaries at the Slade School of Art and often remarkably similar in their work. Ford (1860–1941), a scholar with a classics First from Cambridge, is best remembered for his illustrations to Andrew Lang's eleven *Coloured Fairy Books* which were published between 1889 and 1910. He used a persuasive combination of realism and fantasy: his sensitive observations of the details of plant and animal life were expressed in a straightforward graphic style, but within this naturalistic context, the fairies and monsters, princes and palaces (which were always meticulously researched) became completely convincing. In the later volumes of the series Ford was able to include colour pictures which recall Pre-Raphaelite paintings in their all-over attention to detail and their brilliance of colour. Batten was even more versatile than Ford: he was known as a muralist, as an easel painter of genre and historical subjects, as an etcher, a poet and an authority of man-powered flight. In common with Ford, he succeeded in transposing the sexual metaphors of the original folklore into his own imagery (nicely demonstrated in the two artists' images of hobgoblins with crossed legs and phallically protruding tongues). Batten's subjects tended to

Right H. J. FORD 'The Hobgoblin laughed till his sides ached.' Illustration to *The Snow-Queen*, from *The Pink Fairy Book*, edited by Andrew Lang (Longmans Green, 1901).

Below JOHN D. BATTEN Chapter heading to *The Cauld Lad of Hilton*, from *English Fairy Tales* collected by Joseph Jacobs (David Nutt, 1890).

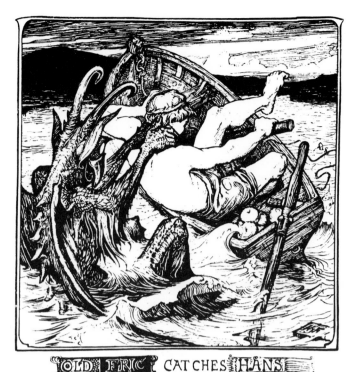

Above H. J. FORD 'Old Eric catches Hans.' Illustration to *Hans, the Mermaid's Son*, from *The Pink Fairy Book*, edited by Andrew Lang (Longmans Green, 1901).

be shown with more detachment and humour than Ford's, and there was more emphasis on line in his drawing style. The graphic work of both belonged to a tradition that stretched back through Crane and Burne-Jones to Rossetti. It was left to Arthur

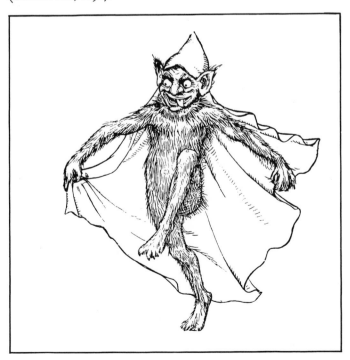

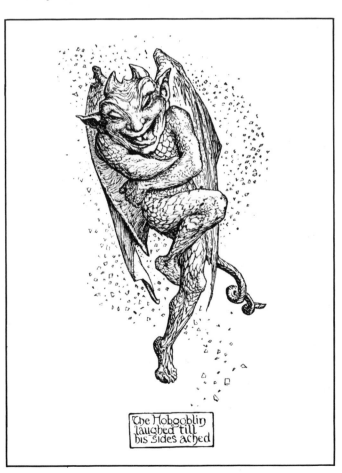

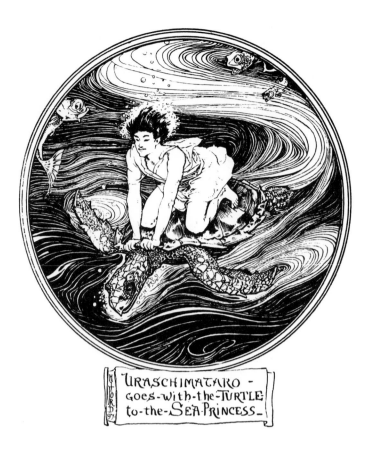

H. J. FORD 'Uraschimataro goes with the Turtle to the Sea Princess.' Illustration to *Uraschimataro and the Turtle*, from *The Pink Fairy Book*, edited by Andrew Lang (Longmans Green, 1901).

Rackham (1867–1939) at the very end of the century to introduce a completely new figurative approach to the folk story.

Rackham offered a consistent vision of a magic world in which the real and the fantastic were blended, often to mysterious, even macabre effect. A cosy, turn-of-the-century idea of bliss emerges from his idyllic landscape backgrounds with their thatched cottages (rather in the rustic style of the architect C. F. A. Voysey), from the Windsor chairs and patterned tea-sets, and from the innocent, golden-haired children. But his witches and goblins, his tempests and hurricanes, his grotesquely writhing trees were terrifying because they, too, could be recognised as relating to common human experience of his time. His ancient goblins and wizened, toothless witches possess in their emaciated limbs and swollen joints, in their ill-fitting shoes misshapen by bunions, nothing more than an exaggerated version of the deformities that were common among the elderly and underfed poor. Rackham captured the fear and disgust felt by the middle class child at the sight of the dirty and the maimed, but he still managed to imbue his physically repellent figures with fascination and even a certain glamour. There is no reason to believe that he intended any definite social message; more likely, he was re-creating from memory the images that had imprinted themselves on his imagination during his south London childhood.

In his treatment of animals, Rackham gave a new twist to the animal-person genre. His animals may frequently have been equipped with clothes and human responses, but they were also shown with much emphasis on their non-human anatomies, with claws, tail and whiskers accentuated rather than the cuddly teddy bear qualities that were favoured in later children's books. Rackham also went in the other direction, imparting animal characteristics to unmistakably human figures as in his illustrations to John Milton's *Comus*. Transmutation played an important part in his imagery: faces peered from tree trunks; tangled or truncated branches threatened to clutch and tear; fire, water and clouds could reveal human features. Even when such directly anthropomorphic features were absent, nature and the elements had a strong sense of life: wind, clouds, smoke and especially water were pervaded by Rackham's animism. Some of these strands of fantasy took up fundamental themes of folklore and myth. Tree-animism was an ancient idea, earlier given form in the 19th century by Cruikshank and re-emerging in the 20th through the writings of Lord Dunsany and J. R. R. Tolkien. Rackham's fairies, like Doyle's and Cruikshank's, belonged to the old European tradition of the 'little people'—tiny supernatural beings ambivalently disposed towards humans.

Rackham studied at the Lambeth School of Art, where he was a contemporary of Ricketts and Shannon as well as of L. Raven Hill and F. H. Townshend, both later famous for their contributions to *Punch*. Rackham also started his career with humorous reportage, though for the *Westminster Budget*, and it was not until the end of the 1890s that he arrived at his true vocation as a fantasy illustrator. His success owed much to the perfection of colour halftone printing around the turn of the century. Now an artist's sketch could be reproduced in full colour with photographic fidelity, and Rackham was among the first book illustrators to appreciate the advantages of working in colour. A thorough understanding of the technicalities enabled him to take full advantage of the new process. Some illustrators, among them Byam Shaw, failed to realise that colour halftones could emphasise the unevenness of tint, particularly if the original was reduced in size, and their attempted scenes of splendour frequently emerged as a tragic mess. Rackham, who worked in transparent watercolours on the completed ink drawing, used colour to evoke mood, to enhance the feeling of agelessness and mystery in his images. Browns and misty greys, creamy whites and greens predominated, often with areas of faded blue and small patches of vermilion. Although the colours

became brighter and more intense in his later work, their function remained the same.

Full colour printing was greeted with rapturous approval by both publishers and public; the new phenomenon was celebrated by the revival of the gift book. This type of expensive, lavishly produced volume had previously been popular in the 1860s as the showcase of the new style of wood-engraved illustration; it was intended for the drawing room rather than for the library or the nursery, and the subject matter was selected to be a vehicle for the work of popular and prestigious illustrators. The colour plates in the second generation of gift books had to be printed on glossy, coated art paper and were usually tipped in by hand on pages of heavier, tinted paper, which was often printed with a plain or decorative border. The platemakers and printers brought all their skill to bear on these volumes and reached a standard of colour printing which has seldom been surpassed. Books lower down the market, however, often contained colour plates that were poorly registered or unevenly inked; sometimes they had only a frontispiece in colour.

In his success as an illustrator of gift books, Rackham was rivalled only by Edmund Dulac (1882–1953), who was also an interesting colourist best known for illustrations to fairy stories but was otherwise completely different in the character of his work. Rackham was fundamentally romantic and influenced by Art Nouveau; he used colour to enhance the content of his drawings. The extremely prolific Dulac, on the other hand, turned to Persian and Indian miniatures as sources and used colour almost entirely for its decorative effect. His work was essentially escapist: his castles rise out of clouds; his people walk on air—even his smooth-skinned frogs have gossamer wings. Instead of Rackham's innocent, gingham-frocked children, his world is peopled with exquisite princesses in silken clothes of rococo or oriental style studded with jewels in star or flower patterns. The tortured forms of Rackham's pollarded willows are replaced by trees of filigree delicacy which provide the backdrop of a milieu in which even the well-fed demons have a cultured, gallic charm. Although Dulac was an able and imaginative draughtsman, there was an element of monotony in his illustration, perhaps because there is no suggestion of any real nastiness. Dulac almost fits the description in Robert Browning's poem of Andrea del Sarto failing to attain genius because his art was too perfect.

Dulac, who was born in France, settled in England when he was in his mid twenties and almost immediately achieved popular success as an illustrator. Although humour is not a quality normally expected in his work, he was an accomplished caricaturist and the author of a comic alphabet (*Lyrics Pathetic and Humorous*, 1908) with limericks of his own composition. Like his friend Ricketts, he also designed for the stage and was a capable wood engraver (as in *The Green Lacquer Pavilion* of 1926). He was well known for his portraits in an oriental style. As a designer of stamps and medals, he was responsible for the profile of George VI used on British postage stamps.

THE FINAL PHASE

Dulac's success showed that the late 19th century taste for the exotic had continued into the present century. The flavour of exoticism is also strong in the work of the Danish artist Kay Nielsen, whose contribution to British illustration began during the years 1911 to 1916, when he lived in London. Nielsen had the unique ability to invoke mystery, tension and even horror with a graphic style that was almost frivolous in its elegance. Like Dulac, he studied at the Académie Julien in Paris, designed for the stage and acknowledged the profound influence on his work of oriental art. His imagery, however, had a wildness and atavism of its own, perhaps stimulated initially by the Norse sagas that had been read aloud to him in childhood by his actress mother. The theatre was important in Nielsen's life: his father was a theatrical director, and he himself later became a Hollywood actor and set designer. The Russian Ballet, which took Paris by storm while Nielsen was studying there, is an influence that is strongly suggested by the vigorously patterned, exotic costumes of the figures in *East of the Sun, West of the Moon*. The earlier *In Powder and Crinoline*, however, is in the rococo style as reinterpreted by Beardsley in *The Rape of the Lock*. Nielsen frequently used symbolism to elaborate his ideas, as in the two life-size guttering candles in his illustration of 'The Lindworm'.

Perhaps the most imaginative, certainly the most macabre use of symbolic association was by the remarkable Irish artist Harry Clarke. Particularly in his illustrations of Goethe's *Faust*, he invented figurations of evil that recall the paintings of Hieronymus Bosch. The *Faust* series includes drawings in black-and-white and in colour peopled with hosts of grotesque and mutilated monsters plus various fungi. There are multiple breasted, cadaverous demons which may be headless or armless with tufts of armpit hair, bird-headed and eye-tipped penises, rats crawling from mouths and other orifices (an echo here of Gillray's cowpox vaccine cartoon), and decrepit, naked witches with chopped wings and with claws for hands and feet. Clarke's Mephistopheles is in the same mould as the figure of Ill Nature in Beardsley's 'The Cave of Spleen' and as 'La Salomé Tatouée' in Gustave Moreau's painting; he is an elegantly

bejewelled, sexually ambiguous creature with cloven high-heeled boots. Clarke's imagery is the more astonishing because it comes from an artist whose chosen medium was stained glass and whose commisions were usually windows for Roman Catholic churches. Many of his images seem to contain bizarre perversions of religious iconography: diabolical gestures parody those traditionally ascribed to saints; flying witches and monsters with truncated or skeletal wings appear as the antithesis of angels; the Snow Queen becomes a paganised Immaculate Conception. In his perverse and satanic imagery, which often had strong homosexual overtones, Clarke exceeded the Decadents of the 1890s. Obscenity, though, was kept at bay by a dimension of comedy which invited the spectator to participate in the inversion of accepted notions of propriety and in the transmutation of the symbols of religious faith.

Clarke, who (like Beardsley) died of consumption, was widely acclaimed by critics both for this artistry and technical innovations in the field of stained glass and for the accomplishment of his graphic work. While applauding his use of colour offset by black and his exquisitely detailed decorative effects, his contemporaries, like Beardsley's, overlooked or at least avoided mentioning the sexual implications of his imagery. Clarke's patterns and textures were outstandingly inventive, sometimes coming from recognisable sources such as medieval illumination or rococo decoration, but sometimes anticipating by forty years the psychedelic effects of the 1960s. These were used in 'Has *No* Copy Been Taken'? to create a crowded, almost claustrophobic feeling, again reminiscent of Beardsley's 'The Cave of Spleen'. Clarke's early work is much more open, as in his illustrations for *The Year's at the Spring*. In 'I am born of a thousand storms', windswept figures burst from the end of an archetypally Art Nouveau whiplash. 'And the dead robed in red' features the sea anemone-jellyfish motif that was to reappear in much of his work. The picture gives a compelling illusion of underwater buoyancy in which every ideomorphic expectation is simultaneously reversed by the singular device of the upward-floating shrouds.

The work of Nielsen and Clarke marked the final phase in an epoch of book illustration that really ended in 1918. One effect of World War I was a progressive decrease in the output of well produced gift books (noted with regret by Rackham in 1929). This was an index of the relative decline in wealth and leisure among the classes that had formed the traditional market for these books. Another war victim was the family periodical which had published illustrated novels in instalments and had provided bread and butter for more than two generations of graphic artists. It was now the cheapest end of the market that was expanding dramatically in the very different illustrative form of the comic strip. At the same time, fantasy fulfilment found a spectacular new outlet in another medium, the cinema.

HARRY CLARKE Headpiece to *Faust* by J. W. von Goethe, translated by John Anster (Harrap, 1925).

General Bibliography

AESTHETIC MOVEMENT

The Aesthetic Adventure, William Gaunt (Cape 1945)
The Aesthetic Movement in England, Walter Hamilton (Beeves & Turner, London 1882)
The Aesthetic Movement—Prelude to Art Nouveau, Elizabeth Aslin (Elek, London 1969)
The Aesthetic Movement, Robin Spencer (Studio Vista, London 1972)

THE ARTS AND CRAFTS MOVEMENT

The Arts and Crafts Movement, Gillian Naylor (Studio Vista, London 1971)

BEARDSLEY, AUBREY VINCENT

Artists of the 1890's, John Rothenstein (Routledge, London 1928)
Aubrey Beardsley, Arthur Symons (1898, republished John Baker 1966)
Aubrey Beardsley, Brian Reade (Victoria & Albert Museum, London 1966)
Aubrey and the Dying Lady, Malcolm Easton (Secker & Warburg, 1972)

BOOK ILLUSTRATION—GENERAL

A History of Book Illustration, David Bland (Faber & Faber, London 1958)
Victorian Illustrated Books, P. H. Muir (B. T. Batsford, London 1971)
Pen Drawings and Pen Draughtsmen (3rd edition), Joseph Pennell (Macmillan 1897)

BOOK ILLUSTRATION, 1860–90

English Illustrators—The Sixties, J. W. Gleeson White (Constable 1897, reprinted Kingsmead, 1970)
Illustrators of the Sixties, Forrest Reid (Faber & Gwyer, London 1928)

BOOK ILLUSTRATION, 1890–1920

The Art Nouveau Book in Britain, John Russell Taylor (Methuen 1966)
British Book Illustration Yesterday and Today, M. C. Salaman (*The Studio*, special issue, 1924–5)
The Decorative Illustration of Books, Walter Crane (1896, reprinted George Bell & Sons, 1972)
English Illustration—The Nineties, James Thorpe (Faber & Faber 1935)
English Book Illustration of Today, R. E. D. Sketchley (Kegan Paul, London 1903)
The Fantastic Kingdom, David Larkin (Ballantine 1974)
Modern Book Illustrators and their Work, M. C. Salaman (*The Studio*, special issue 1914)
Modern Pen Drawings, European and American, C. Holmes (*The Studio*, special issue 1901)
The Twentieth Century Book, John Lewis (Studio Vista, London 1967)

CHILDREN'S BOOKS

Children's Books and their Illustrators, J. W. Gleeson White (*The Studio* special winter number 1897–8)
English Children's Books 1600–1900, P. H. Muir (B. T. Batsford 1954)
Illustrating Children's Books, H. C. Pitz (Watson Guptill 1963)
Illustrators of Children's Books, Bertha E. Mahoney etc. (Horn Book Inc. Boston 1947)

CRANE, WALTER

The Art of Walter Crane, P. G. Konody (George Bell & Sons, London 1902)
A Bibliography of First Editions of Books Illustrated by Walter Crane, Gertrude C. E. Massé (Chelsea Publ. Co. London 1923)
Ideals in Art, Walter Crane (George Bell, London 1905)

DOYLE, RICHARD

Richard Doyle, Daria Hambourg (*English Masters of Black and White*, Art and Technics 1948)

THE EIGHTEEN NINETIES

The Eighteen Nineties, Holbrook Jackson (1913, republished Penguin Books 1939)
Dreamers of Decadence, Philippe Jullian (1971, reprinted Phaidon 1974)

HOUGHTON, ARTHUR BOYD

Arthur Boyd Houghton, Laurence Housman (Kegan Paul, London 1896)

KING, JESSIE MARION

Miss Jessie M. King and her work, Walter R. Watson (*The Studio*, Vol. 26)

LEAR, EDWARD

The Complete Nonsense of Edward Lear, edited and introduced by Holbrook Jackson (Faber & Faber 1947)

PRINTING PROCESSES

Modern Illustration, Joseph Pennell (*The Ex-Libris Series*, ed. J. W. Gleeson White, Geo. Bell & Sons, London and New York 1895)
Victorian Book Design and Colour Printing, Ruari MacLean (Faber & Faber 1963 and 1972)
Victorian Book Illustration. The Technical Revolution, Geoffrey Wakeman (Newton Abbott, David & Charles 1973)

RACKHAM, ARTHUR

Arthur Rackham, his life and work, Derek Hudson (William Heinemann, London 1960)

RICKETTS, CHARLES DE SOUSY

Self-Portrait. Taken from the Letters and Journals of Charles Ricketts R.A., compiled by T. Sturge Moore (Peter Davies, London 1939)

ROBINSON, WILLIAM HEATH

Heath Robinson, Artist and Comic Genius, John Lewis (Constable 1973)

ROSSETTI, DANTE GABRIEL

Dante Gabriel Rossetti, Painter and Poet, introduction by John Gere (Royal Academy of Arts. London 1973)

SULLIVAN, EDMUND JOSEPH

Edmund Sullivan, James Thorpe (*English Masters of Black and White*, Art and Technics, 1948)

TENNIEL, JOHN

Sir John Tenniel, Frances Sarzano (*English Masters of Black and White*, Art and Technics 1940)

SYMBOLISM

The Symbolist Movement in Literature, Arthur Symons (Heinemann, London 1899)
A Book of Images, W. T. Horton. Introduction by W. B. Yeats (Unicorn Quartos no. 2, 1898)

EDWARD LEAR
There was an Old Person of Bangôr,
Whose face was distorted with anger,
He tore off his boots, and subsisted on roots,
That borascible person of Bangor.
From *The Book of Nonsense* by Edward Lear (Warne, 1846).

EDWARD LEAR
There was a Young Lady whose chin,
Resembled the point of a pin;
So she had it made sharp, and purchased a harp,
And played several tunes with her chin.
From *The Book of Nonsense* by Edward Lear (Warne, 1846).

EDWARD LEAR
There was an Old Man in a tree,
Who was horribly bored by a Bee;
When they said 'Does it buzz?' he replied, 'Yes, it does!
'It's a regular brute of a Bee!'
From *The Book of Nonsense* by Edward Lear (Warne, 1846).

EDWARD LEAR
There was a Young Lady whose bonnet,
Came untied when the birds sate upon it;
But she said 'I don't care! all the birds in the air
'Are welcome to sit on my bonnet!'
From *The Book of Nonsense* by Edward Lear (Warne, 1846).

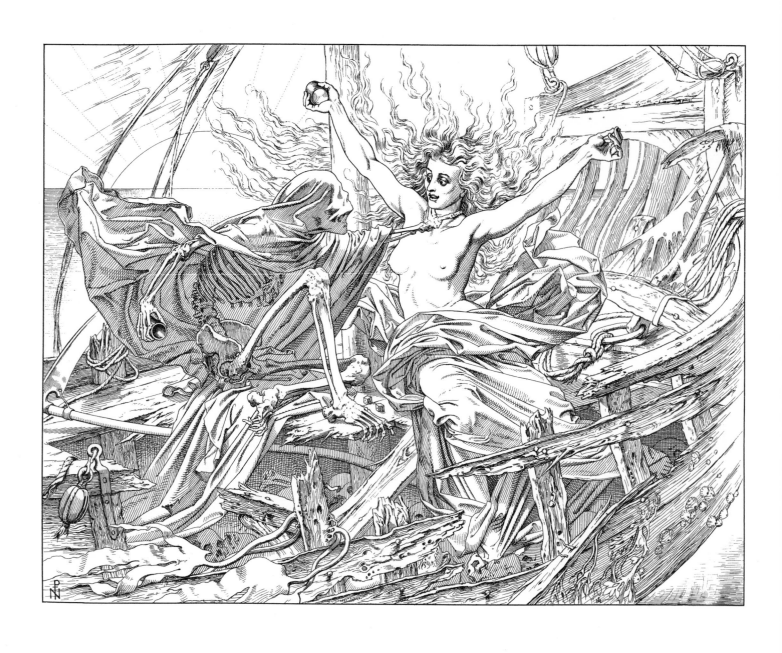

J. NOEL PATON
The naked hulk alongside came,
And the twain were casting dice;
'The game is done! I've won, I've won!'
Quoth she, and whistles thrice.
From Part the Seventh, *Coleridge's Rime of the Ancient Mariner*
(Art Union, 1863).

J. NOEL PATON
'The spirit who bideth by himself
In the land of mist and snow,
He loved the bird that loved the man
Who shot him with his bow.'
From Part the Seventh, *Coleridge's Rime of the Ancient Mariner*
(Art Union, 1863).

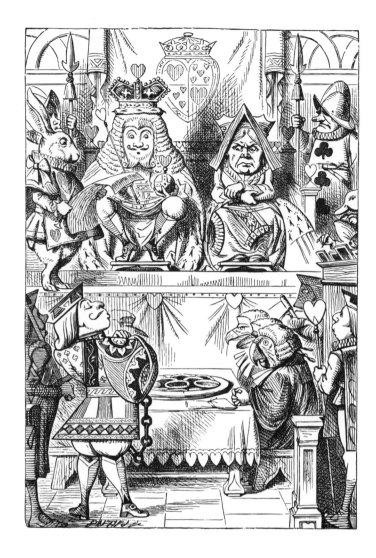

JOHN TENNIEL 'The Trial of the Knave' (*left*), 'The Caterpillar and Alice' (*above*), 'The Frog-Footman' (*bottom left*) and 'The Cheshire-Cat and the Queen's Croquet Ground' (*below*). From *Alice's Adventures in Wonderland* by Lewis Carroll (Macmillan, 1865).

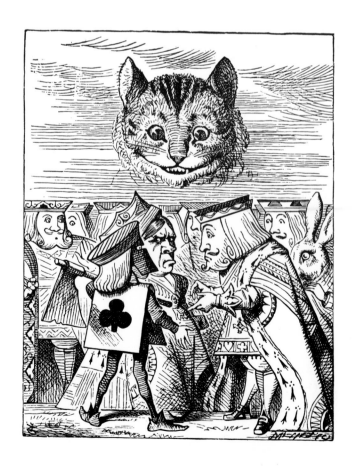

JOHN EVERETT MILLAIS 'A Dream of Fair Women' from *Poems* by Alfred, Lord Tennyson (Edward Moxon, 1859). Engraved by Dalziel Bros.

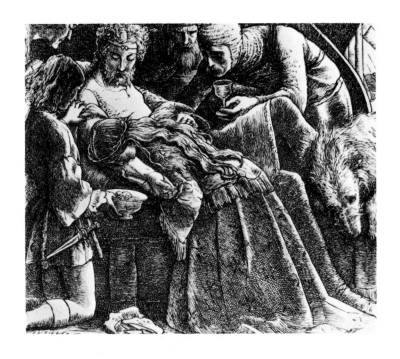

WILLIAM HOLMAN HUNT 'The Lady of Shalott' from *Poems* by Alfred, Lord Tennyson (Edward Moxon, 1859). Engraved by J. Thompson.

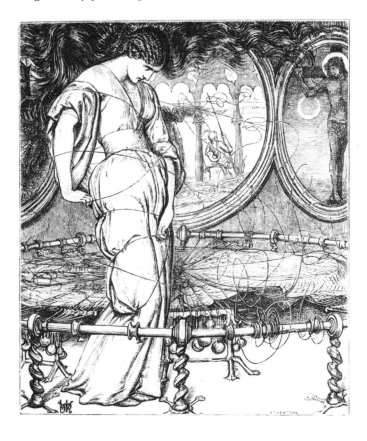

ARTHUR HUGHES 'Up the airy mountain, down the rushy glen, We daren't go a-hunting for fear of little men.' Illustration to *The Fairies* in *The Music Masters, a love story and two series of Day and Night Songs* by William Allingham (Routledge, 1855). Engraved by Dalziel Bros.

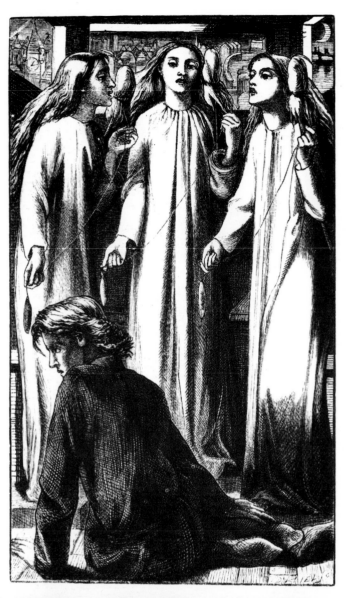

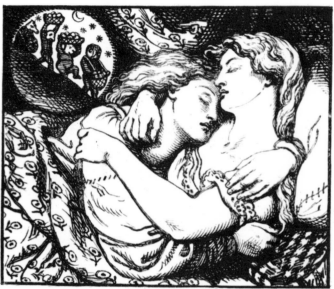

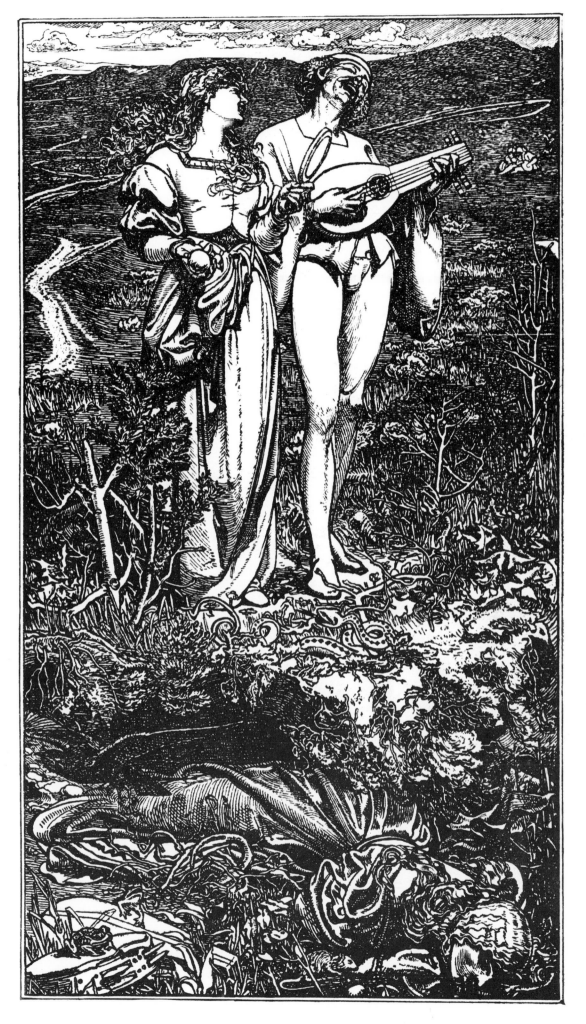

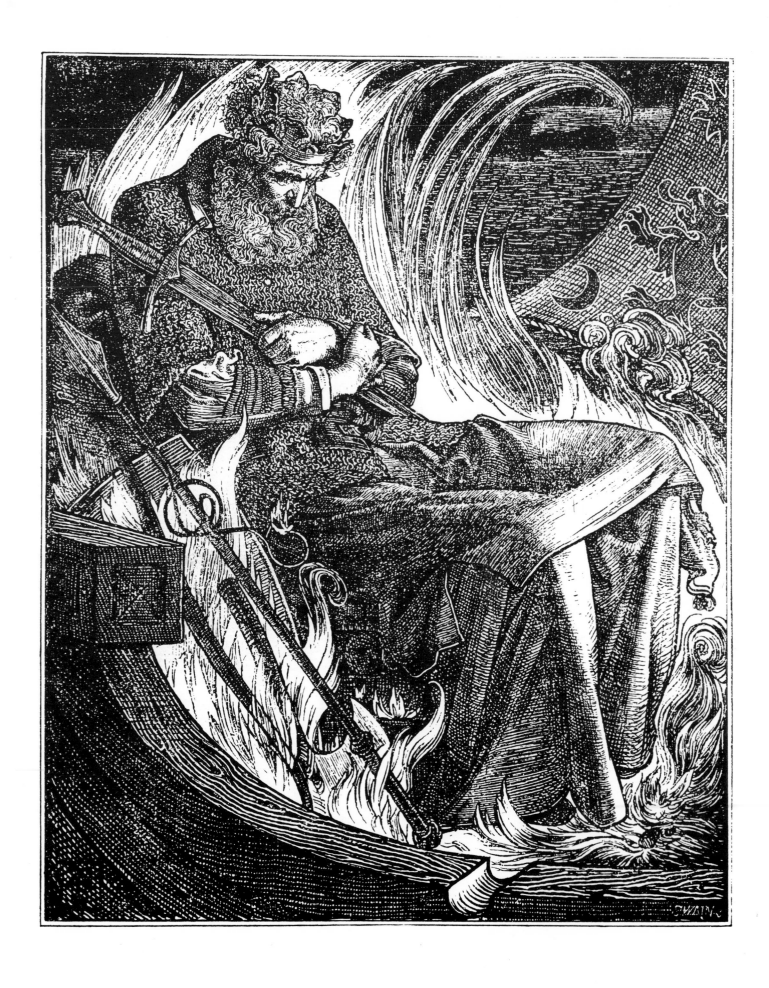

FREDERICK SANDYS 'The Death of King Warwolf' which appeared in *Once a Week*, 1862.

FREDERICK SANDYS Illustration to
Harold Harfagr by George Borrow for
Vol. VII of *Once A Week* (1862).

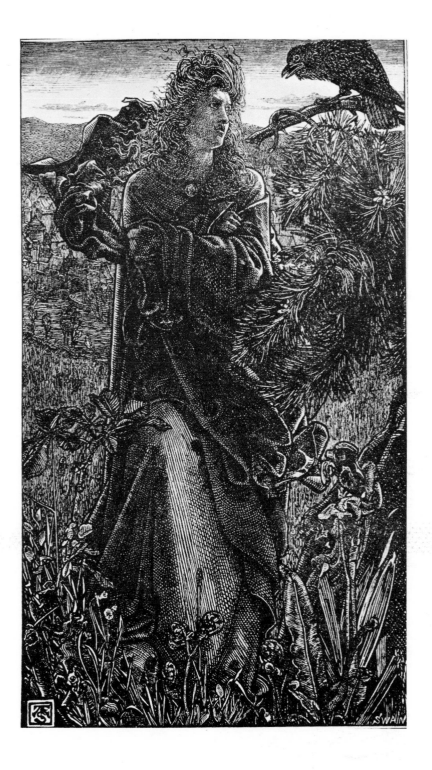

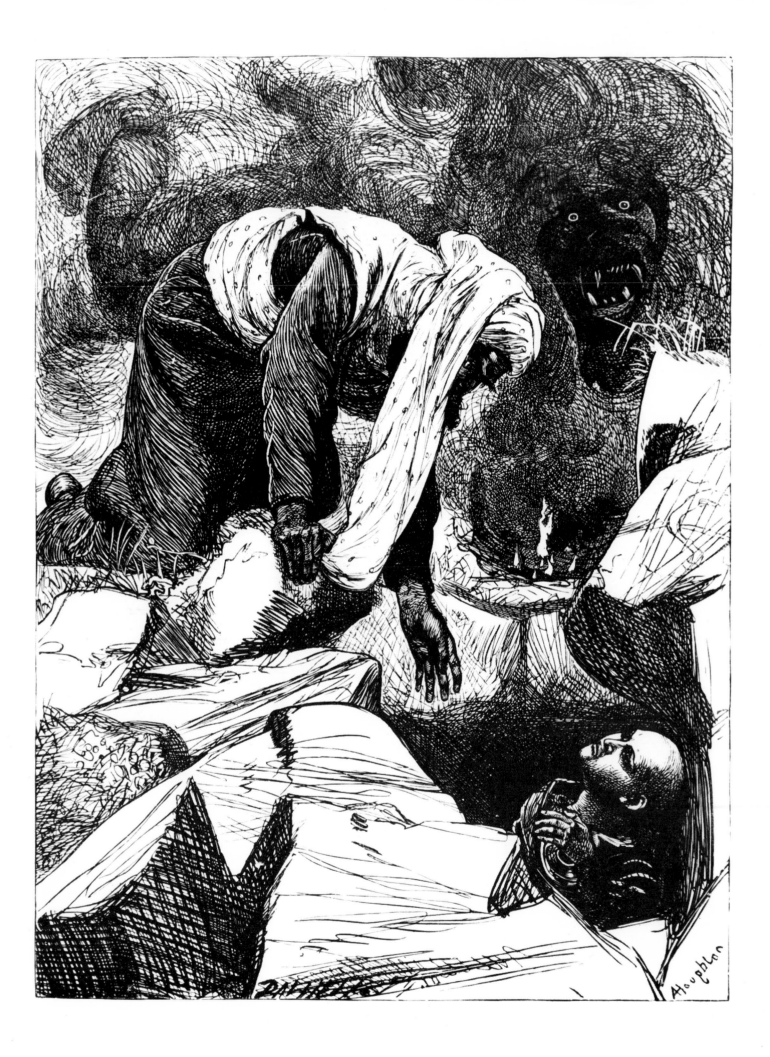

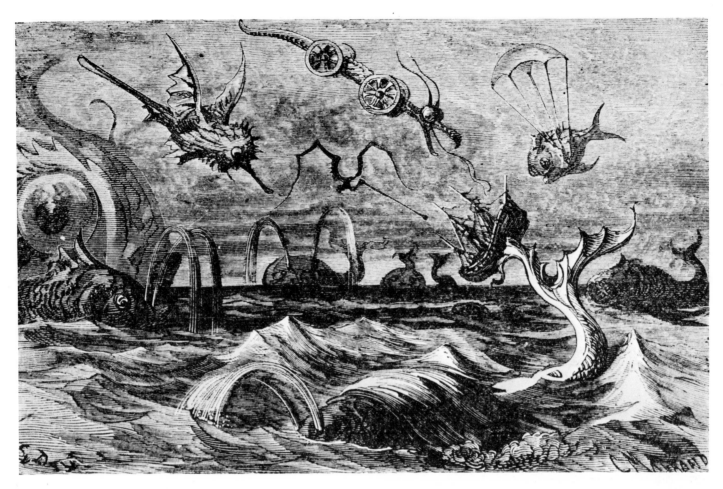

GUSTAVE DORÉ 'Baron Munchausen aboard the Dutch ship in a sea of wine about to be swallowed by a monster' from *The Adventures of Baron Munchausen* (Cassell, Petter & Galpin, 1866).

Overleaf GUSTAVE DORÉ 'Baron Munchausen's second, but accidental, visit to the moon—"It looked round and shining like a glittering island." ' (*left*) and 'I met from time to time with huge fishes.' From *The Adventures of Baron Munchausen* (Cassell, Petter & Galpin, 1866).

Left A. BOYD HOUGHTON 'The African magician commands Aladdin to give him the lamp' from *Dalziel's Illustrated Arabian Nights*, revised by H. W. Dulcken (Ward, Lock & Tyler, 1863–65).

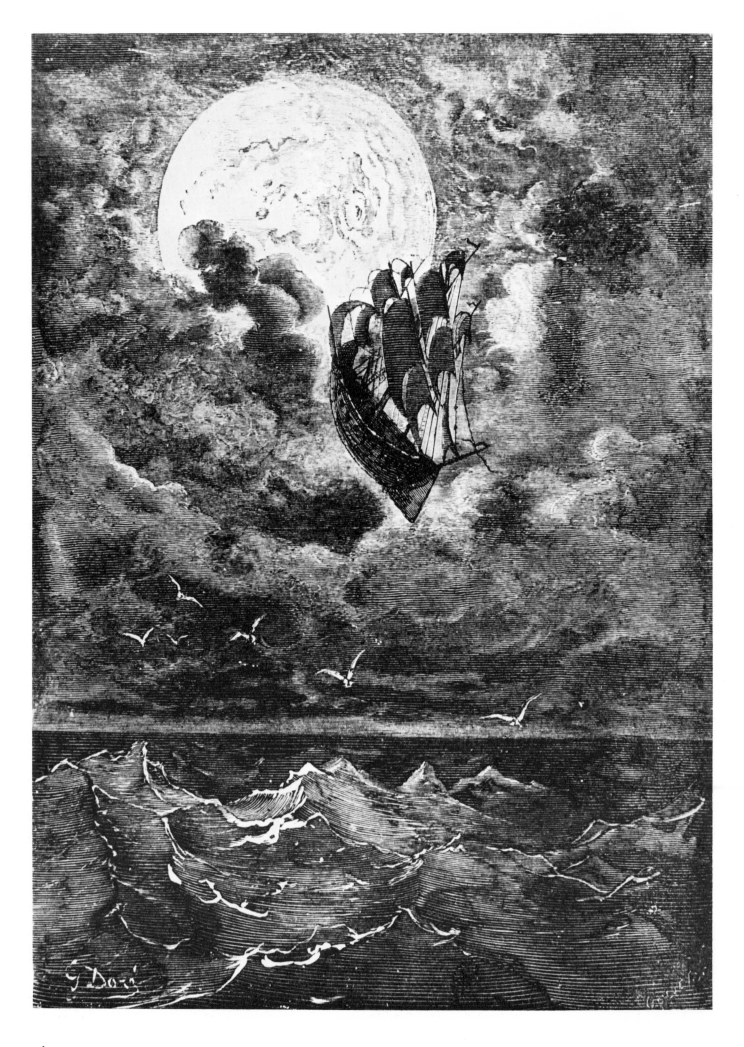

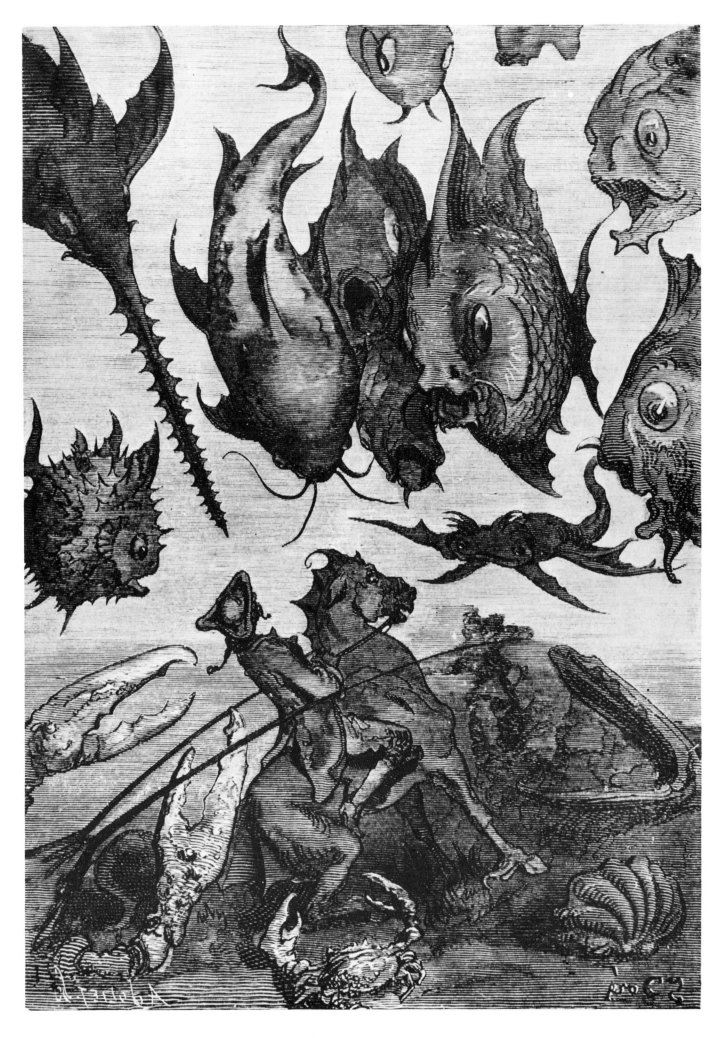

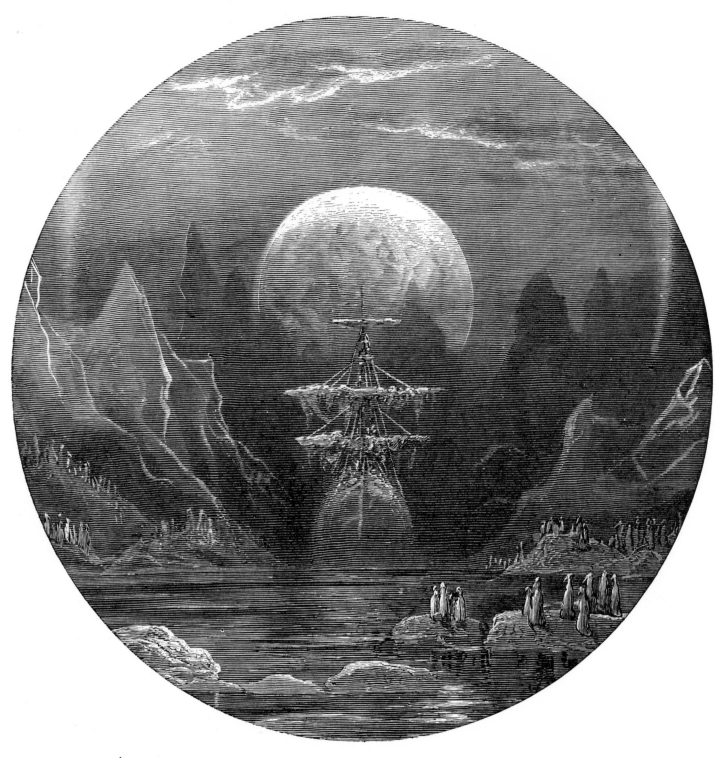

GUSTAVE DORÉ Illustration for title page to *The Rime of the Ancient Mariner* by S. T. Coleridge (Hamilton Adams, and the Doré Gallery, 1876).

Right EDWARD BURNE-JONES Illustration to Book III 'The Road to the Well at the World's End' from *The Well at the World's End* by William Morris (Kelmscott Press, 1896).

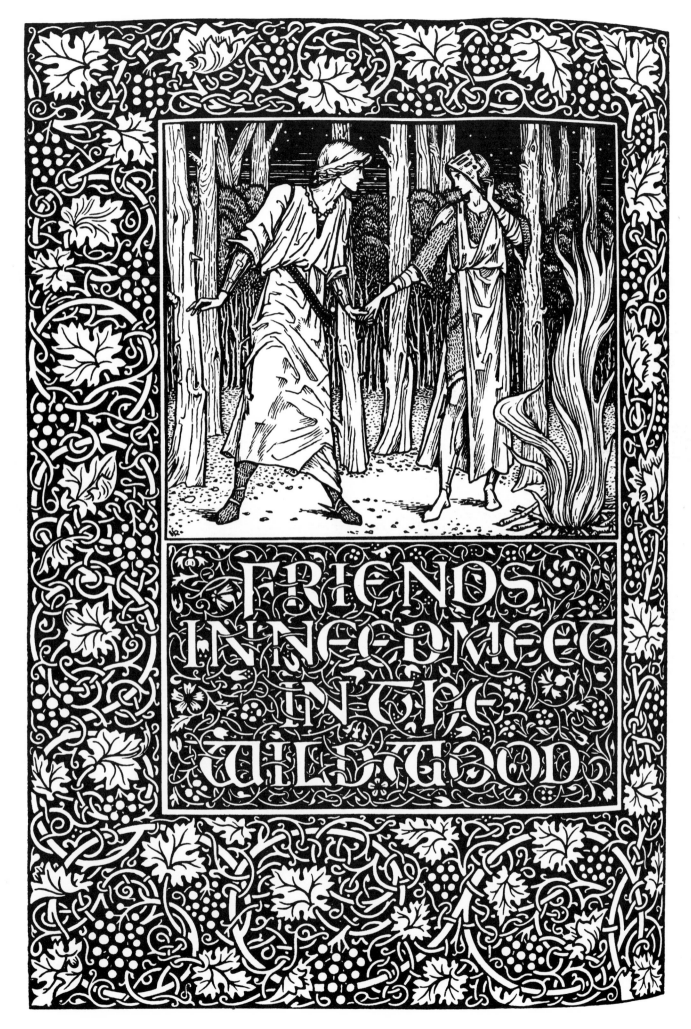

FRIENDS IN NEED MEET IN THE WILD WOOD

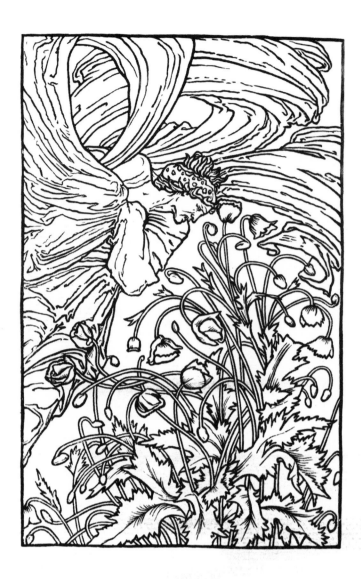

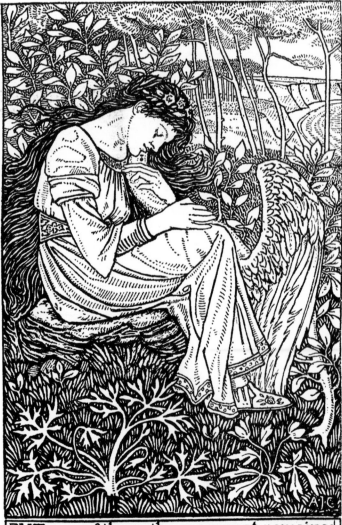

Left EDWARD BURNE-JONES Frontispiece for *King Poppy* by the Earl of Lytton (Longmans, Green, 1892).

Opposite A. J. GASKIN Illustration to *Good King Wenceslaus*. A Carol by Dr Neale, introduction by William Morris (Cornish, Birmingham, 1894).

A. J. GASKIN 'The Wild Swans' from *Stories by Hans Christian Andersen*, translated by H. Oskar Sommer (George Allen, 1893).

PAGE AND MONARCH FORTH THEY WENT.
FORTH THEY WENT TOGETHER THROUGH THE
RUDE WINDS LOUD LAMENT AND THE BITTER WEATHER.

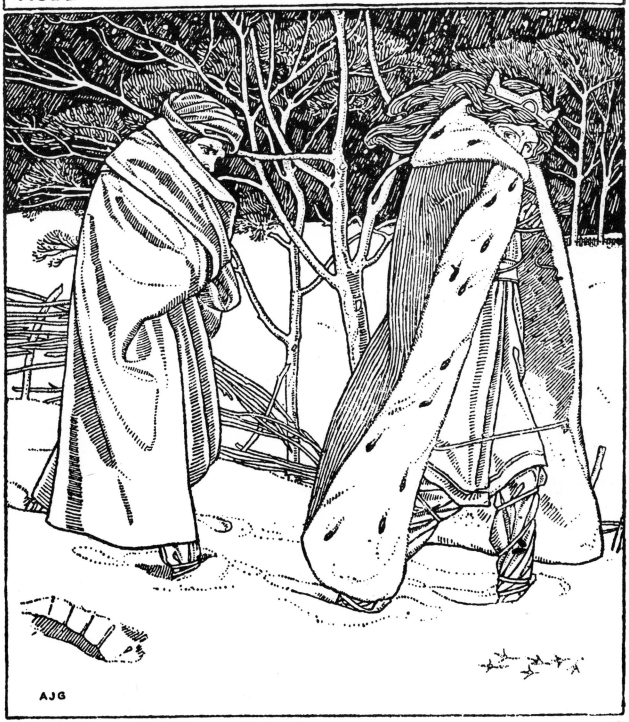

"SIRE THE NIGHT IS DARKER NOW, AND THE WIND
BLOWS STRONGER: FAILS MY HEART, I KNOW
NOT HOW, I CAN GO NO LONGER." "MARK MY
FOOTSTEPS, MY GOOD PAGE: TREAD THOU
IN THEM BOLDLY, THOU SHALT FIND THE
WINTER WIND FREEZE THY BLOOD LESS COLDLY."

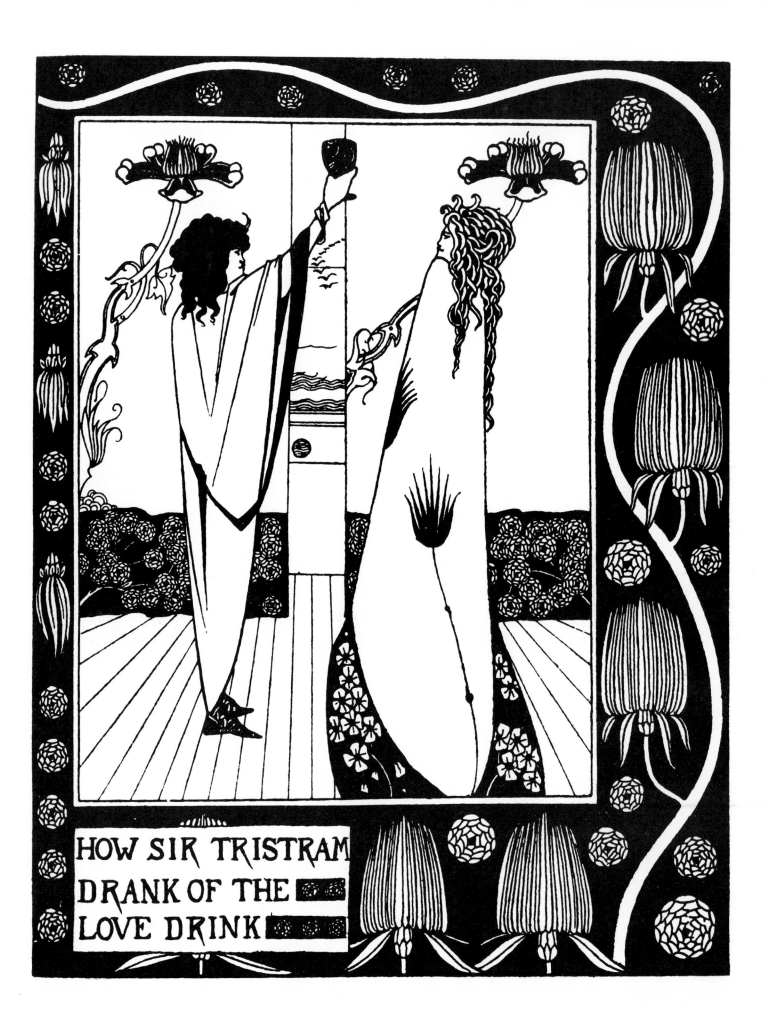

HOW SIR TRISTRAM DRANK OF THE LOVE DRINK

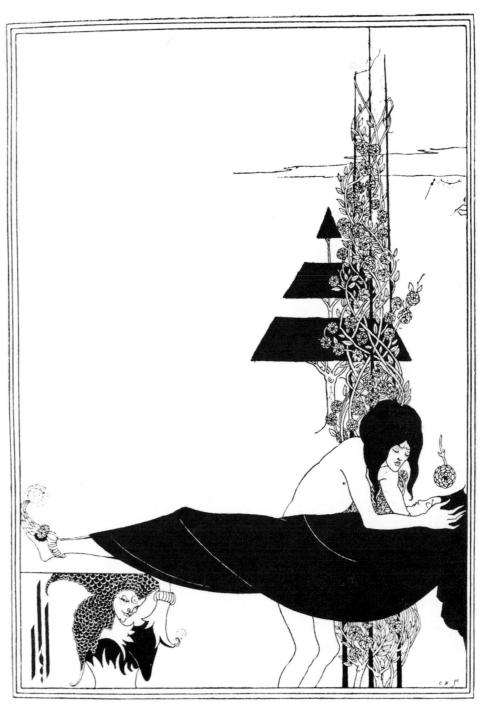

Above AUBREY BEARDSLEY From *Salome*, A tragedy in one act, translated by Lord A. B. Douglas from the French of Oscar Wilde (Elkin Mathews & John Lane, 1894).

Left and above AUBREY BEARDSLEY 'How Sir Tristram drank of the love drink' and two chapter headings from *The Birth, Life and Acts of King Arthur* by Thomas Malory (Elkin Mathews & John Lane, 1894).

Overleaf AUBREY BEARDSLEY 'How King Arthur saw the Questing Beast.', frontispiece for Vol. I (*left*) and 'The Achieving of the Sangreal.', frontispiece for Vol. III. *The Birth, Life and Acts of King Arthur* by Thomas Malory (Dent, 1894).

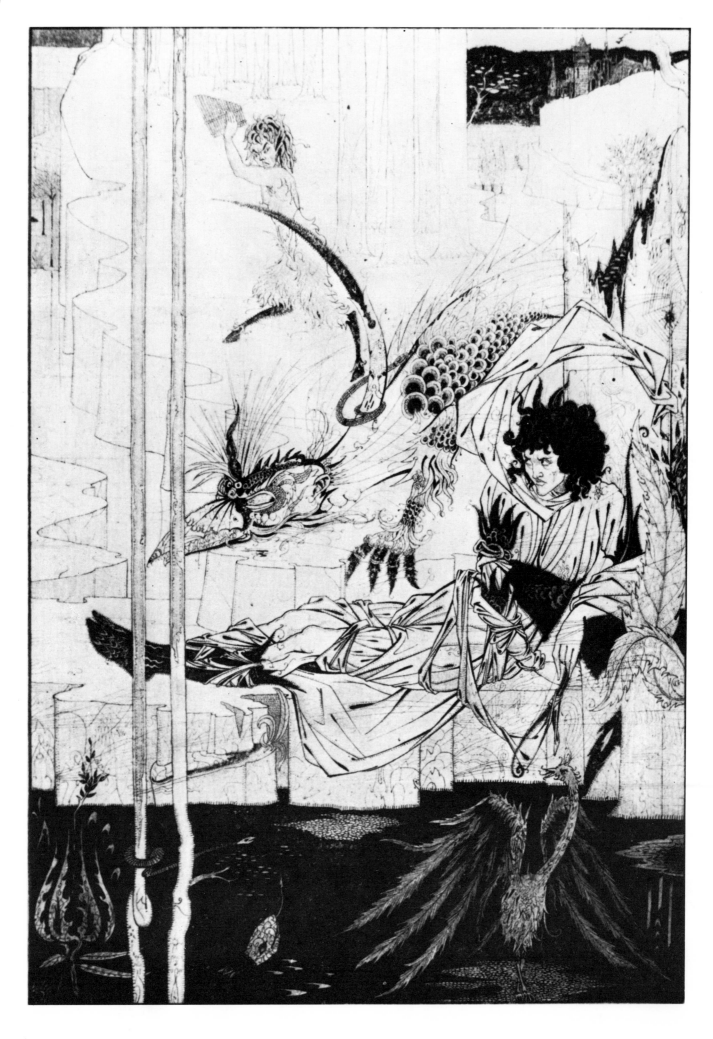

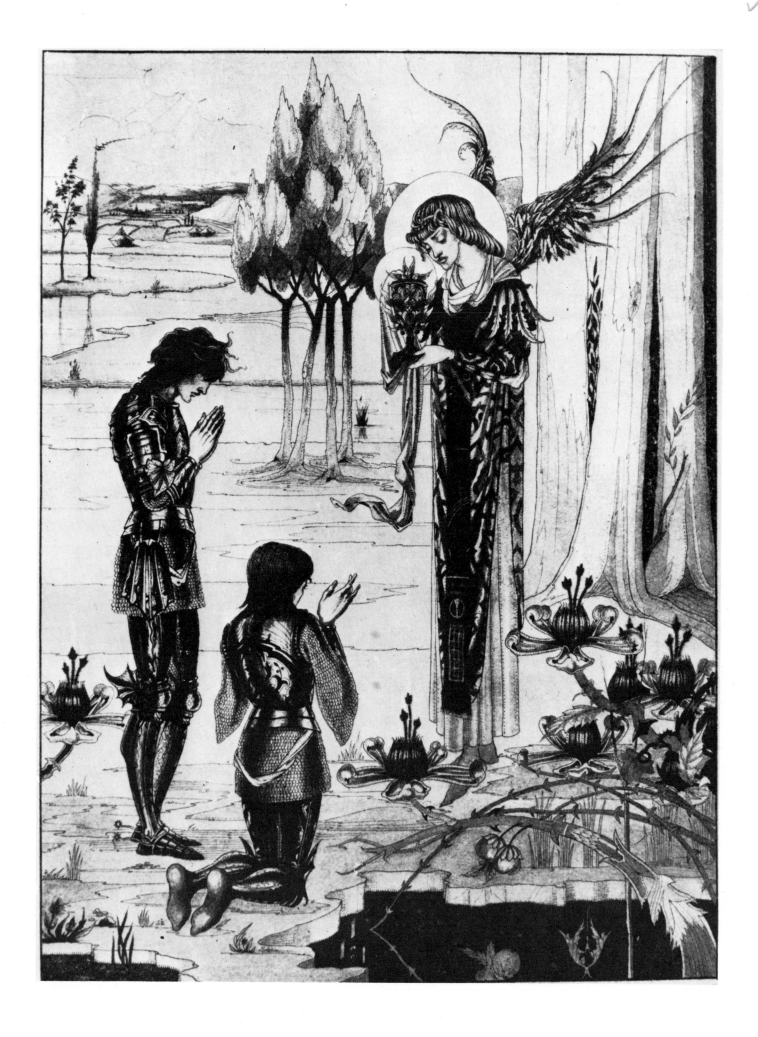

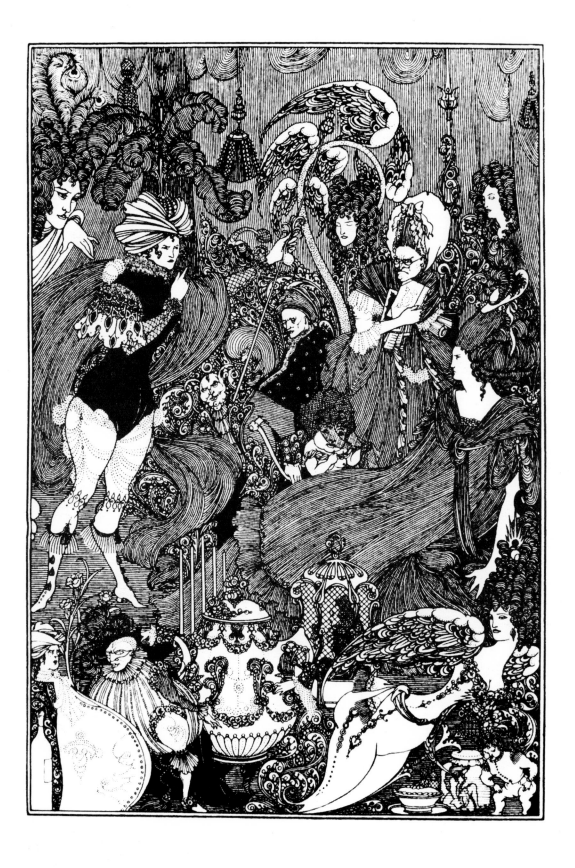

AUBREY BEARDSLEY 'The Cave of Spleen'—'A constant
vapour o'er the Palace flies; Strange Phantoms rising as the
Mists arise.' From *The Rape of the Lock* by Alexander Pope
(Leonard Smithers, 1896).

Right AUBREY BEARDSLEY 'Th' Advent'rous Baron the
bright locks admir'd He saw, he wish'd, and to the prize
aspired.' From *The Rape of the Lock* by Alexander Pope
(Leonard Smithers, 1896).

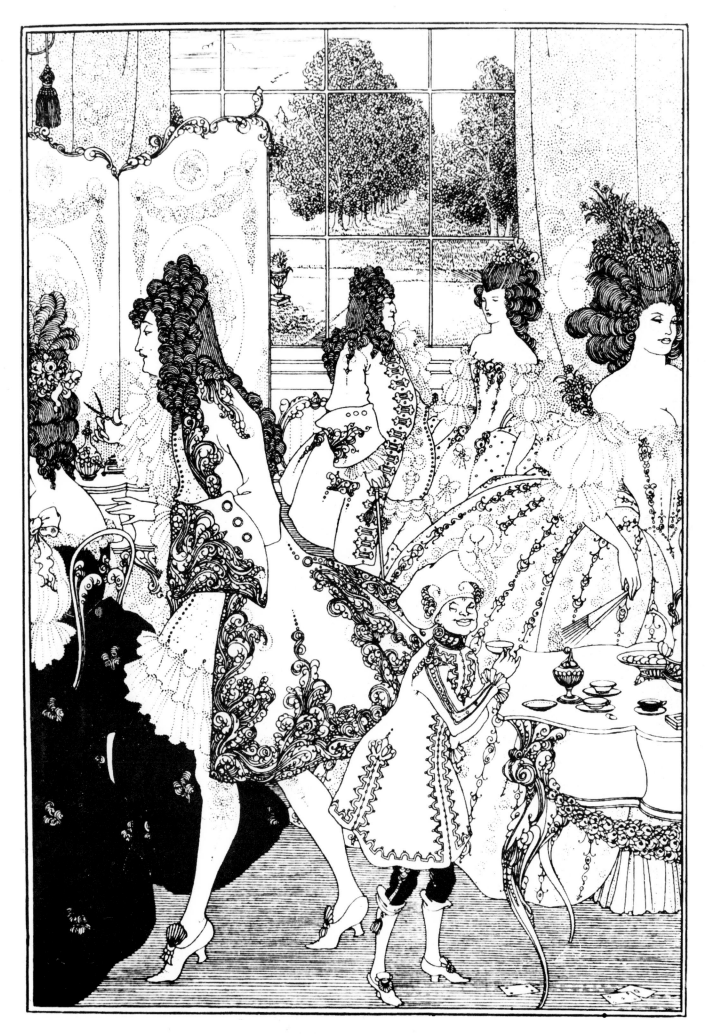

AUBREY BEARDSLEY Endpiece to *The Rape of the Lock* by
Alexander Pope (Leonard Smithers, 1896).

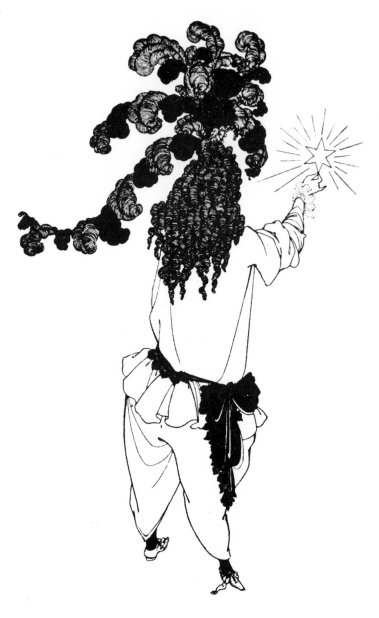

Below AUBREY BEARDSLEY Endpiece to *Salome*, A
tragedy in one act, translated by Lord A. B. Douglas from
the French of Oscar Wilde (Elkin Mathews & John Lane,
1894).

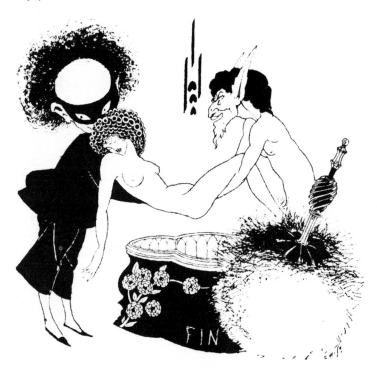

Right AUBREY BEARDSLEY From
Salome, A tragedy in one act, translated
by Lord A. B. Douglas from the French
of Oscar Wilde (Elkin Mathews &
John Lane, 1894).

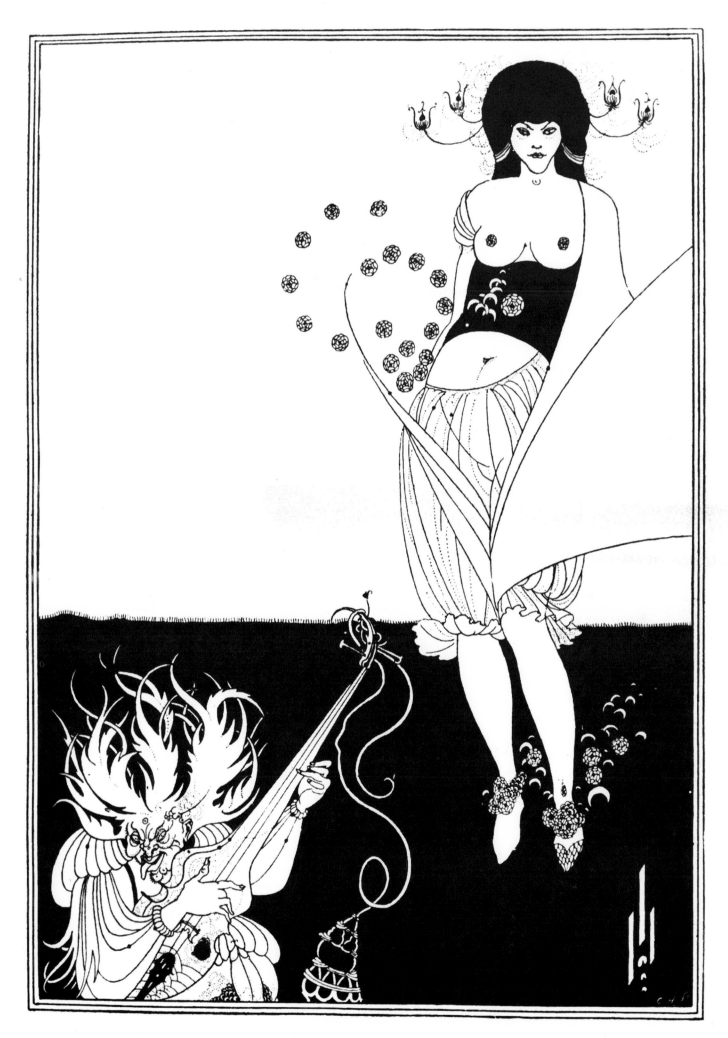

49

W. T. HORTON 'St George' (*top left*), 'The Wave' (*above*) and 'The Path to the Moon' (*bottom left*) from *The Book of Images*, drawn by Horton and introduced by W. B. Yeats (Unicorn Press, 1898).

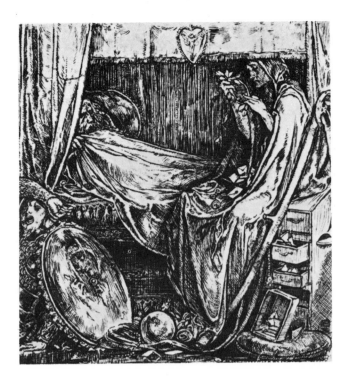

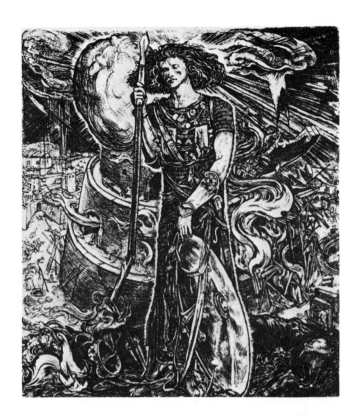

CHARLES RICKETTS 'The Defeat of Glory' (*above*) and 'Nimrod' (*above right*) from *Poems Dramatic & Lyrical* by John Leicester Warren, Lord de Tabley (Elkin Mathews & John Lane, 1893).

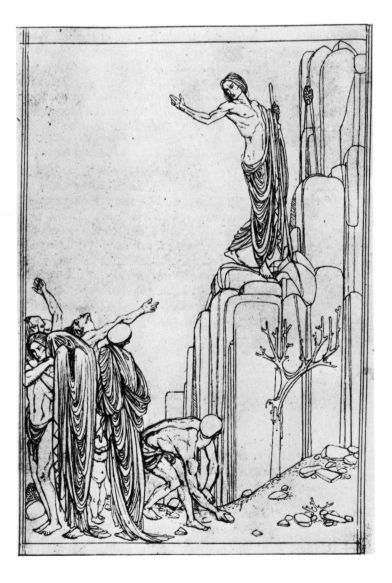

CHARLES RICKETTS 'The Teacher of Wisdom' from *Poems in Prose* by Oscar Wilde.

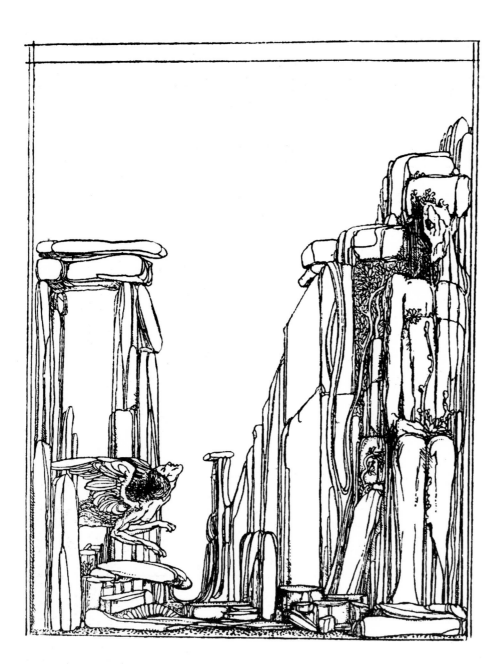

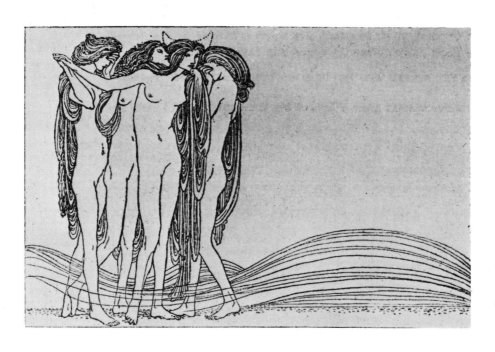

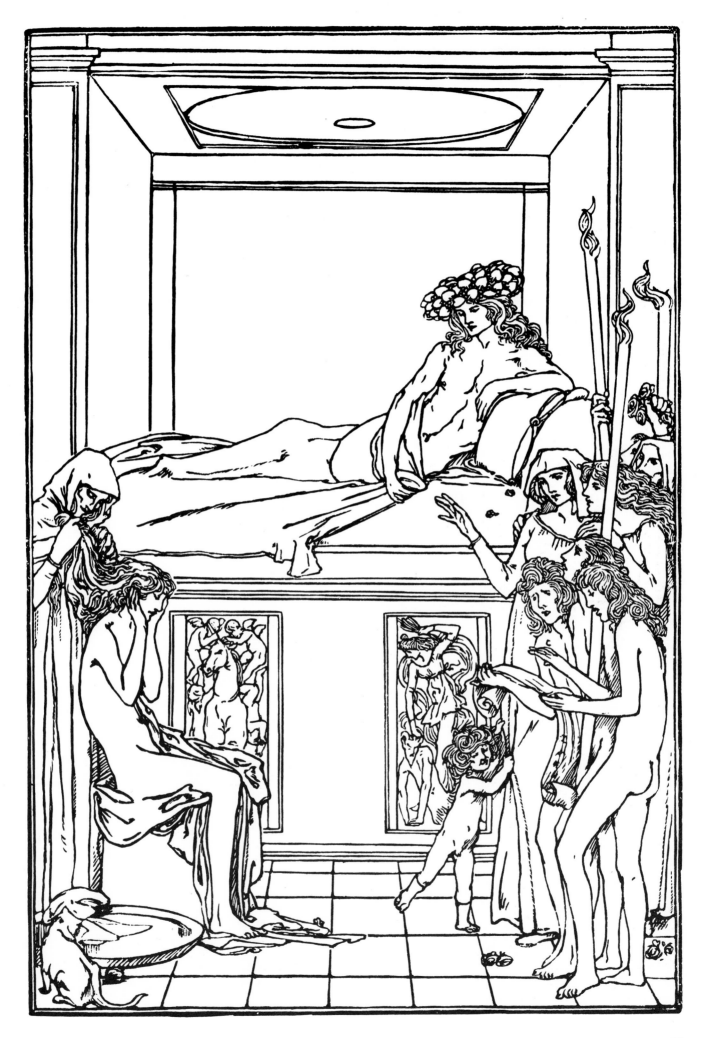

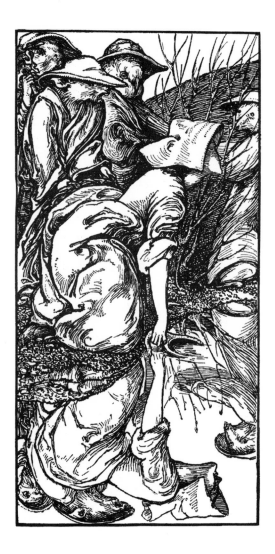

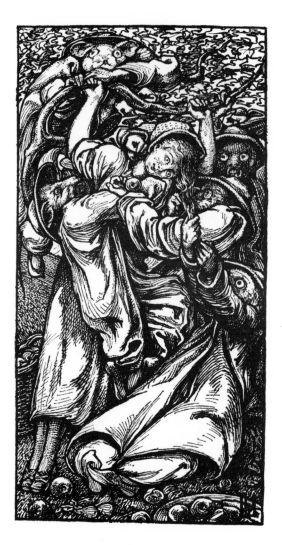

Top LAURENCE HOUSMAN Four illustrations to *Goblin Market* by Christina Rossetti (Macmillan, 1893).

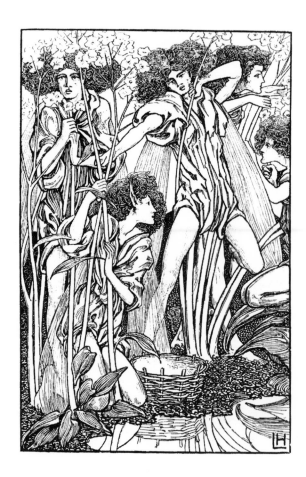

LAURENCE HOUSMAN 'The Building' from *The End of Elfintown* by Jane Barlow (Macmillan, 1894).

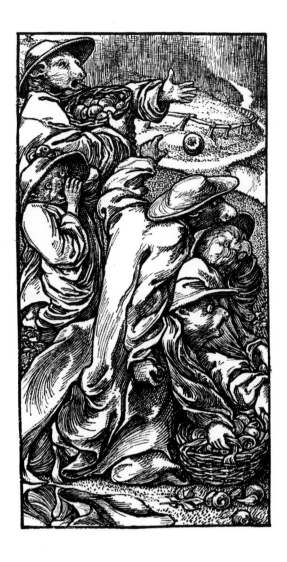

LAURENCE HOUSMAN 'The Flitting' from *The End of Elfintown* by Jane Barlow (Macmillan, 1894).

Above WILLIAM STRANG Illustration to *Death & the Ploughman's Wife*, a ballad made and etched by Strang (Lawrence & Bullen, 1894).

Left WILLIAM STRANG Illustration to *The Fourth Voyage of Es-Sindibad of the Sea* from *Sinbad the Sailor, & Ali Baba and the Forty Thieves* (Lawrence & Bullen, 1896).

ELEANOR VERE BOYLE 'When Spring begins' from *The Story without an End* by Sarah Austin from the German of Carové (Sampson Low, Son & Marston, 1868).

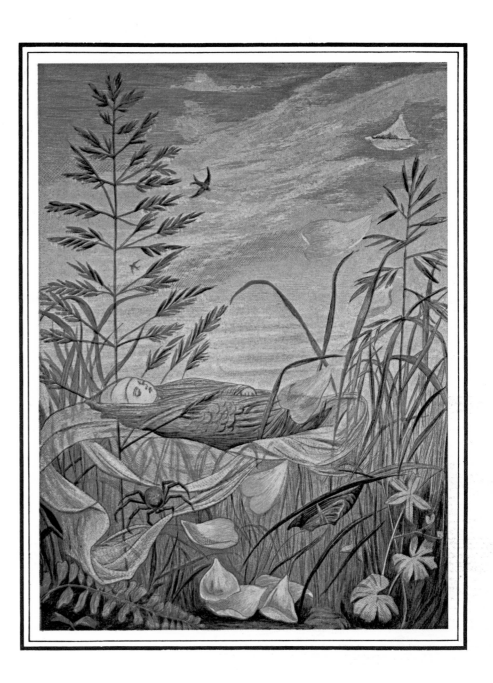

ELEANOR VERE BOYLE Endpiece (*right*) and illustration to *Beauty and the Beast. An Old Tale New-Told, with pictures* (Sampson Low, Marston, Low & Searle, 1875).

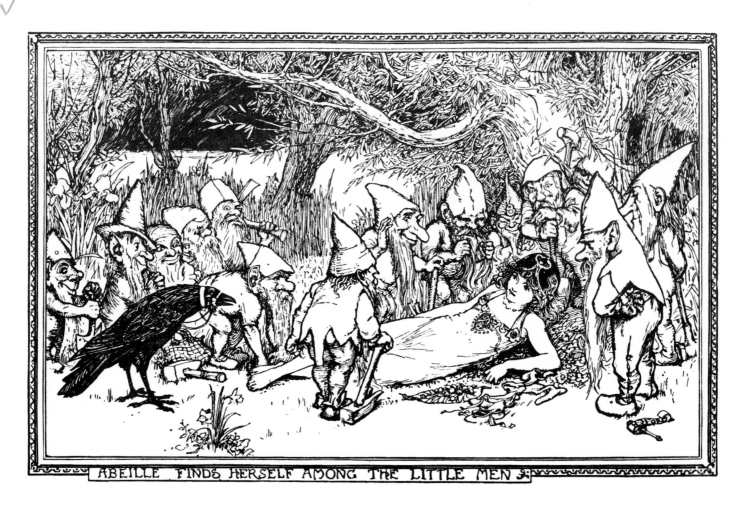

ABEILLE FINDS HERSELF AMONG THE LITTLE MEN

The Watch comes home

THE LAST BATTLE

Sir Mordred

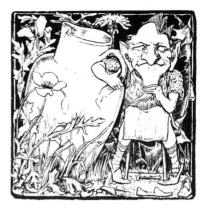

JOHN D. BATTEN Chapter headpiece to *The Field of Boliauns* from *Celtic Fairy Tales*, selected and edited by Joseph Jacobs (David Nutt, 1892).

Above JOHN D. BATTEN 'The Demon with the Matted Hair' from *Indian Fairy Tales*, selected and edited by Joseph Jacobs (David Nutt, 1892).

Below JOHN D. BATTEN 'The Laidly Worm of Spindleston Heugh' from *English Fairy Tales*, collected by Joseph Jacobs (David Nutt, 1890).

Top left H. J. FORD Illustration to *The Story of King Loc* from *The Olive Fairy Book* edited by Andrew Lang (Longmans, Green, 1907).

Left H. J. FORD Illustration to *The End of it All* from *The Red Romance Book* edited by Andrew Lang (Longmans, Green, 1905)

Far left H. J. FORD Illustration to *The White Dove* from *The Pink Fairy Book* edited by Andrew Lang (Longmans, Green, 1901).

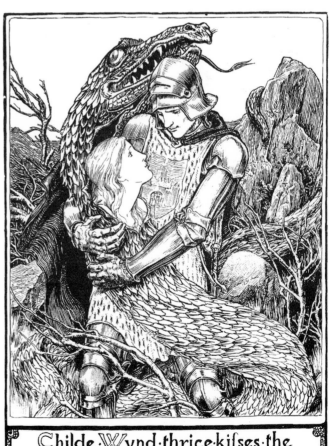

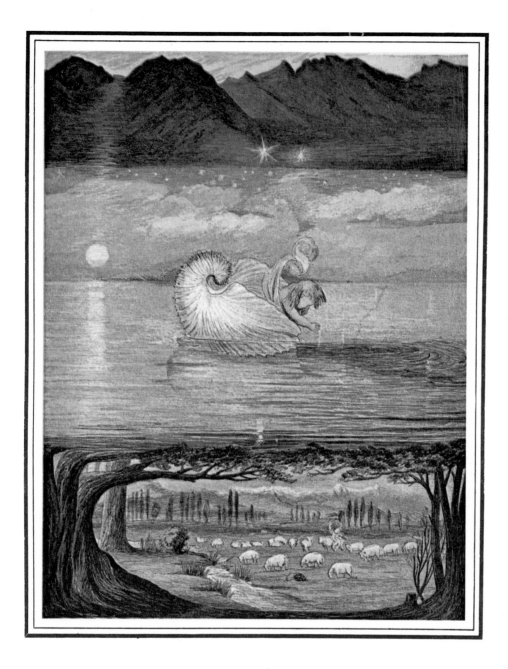

ELEANOR VERE BOYLE 'A golden boat on a great, great water.' From *The Story without an End* by Sarah Austin from the German of Carové (Sampson Low, Son & Marston, 1868).

ELEANOR VERE BOYLE Chapter heading for *Beauty and the Beast. An Old Tale New-Told, with pictures* (Sampson Low, Marston, Low & Searle, 1875).

Above RICHARD DOYLE 'Girls combing beards of goats.'
Original watercolour, probably unpublished.

Below RICHARD DOYLE 'The Knight and the Spectre.'
Original watercolour, probably unpublished.

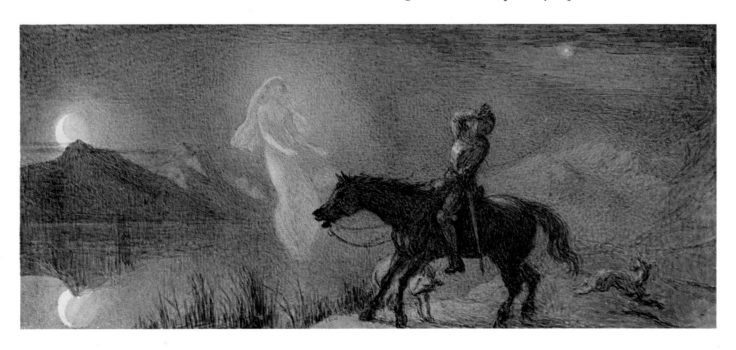

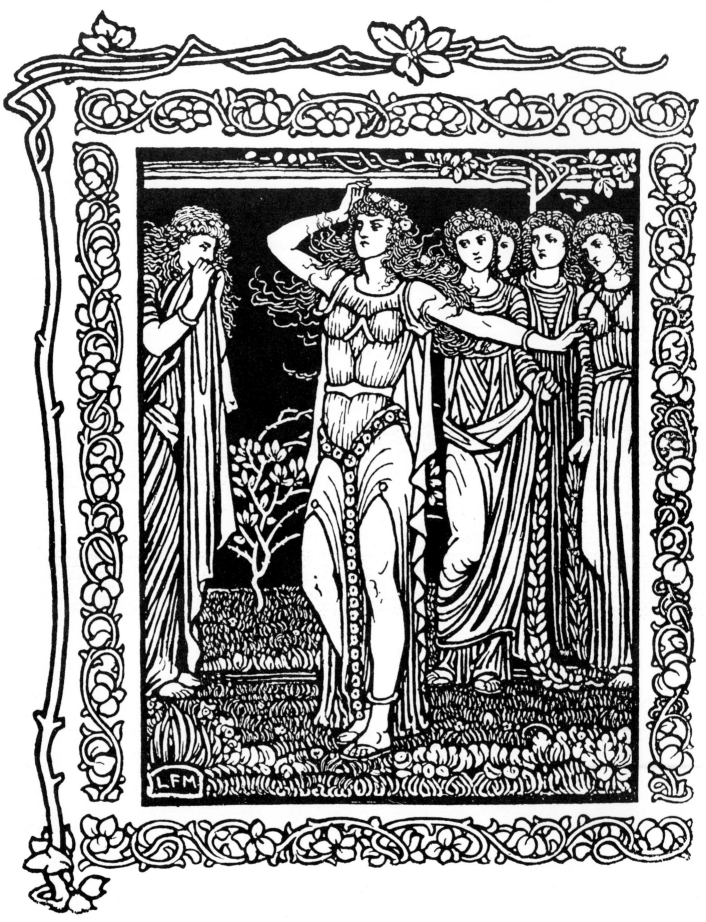

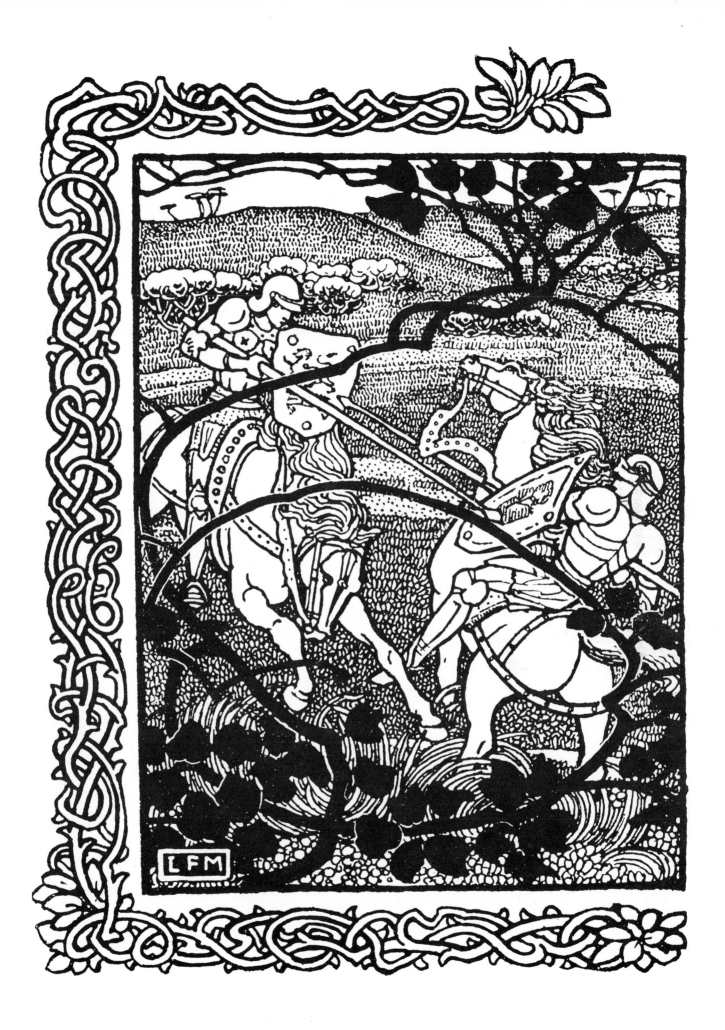

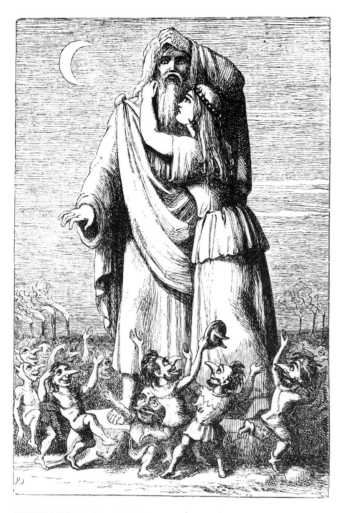

RICHARD DOYLE 'She threw her arms around the stony figure, which at that moment received life and movement.' Illustration to *The Feast of the Dwarfs* from *The Doyle Fairy Book*, containing 29 fairy tales translated by Anthony R. Montalba (Dean & Son, 1890).

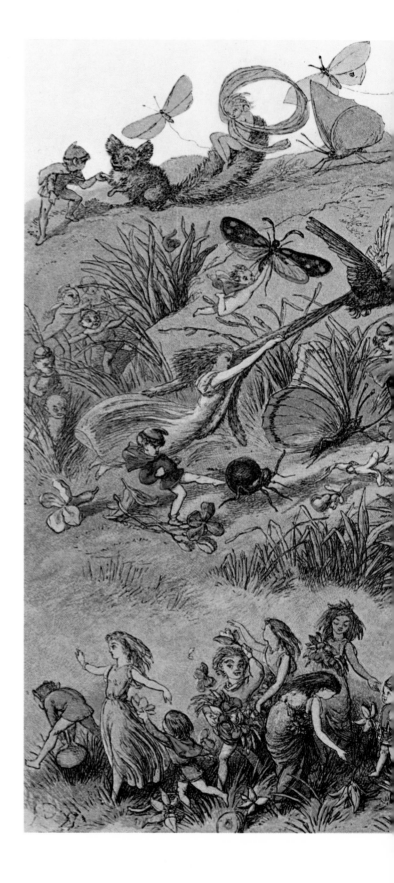

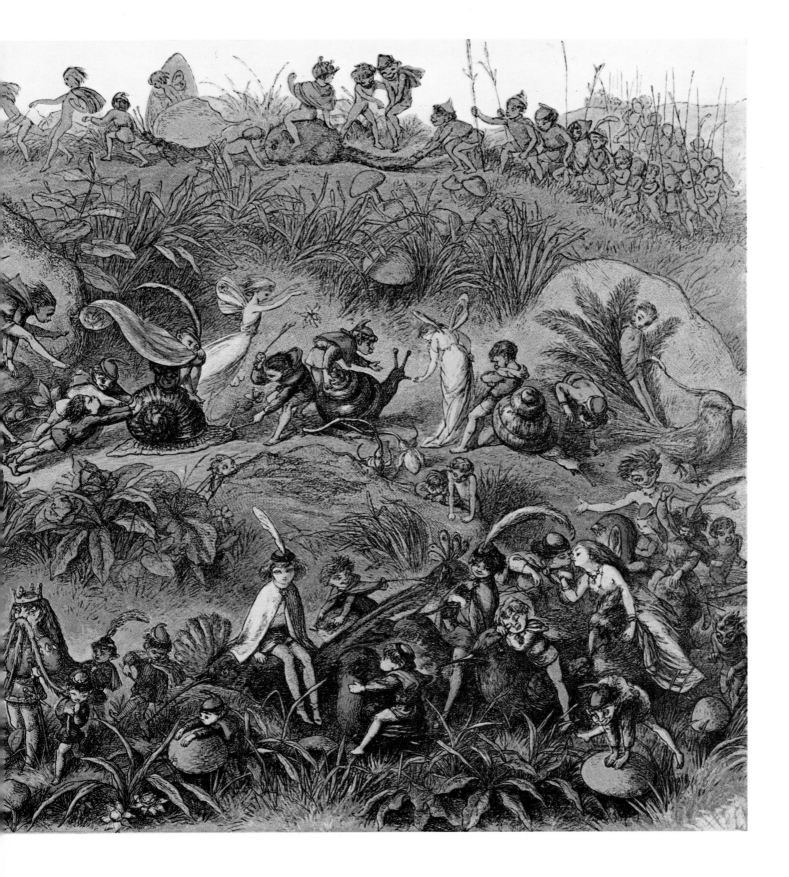

RICHARD DOYLE 'Triumphal march of the Elf-King. This important personage, nearly related to the Goblin family, is conspicuous for the length of his hair, which on state occasions it requires four pages to support. Fairies in waiting strew flowers in his path, and in his train are many of the most distinguished Trolls, Kobolds, Nixies, Pixies, Wood-Sprites, birds, butterflies, and other inhabitants of the kingdom.' From *In Fairyland*, a poem by William Allingham with a series of pictures from the Elf-World (Longmans, Green, Reader & Dyer, 1870).

A. GARTH JONES 'A Voyage to Fairyland' from the story,
*How Dora made a voyage to Fairyland, and what happened on the
way,* in The Parade, *an illustrated Gift Book for Boys and Girls*
(H. Henry, 1897).

Left LOUIS FAIRFAX MUCKLEY 'Like as a ship, whom
cruell tempest drives upon a rocke.' From Vol. III, 'The
Fifth Booke' of *The Faerie Queene* by Edmund Spenser, with an
introduction by John W. Hales (J. M. Dent, 1897, 3 volumes).

Above RICHARD DOYLE 'Asleep in the moonlight. The dancing Elves have all gone to rest; the King and Queen are evidently friends again, and, let us hope, live happily ever afterwards. 'From *In Fairyland*, a poem by William Allingham with a series of pictures from the Elf-World (Longmans, Green, Reader & Dwyer, 1870).

Left A. GARTH JONES 'Such notes, as, warbled to the string, Drew iron tears down Pluto's cheek.' From *Il Penseroso* in *The Minor Poems of John Milton* (George Bell & Sons, 1898).

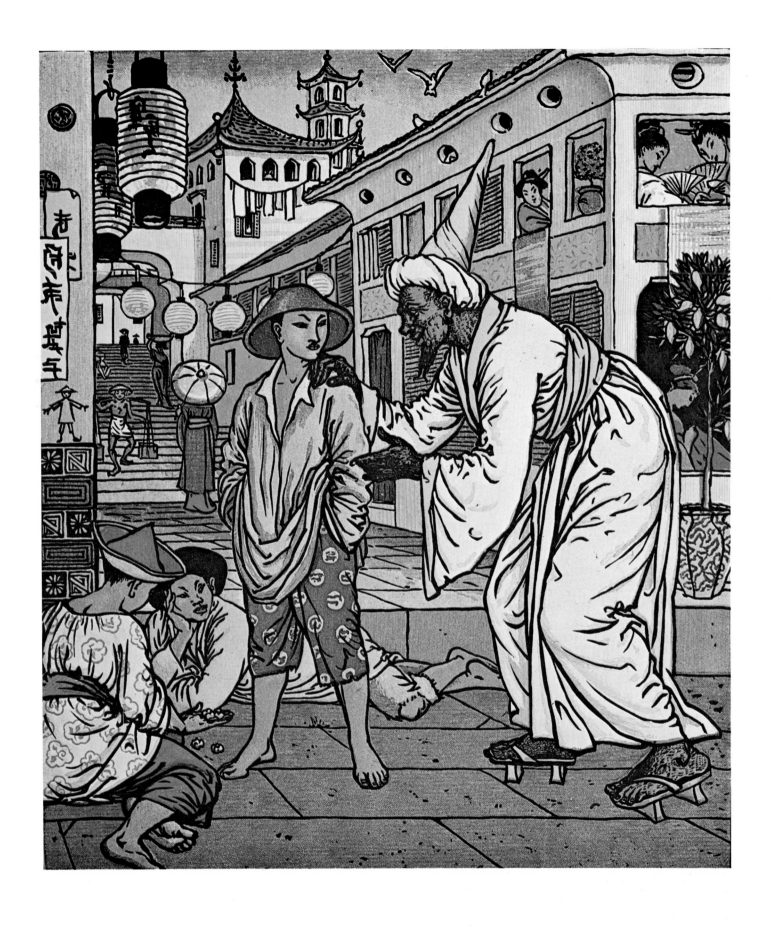

Above WALTER CRANE Illustration to *Aladdin's Picture Book* (George Routledge, 1876). Printed in colours by Edmund Evans.

Overleaf SIDNEY SIME 'How Shaun found the Ultimate God' for *The Sorrow of Search* (*left*) and 'The Tomb of the Morning Zai' for *The Protector of the Secret*. From *Time and the Gods* by Lord Dunsany (E. J. M. D. Plunkett), with illustrations in photogravure (G. P. Putnam's Sons, 1922).

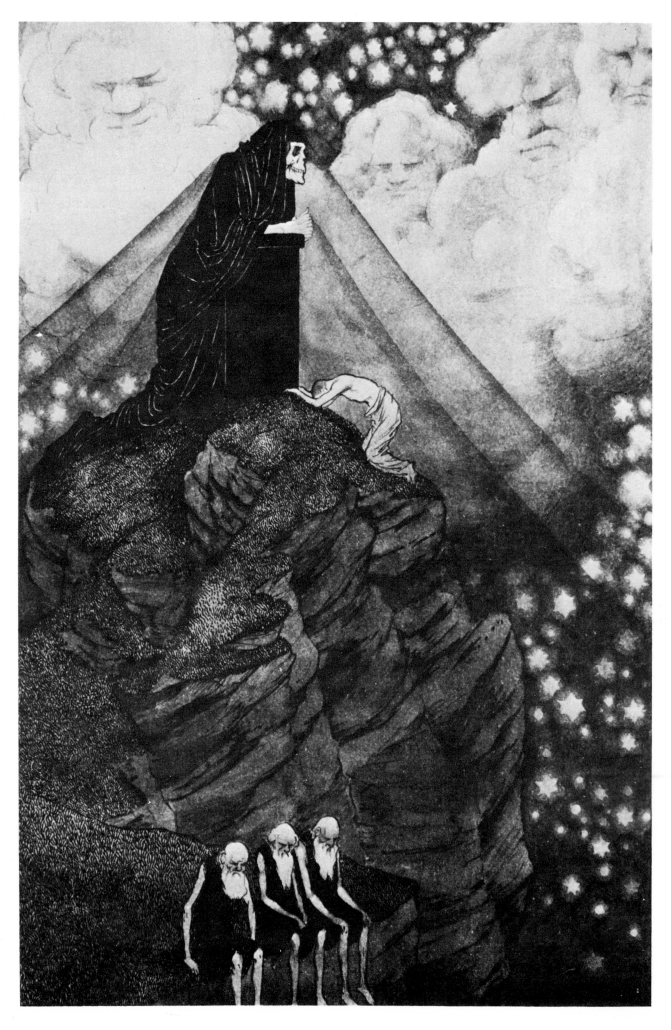

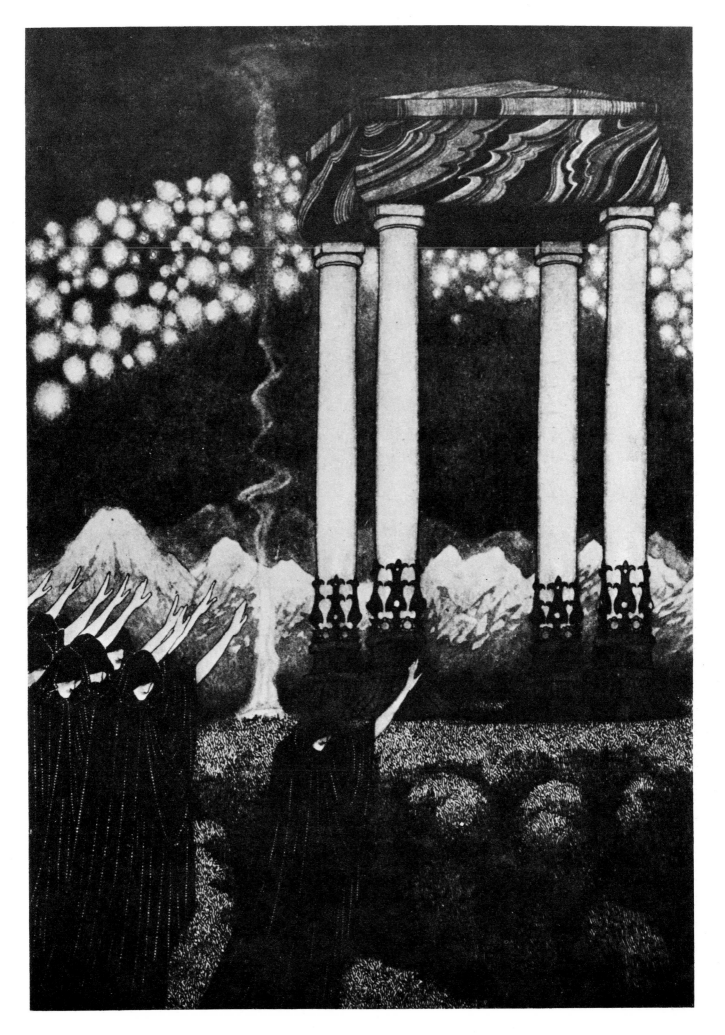

Wide Oxeyes in the meads that gaze

WALTER CRANE 'Wide oxeyes in the meads that gaze'
from *Flora's Feast: a masque of flowers*, presented by Walter
Crane (Cassell & Co., 1889).

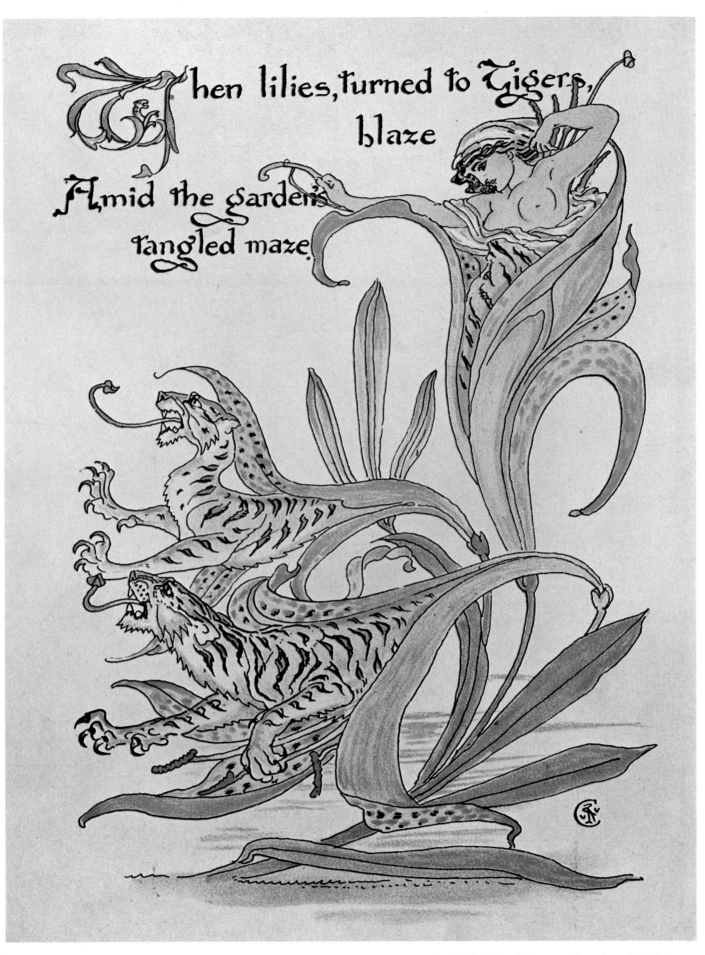

When lilies, turned to Tigers, blaze

Amid the garden's tangled maze.

WALTER CRANE 'When lilies turned to tigers blaze' from *Flora's Feast: a masque of flowers*, presented by Walter Crane (Cassell & Co., 1889).

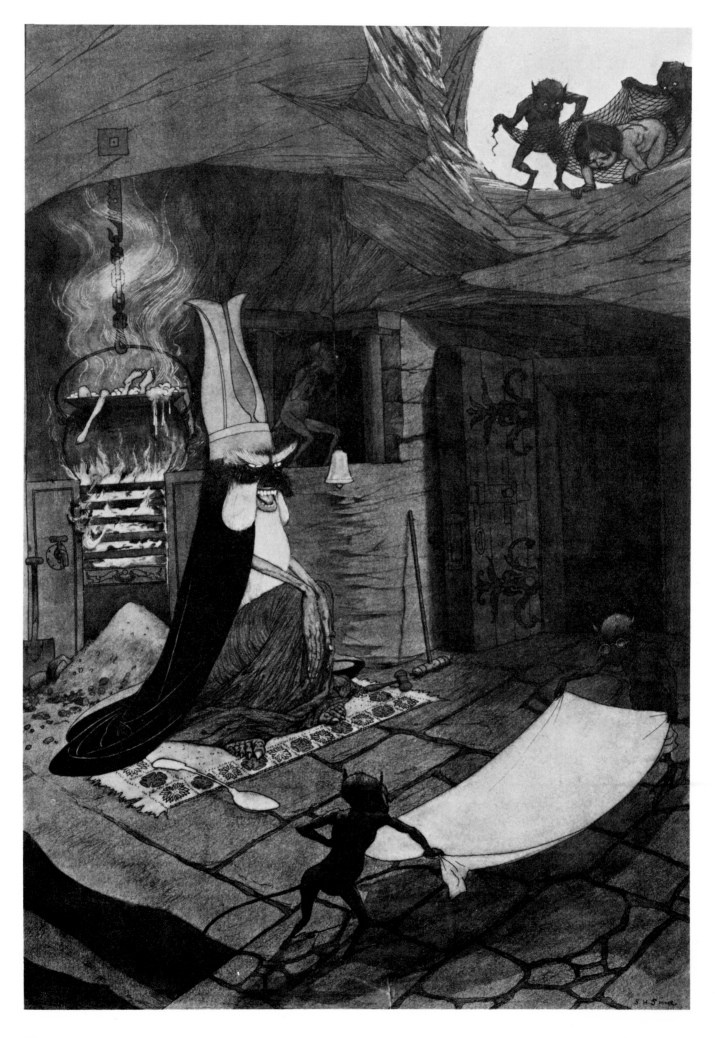

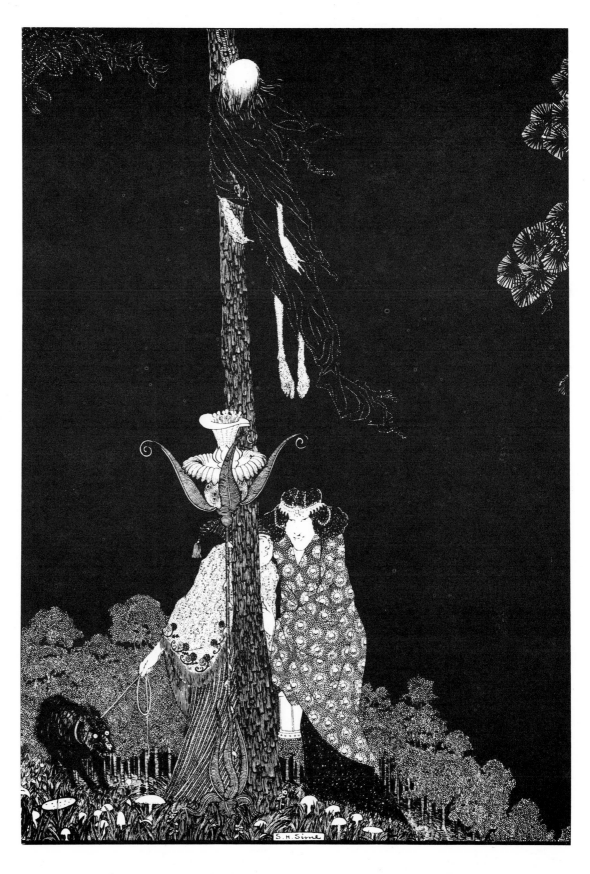

Left SIDNEY SIME 'The sudden discovery of that infamous den, that renowned and impregnable stronghold, the fear and envy of universal wizardry, not only drowned my memory of the quest—it involved me in perilous side issues. The malevolence underlying the Pophoff's hospitable greeting passed unheeded by me, absorbed as I was, for how long I know not, in a profound and fatal curiosity.' Original drawing for *The Fantasy of Life*, a series of drawings to unknown tales. For *The Tatler*, 28th August, 1901.

Above SIDNEY SIME 'The Felon Flower', original drawing for *The Legend of the Mandrake*, published in *Eureka*, September, 1897.

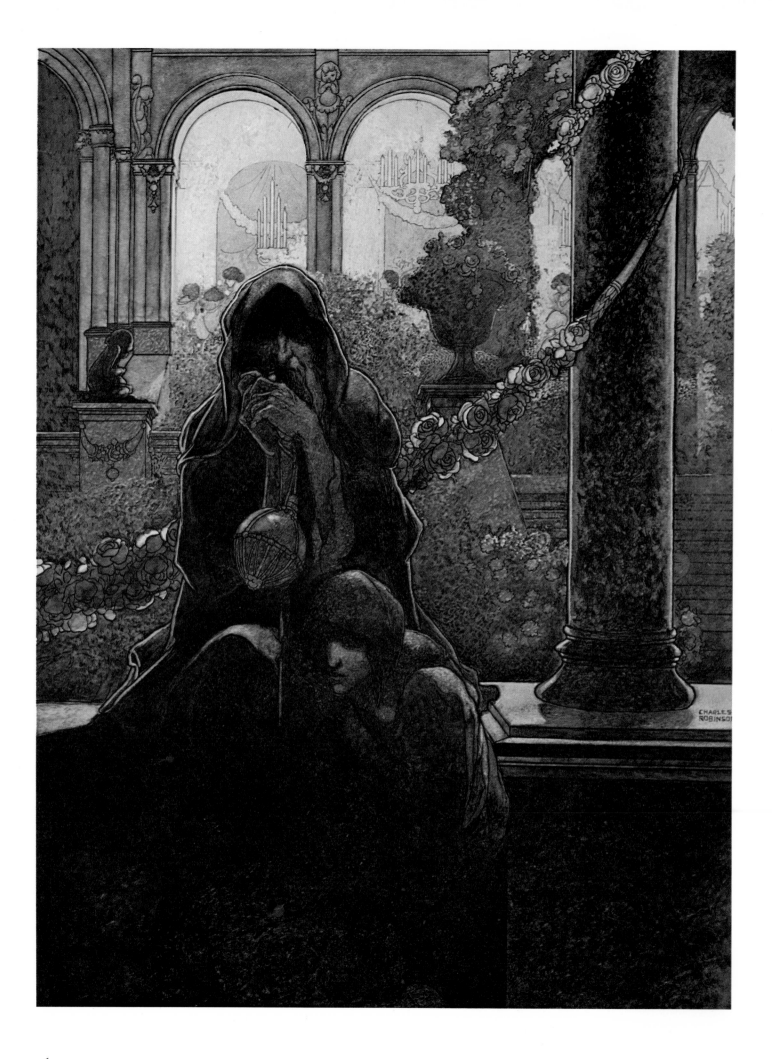

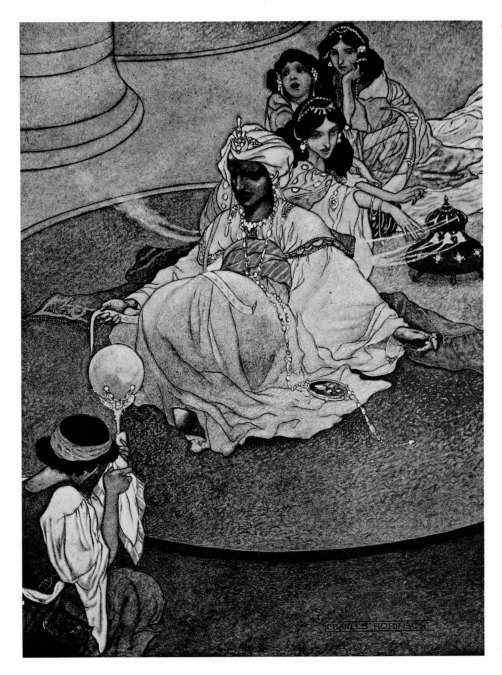

Left CHARLES ROBINSON 'The rich making merry in their beautiful houses while beggars were sitting at the gate.' Original watercolour for *The Happy Prince* by Oscar Wilde (Duckworth, 1913).

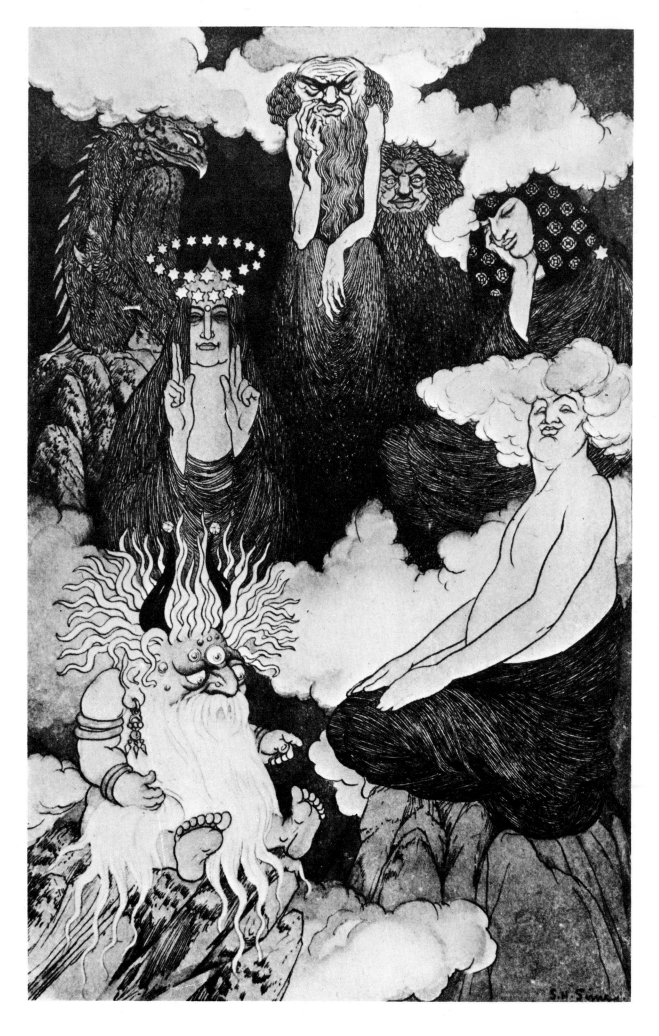

CANTO · IX ·

His loves and lignage Arthur tells:
The Knights knitt friendly hands:
Sir Trevisan flies from Despeyre,
Whom Redcrosse knight withstands.

WALTER CRANE Illustration to Vol.
I, Book I, Canto IX (*above*) and Vol.
III, Book II, Canto II (*right*) of *The
Faerie Queene* by Edmund Spenser,
edited by Thomas J. Wise (George
Allen, 1895).

Left SIDNEY SIME 'Lo, the Gods',
illustration to *For the Honour of the Gods*
for *Time and the Gods* by Lord Dunsany
(E. J. M. D. Plunkett), photogravure
(G. P. Putnam's Sons, 1922).

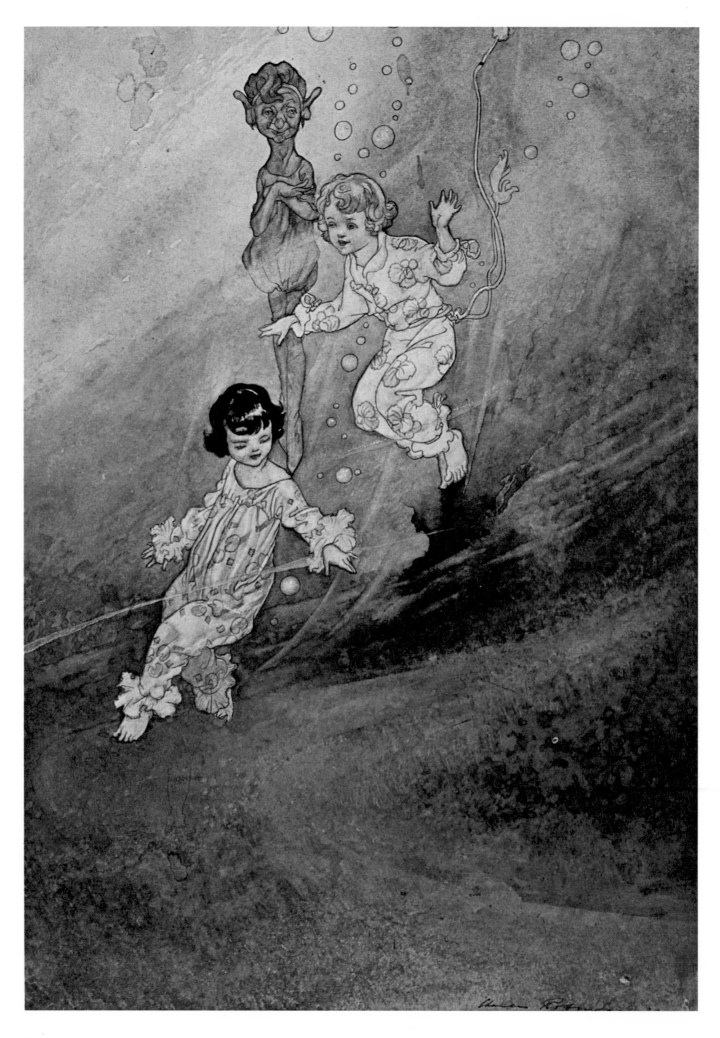

Left CHARLES ROBINSON Untitled
and unpublished original watercolour

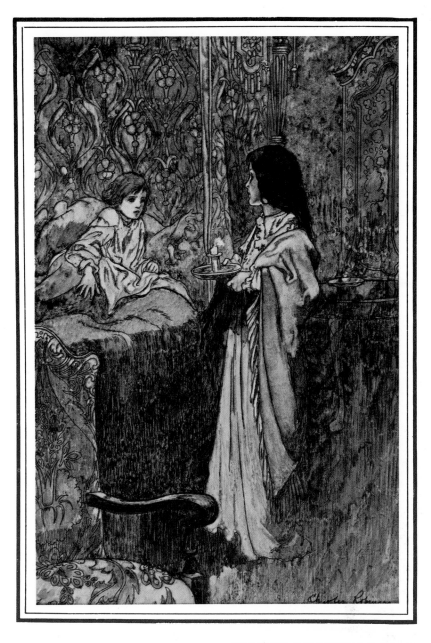

CHARLES ROBINSON Original
illustration to *The Secret Garden* by
Frances Hodgson Burnett (William
Heinemann, 1911).

§ xxxvij

This magic house, so fair, so disarrayed,
What god, what demon first its foundings
laid ?
Who thus its treasure to Oblivion casts,
Still hungering at the gate but never stayed ? "

xxxviij

And I was answered ere my thought found tongue,
As pealing from the gate their voices rung,
Like wailing harp & voice together heard :
With ear intent upon their speech I hung.

xxxix.

"Let no man ask, but he who doth not shrink
To stand at gaze upon thoughts giddy brink,
Where breaks the endless sea, & ebbs & flows
The tides of life & death that Time doth drink."

WALTER CRANE Two pages from *The Sirens Three*, a poem
written and illustrated by Crane (Macmillan, 1886).

CIX.

PROTEAN life which man doth vain pursue
From youth's green meads to ages' mountain's blue
The painted fly a breathless child doth chase—
Through all its changing shapes to change but true:

CX.

This quivering bubble, dyed with every stain
Of splendour & of passion, why in vain—
Ah! why?—It sails the summer air—
An iridescent moment lost in rain?

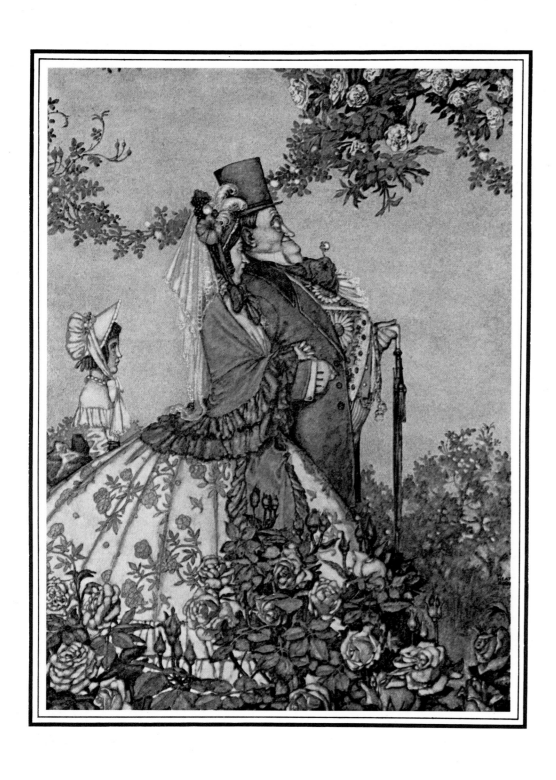

WILLIAM HEATH ROBINSON 'The Respectable
Gentleman' from his *Bill the Minder* (Constable, 1912).

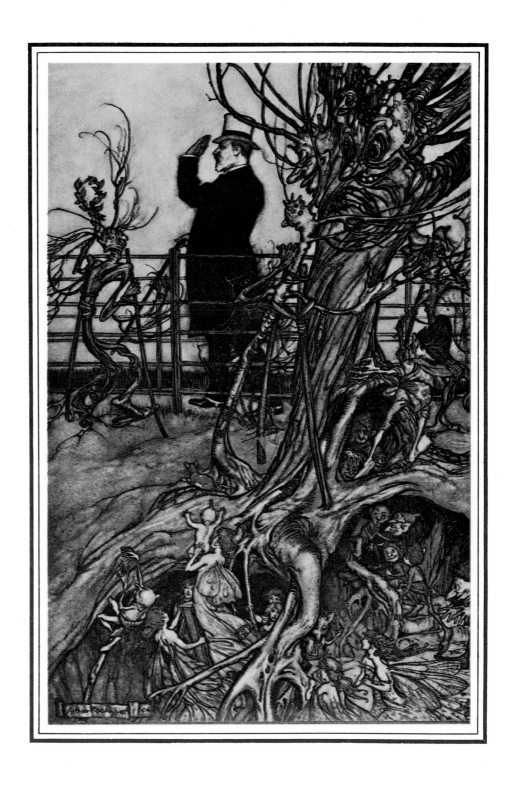

ARTHUR RACKHAM 'The Kensington Gardens are in
London, where the King lives.' From *Peter Pan in
Kensington Gardens* by J. M. Barrie (Hodder & Stoughton,
1907).

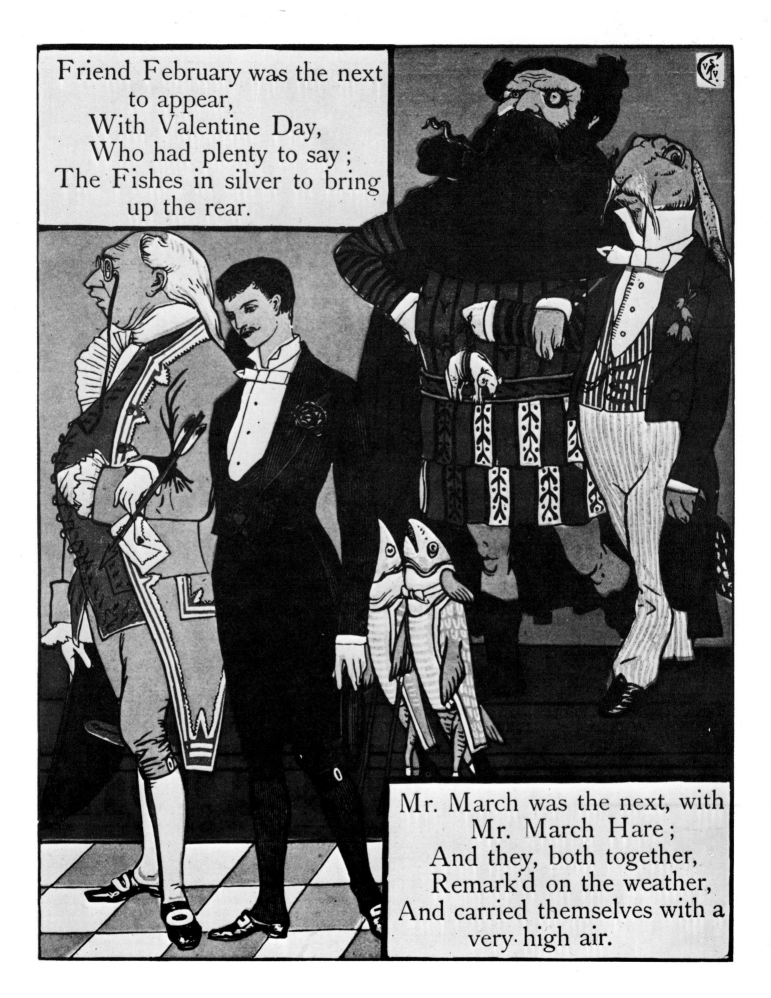

Friend February was the next
to appear,
With Valentine Day,
Who had plenty to say ;
The Fishes in silver to bring
up the rear.

Mr. March was the next, with
Mr. March Hare ;
And they, both together,
Remark'd on the weather,
And carried themselves with a
very high air.

WALTER CRANE 'King Luckieboy's Party.' From *Walter Crane's New Series of Picture Books* (1885–86).

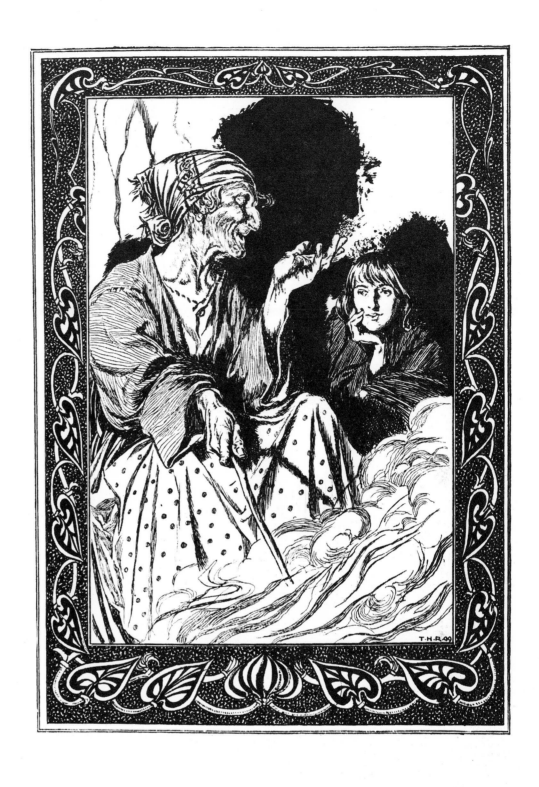

THOMAS ROBINSON Illustration to *The Garden of Paradise* from *Fairy Tales from Hans Christian Andersen*, translated by Mrs E. Lucas (J. M. Dent, 1899).

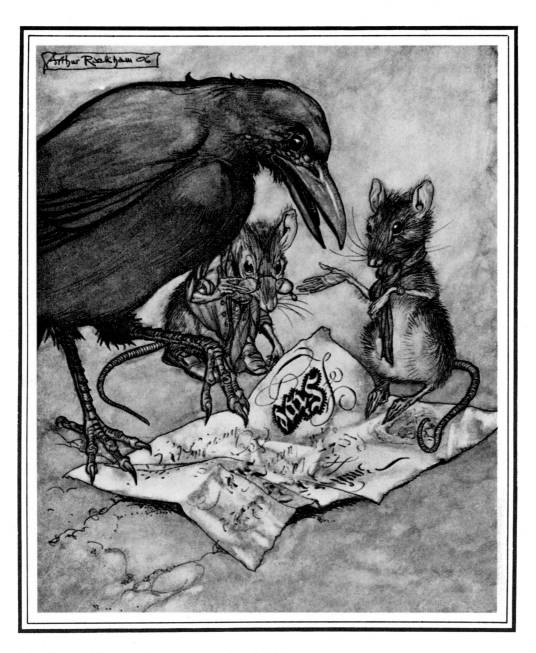

ARTHUR RACKHAM "'Preposterous!" cried Solomon in a
rage.' From *Peter Pan in Kensington Gardens* by J. M. Barrie
(Hodder & Stoughton, 1907).

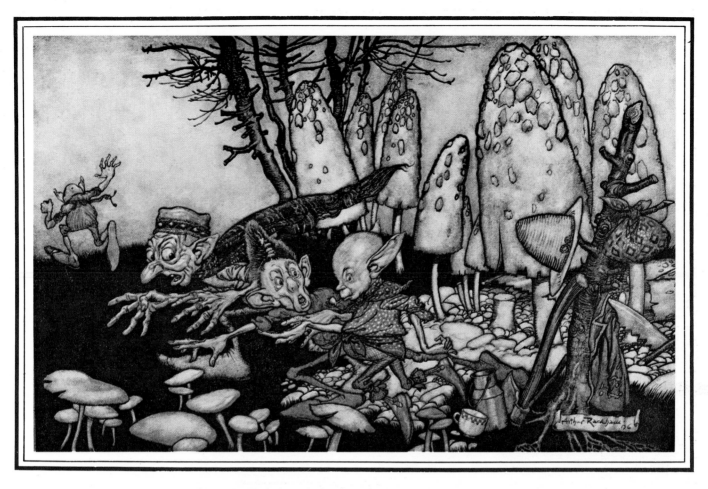

ARTHUR RACKHAM 'A band of workmen, who were
sawing down a toadstool, rushed away, leaving their tools
behind them.' From *Peter Pan in Kensington Gardens* by J. M.
Barrie (Hodder & Stoughton, 1907).

CHARLES ROBINSON 'The Trold Chieften from the
Dovréfield wore a Crown of hardened Icicles and Fir-cones'
for *The Elf-Hill* from *Fairy Tales from Hans Christian
Andersen* translated by Mrs E. Lucas (J. M. Dent, 1899).

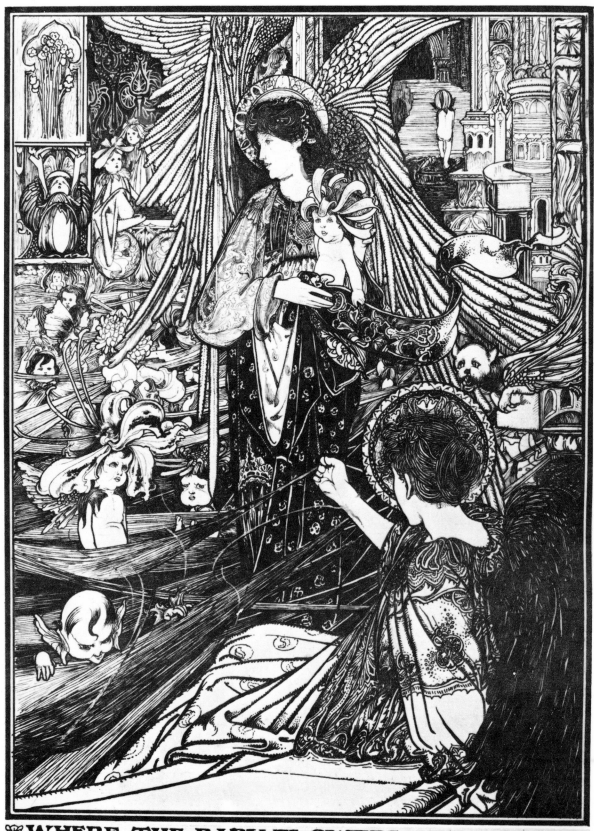

WHERE THE BABY FLOWERS ARE BORN,

CHARLES ROBINSON Original for illustration to *King
Longbeard* or, *The Annals of the Golden Dreamland* by
Barrington MacGregor (John Lane, 1898).

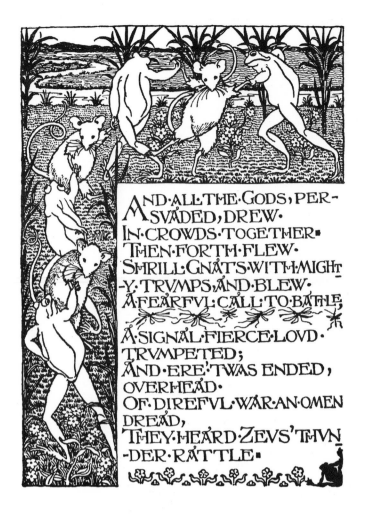

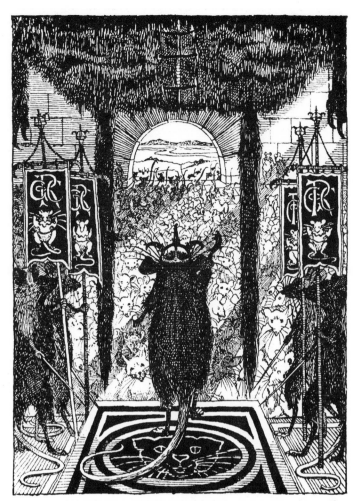

AND·ALL·THE·GODS, PER-
SVÁDED, DREW·
IN·CROWDS·TOGETHER·
THEN·FORTH·FLEW·
SHRILL·GNÁTS·WITH·MIGHT
-Y·TRVMPS, ÁND·BLEW·
A·FEÁRFVL·CÁLL·TO·BÁTTLE,

A·SIGNÁL·FIERCE·LOVD·
TRVMPETED;
AND·ERE·'TWAS ENDED,
OVERHEÁD·
OF·DIREFVL·WÁR·AN·OMEN
DREÁD,
THEY·HEÁRD·ZEVS'·THVN
-DER·RÁTTLE·

F. D. BEDFORD A page (*above left*) and 'King Gnawcrust, wild with wrath and grief to lose his child, rose speaking words impassioned.' (*above right*) From *The Battle of the Frogs and Mice* by Homer, rendered into English by Jane Barlow (Methuen, 1894).

Right F. D. BEDFORD 'The Old Grey Man of the Sea', illustration to *The Turkey Factor* from *Old English Fairy Tales* collected by S. Baring Gould (Methuen, 1895).

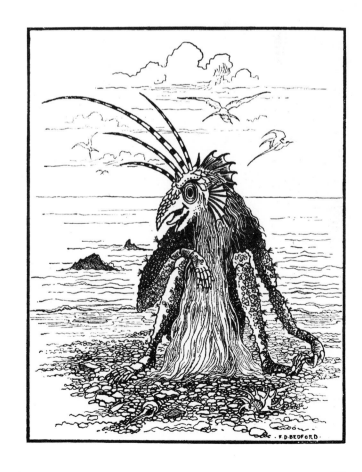

J

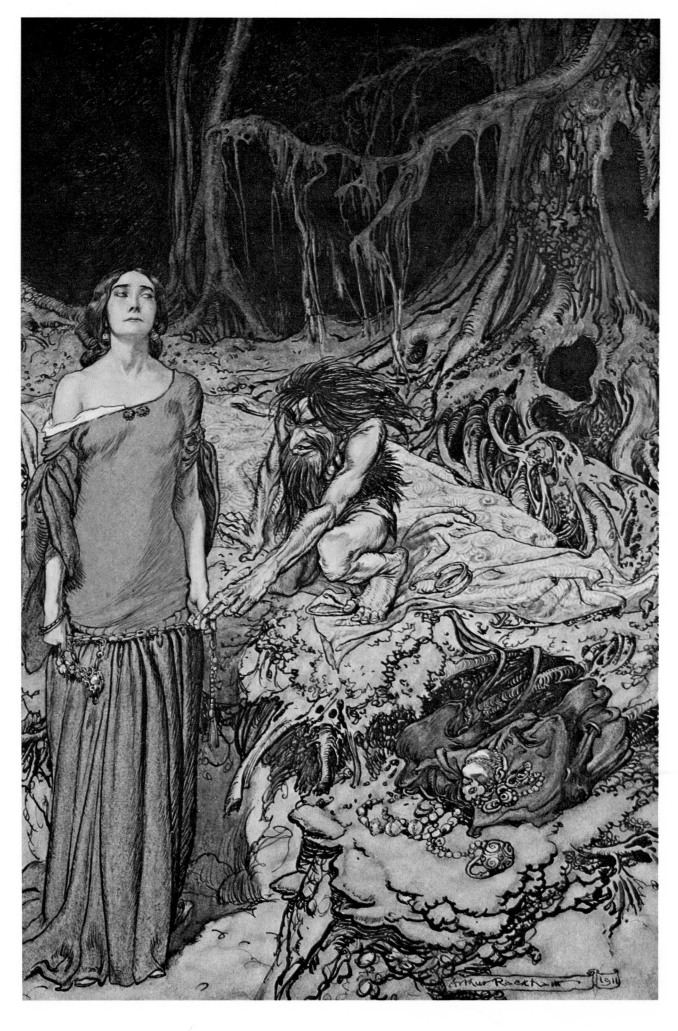

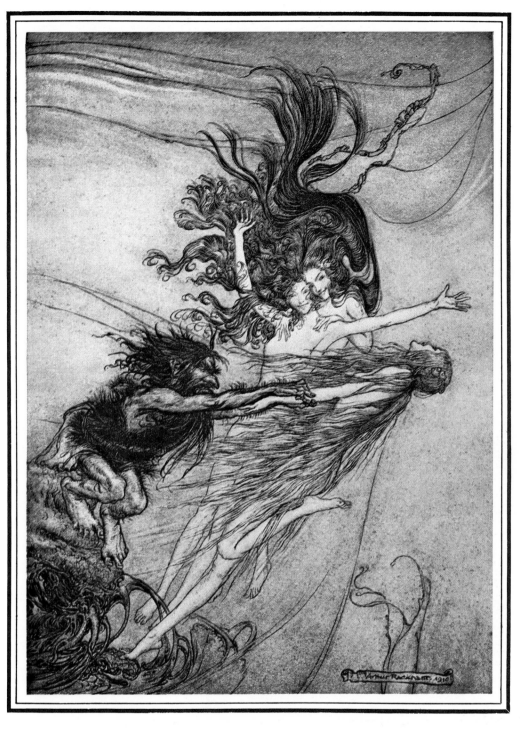

ARTHUR RACKHAM 'The Rhinemaidens teasing Alberich'
from *The Rhinegold and The Valkyrie* by Richard Wagner
(Heinemann, 1910).

ARTHUR RACKHAM 'The Wooing of Grunhilde, the
mother of Hagen'. Original for *Siegfried & The Twilight of the
Gods* by Richard Wagner, translated by Margaret Armour
(Heinemann, 1911).

ROBERT ANNING BELL 'Ariel' (*right*) and 'Caliban'
(*opposite*) from *The Tempest* by William Shakespeare
(Freemantle, 1901).

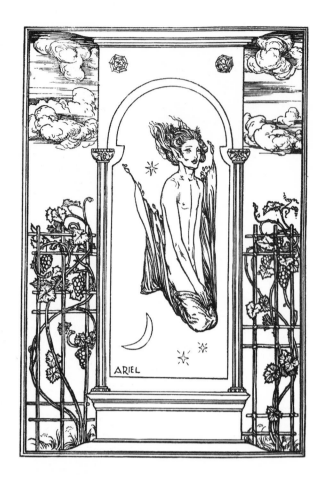

J. BYAM SHAW 'I found no truth in one report at least'
for *How it Strikes a Contemporary* (*below*) and '*Childe Roland
to the Dark Tower came*' (*below right*) from *Poems by Robert
Browning* (George Bell, 1897).

'I·FOVND·NO
TRVTH·IN
ONE·REPORT
AT·LEAST·'

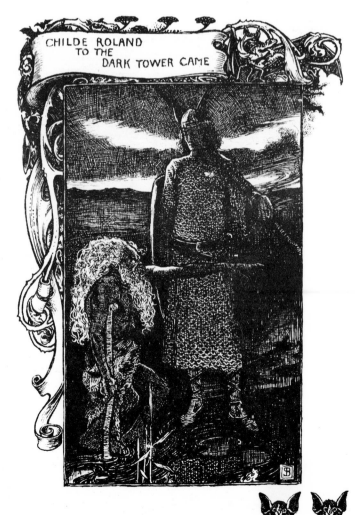

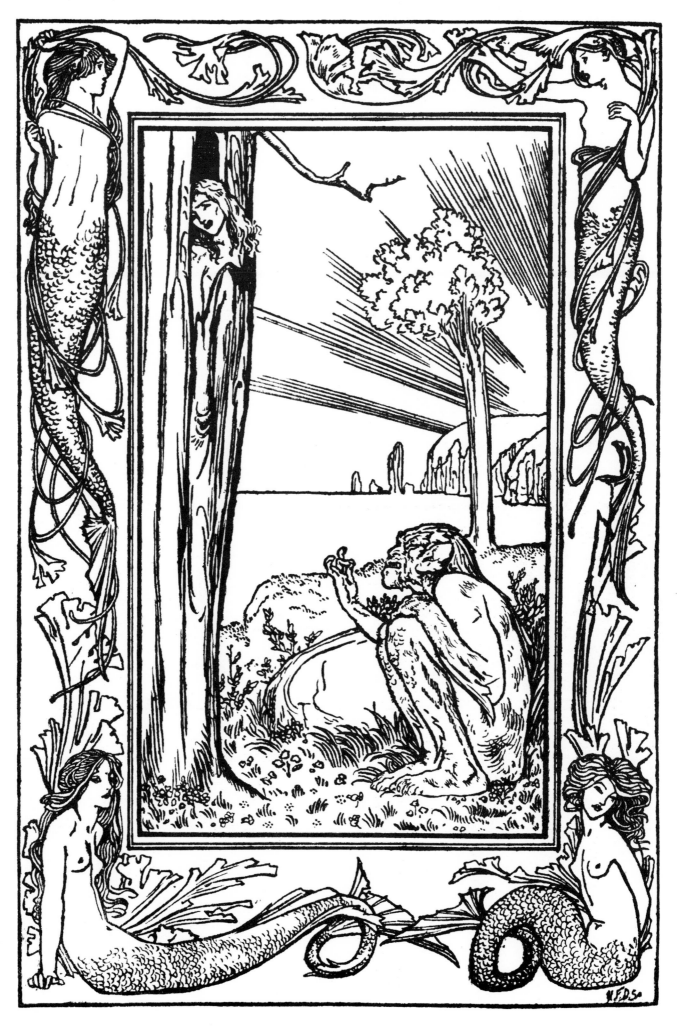

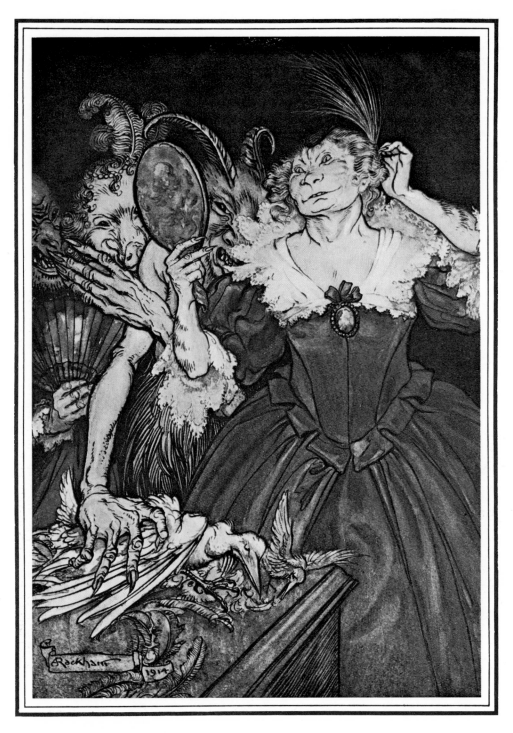

ARTHUR RACKHAM
And they, so perfect is their misery,
Not once perceive their foul disfigurement,
But boast themselves more comely than before.
From *Comus* by John Milton (Heinemann, 1921).

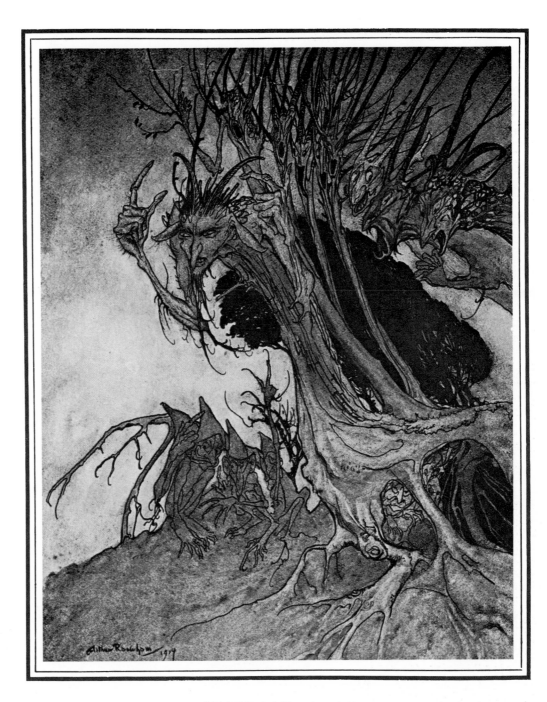

ARTHUR RACKHAM 'Calling shapes, and beckoning shadows dire.' From *Comus* by John Milton (Heinemann, 1921).

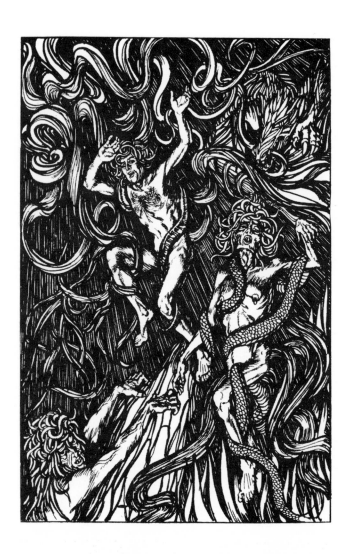

Left and below left E. J. SULLIVAN 'Chaos' and (*below*) 'Old Clothes' from *Sartor Resartus* by Thomas Carlyle (George Bell, 1898).

Below and far right below E. J. SULLIVAN 'A Bride of Christ' (*below*) and 'Dancing Partners' from *The Kaiser's Garland*, a book of cartoons by the artist (William Heinemann Ltd., 1915).

Right below E. J. SULLIVAN 'Giant Despair' from Vol. I, *The Pilgrim's Progress* by John Bunyan (George Newnes, 1901).

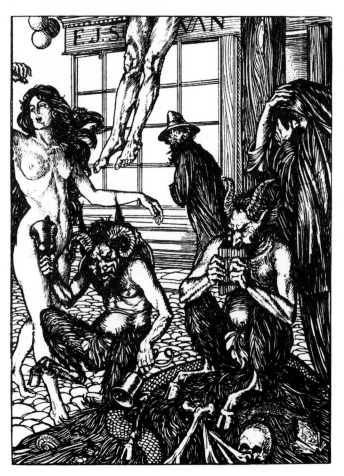

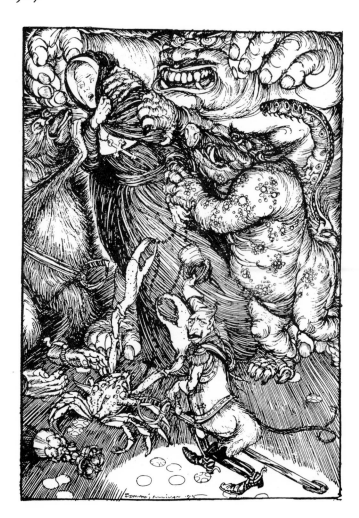

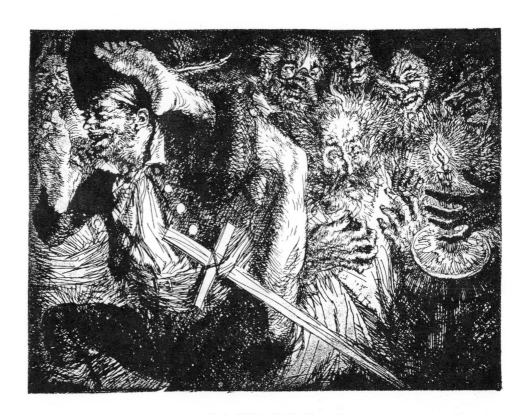

Above E. J. SULLIVAN 'Don Quixote among the enchanters'.

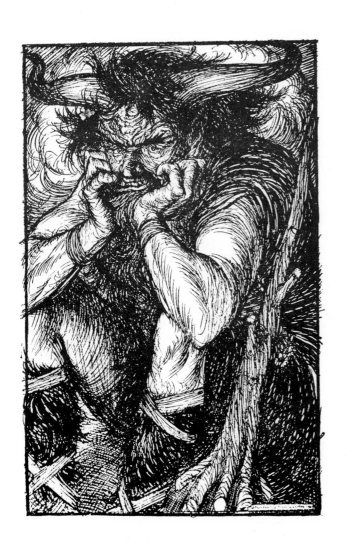

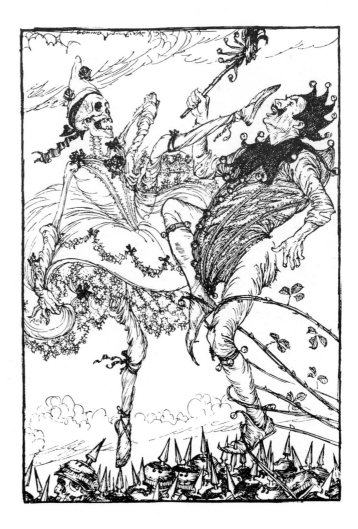

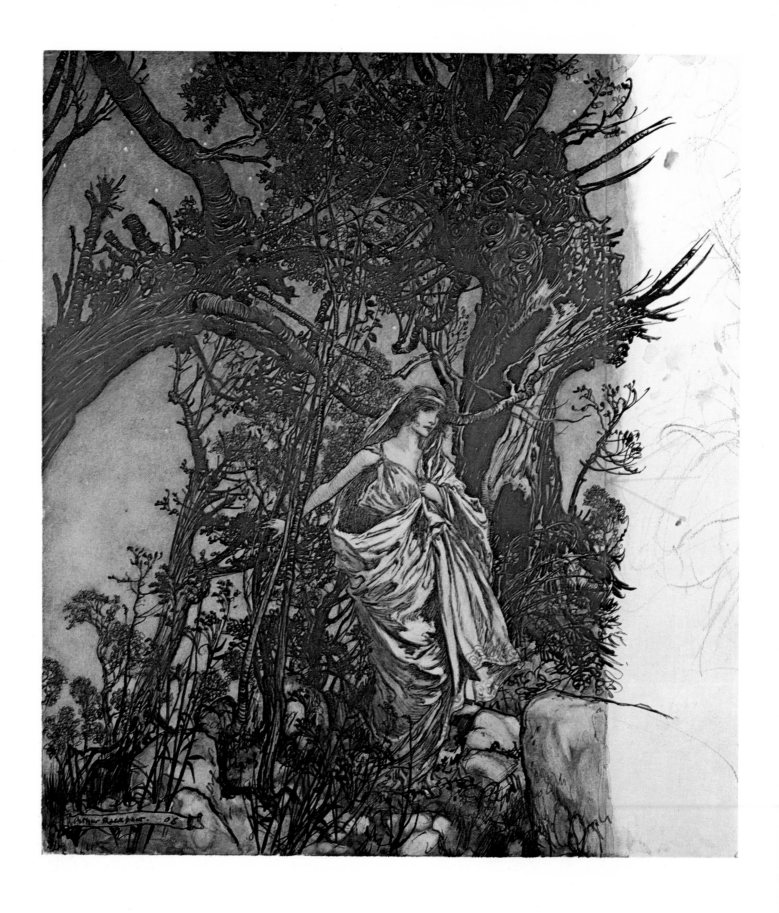

ARTHUR RACKHAM 'Never so weary, never so in woe'
Original watercolour of Hermia for *A Midsummer Night's Dream* by William Shakespeare (1908).

Right ARTHUR RACKHAM 'The Widow Whitgift and her Sons'—"Go," she says, "Go with my leave and goodwill."'
Original watercolour illustration, dated 1906, for *Dymchurch Flit*, used as frontispiece in *Puck of Pook's Hill* by Rudyard Kipling.

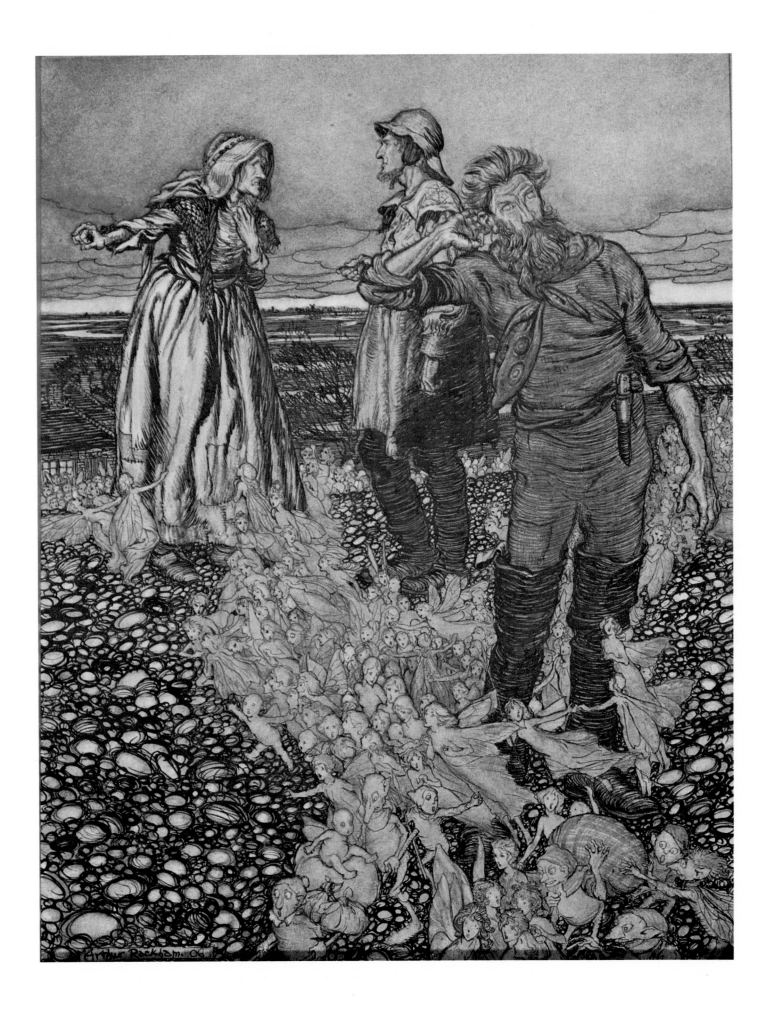

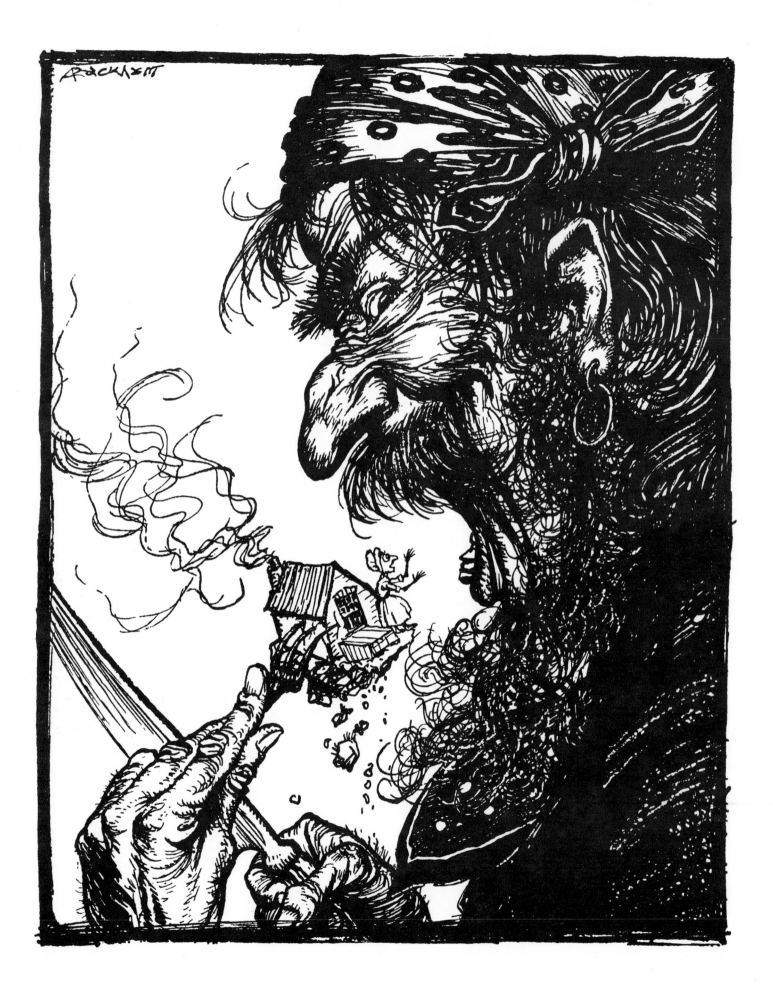

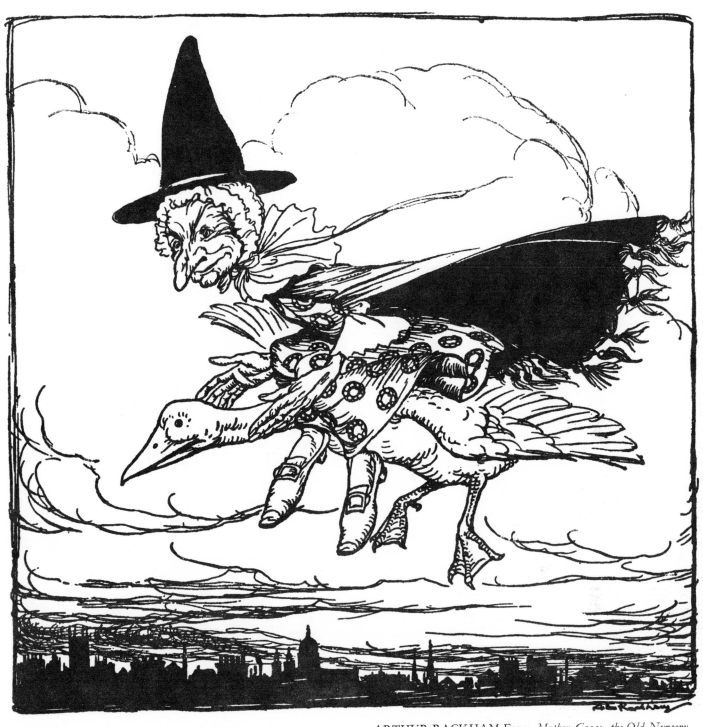

ARTHUR RACKHAM From *Mother Goose, the Old Nursery Rhymes* (Heinemann, 1913).

Left ARTHUR RACKHAM 'There was an old woman called nothing at all' from *Mother Goose, the Old Nursery Rhymes* (Heinemann, 1913).

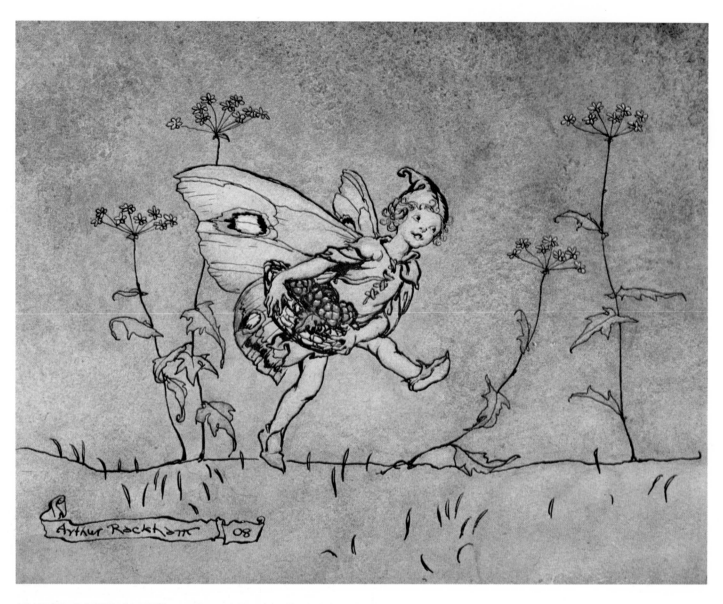

ARTHUR RACKHAM 'Elf attendant on Bottom "feed him
with apricocks, dewberries . . ."' Original watercolour for
A Midsummer Night's Dream (Heinemann, 1908).

ARTHUR RACKHAM Original for *Gulliver's Travels* by
Jonathan Swift (J. M. Dent, 1909).

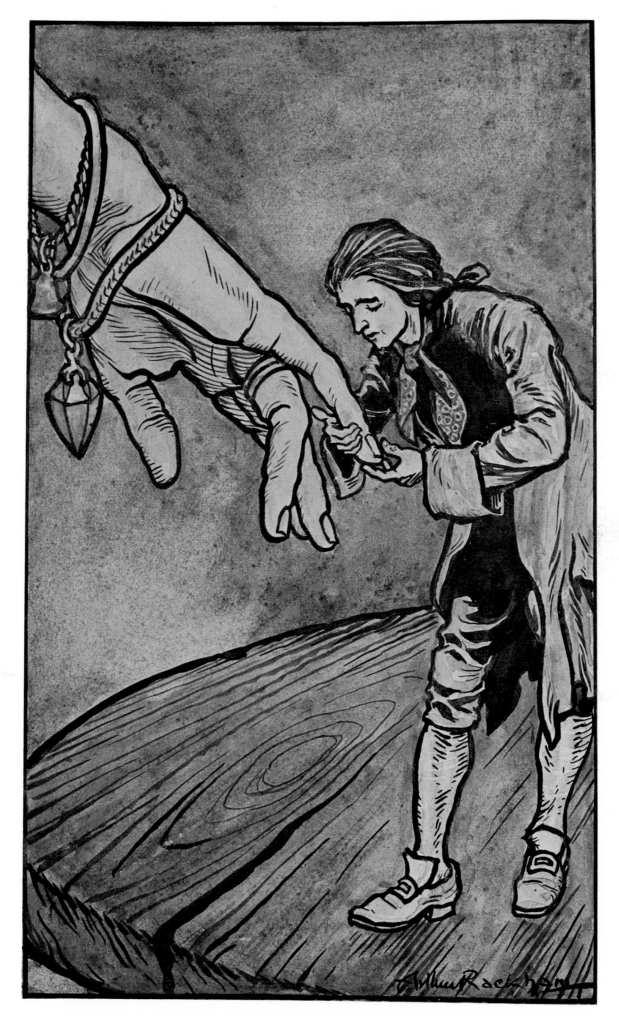

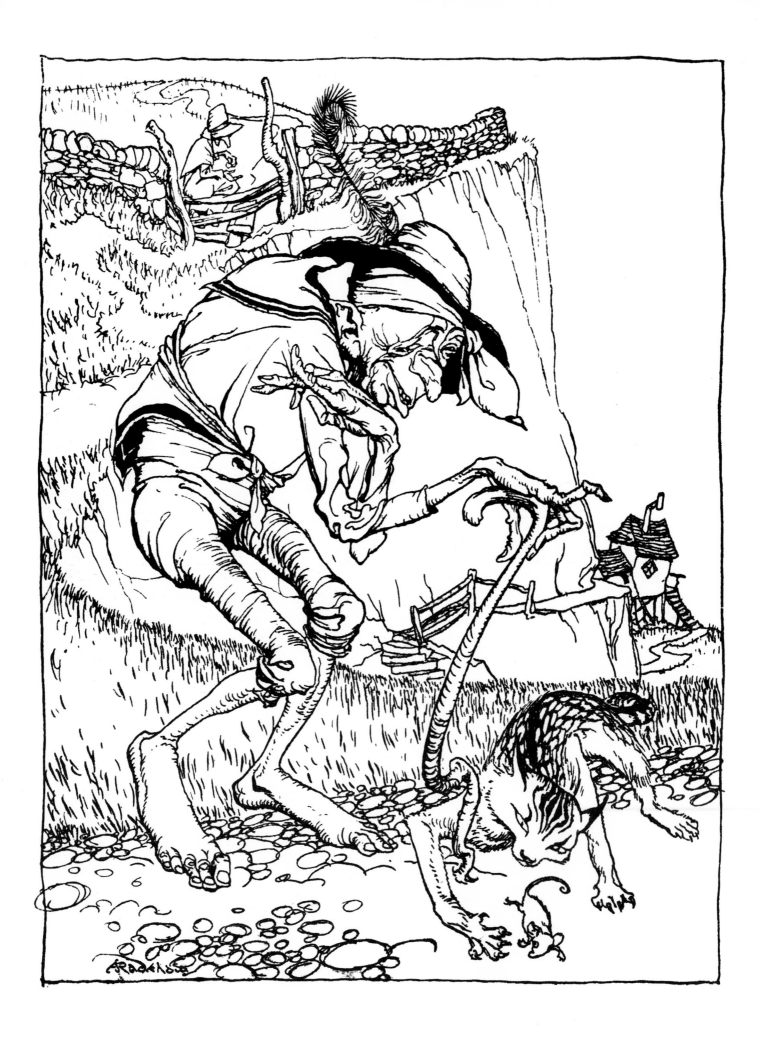

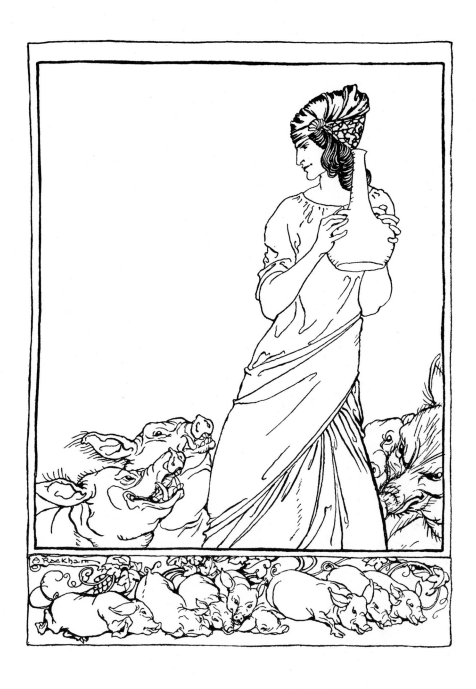

REGINALD KNOWLES Title page to *Norse Fairy Tales*
by P. C. Asbjörnsen and J. I. Moe, selected and adapted by
Sir George Dasent. (S. T. Freeman, 1910).

REGINALD L. KNOWLES 'Kiss me, you lassie', illustration
to *Bushy Bride* in *Norse Fairy Tales* by P. C. Asbjörnsen and
J. I. Moe, selected and adapted by Sir George Dasent (S. T.
Freeman, 1910).

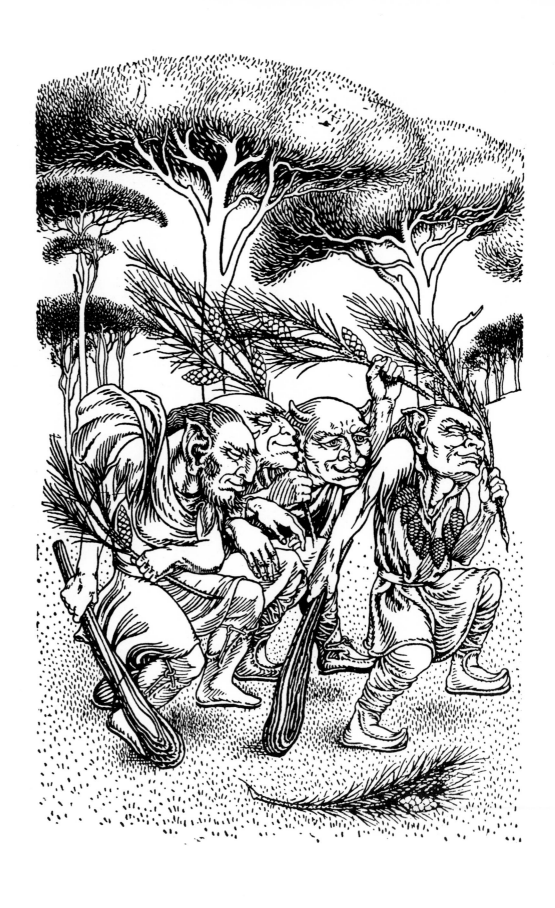

REGINALD L. KNOWLES 'When everything was ready'
and 'Down came the Trolls' a double page spread from *Norse
Fairy Tales* by P. C. Asbjörnsen and J. I. Moe, selected and
adapted by Sir George Dasent (S. T. Freeman, 1910).

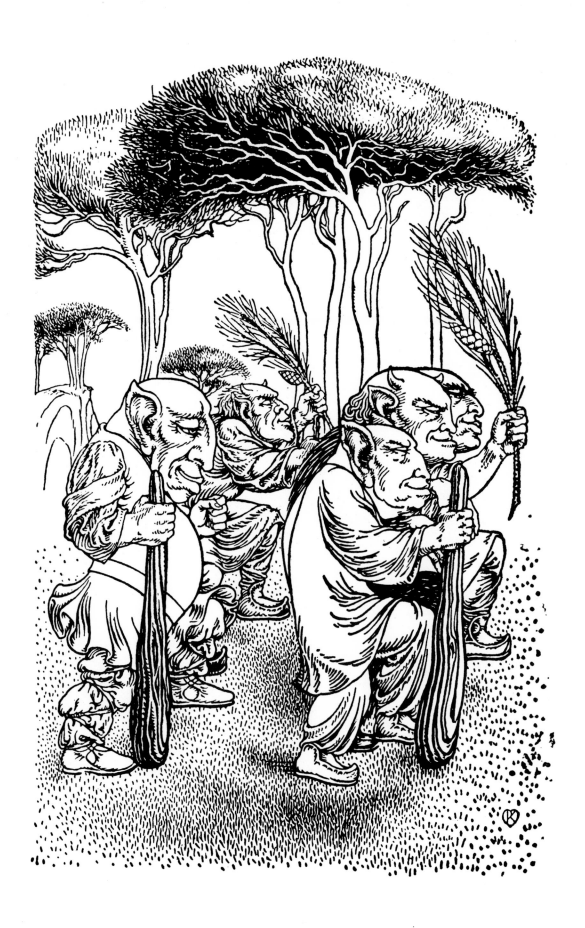

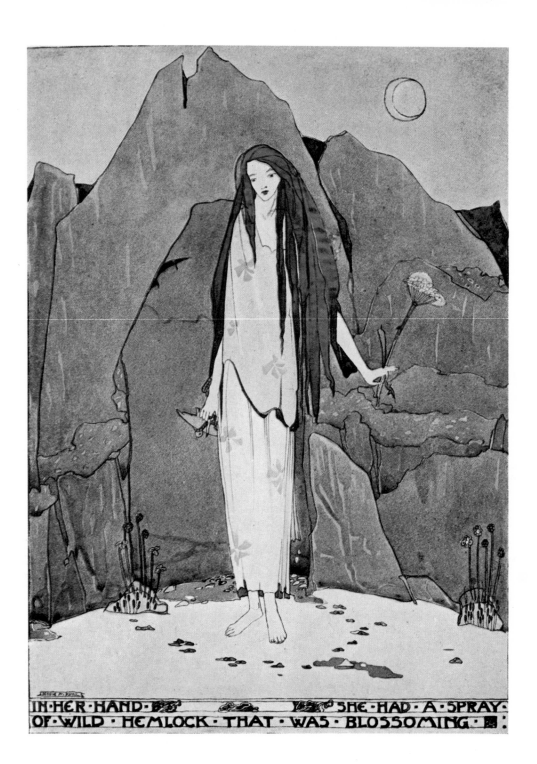

JESSIE M. KING From *A House of Pomegranates* by Oscar
Wilde (first published by Methuen, 1891, this copy 1915).

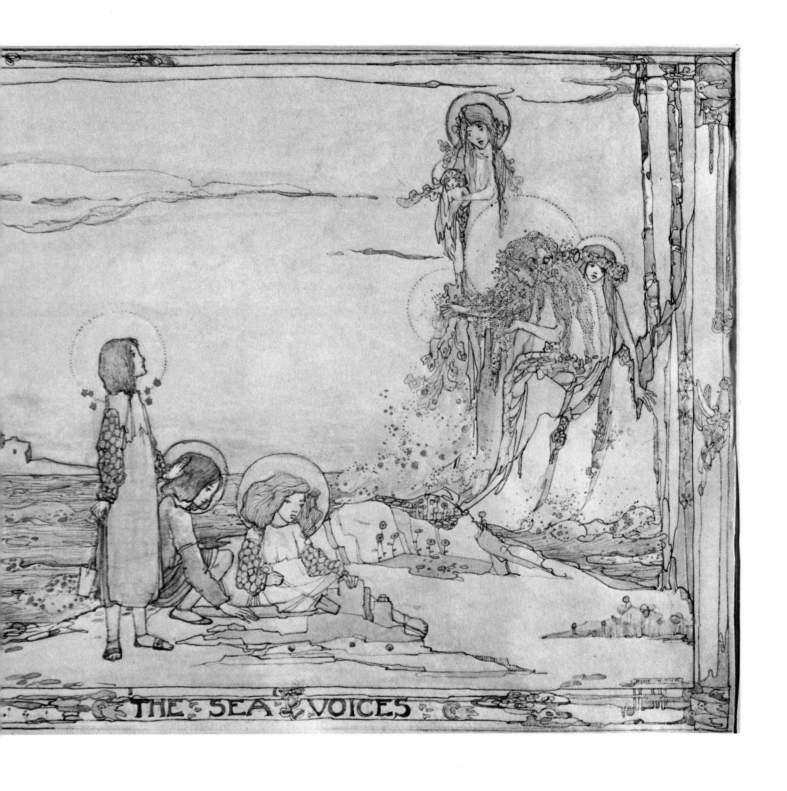

THE SEA VOICES

JESSIE M. KING. Illustration, probably unpublished, for unknown story (c 1910).

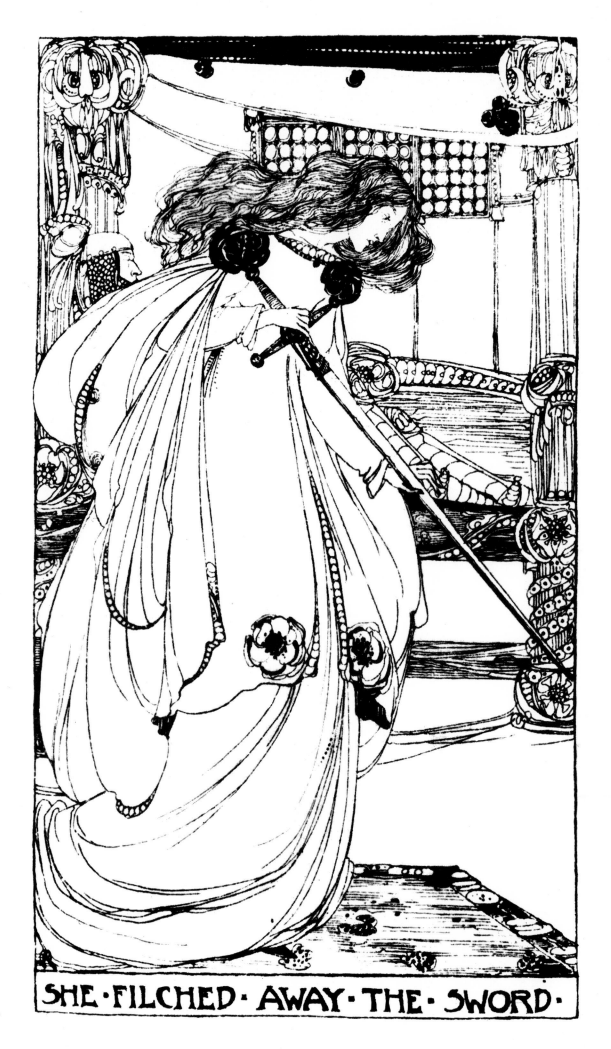

SHE·FILCHED·AWAY·THE·SWORD·

THE·GRAAL·APPEARETH·TO·MESSIRE·GAWAIN·AT·THE·FEAST:

Left and above JESSIE M. KING From *The High History of the Holy Graal* by Perceval le Gallois, Knight of the Round Table, translated from Old French by Sebastian Evans (J. M. Dent, 1903).

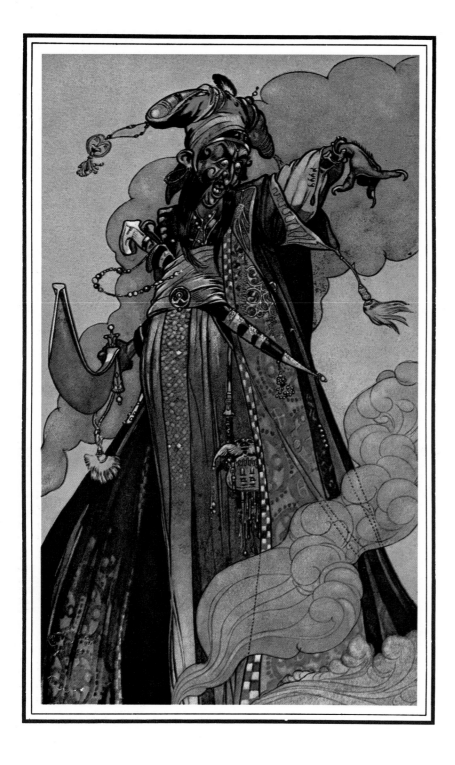

RENÉ BULL 'He saw a Genie of
monstrous bulk advancing towards
him.' From *The Arabian Nights*
(Constable, 1912).

RENÉ BULL 'After a long and careful course of magical enquiries' from *Aladdin;—or The Wonderful Lamp* in *The Arabian Nights* (Constable, 1912).

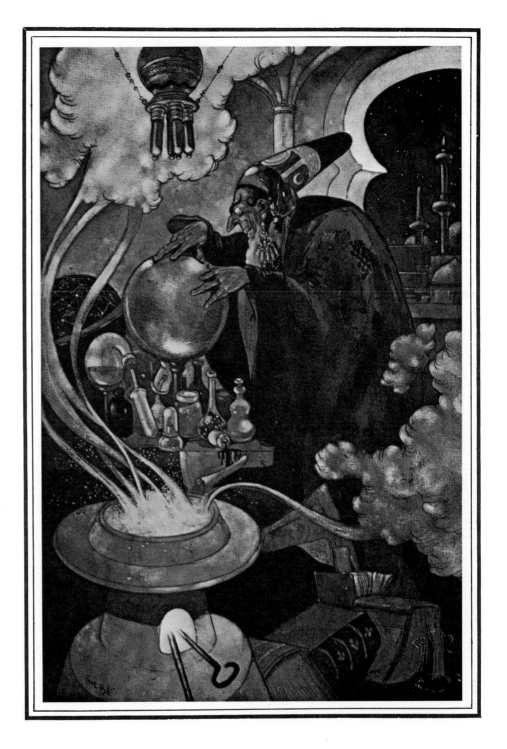

W. HEATH ROBINSON 'One aloof sentinel' (*left*) and
illustrations to Act V (*above*) and Act III scene ii (*right*) from
A Midsummer Night's Dream by William Shakespeare
(Constable, 1914).

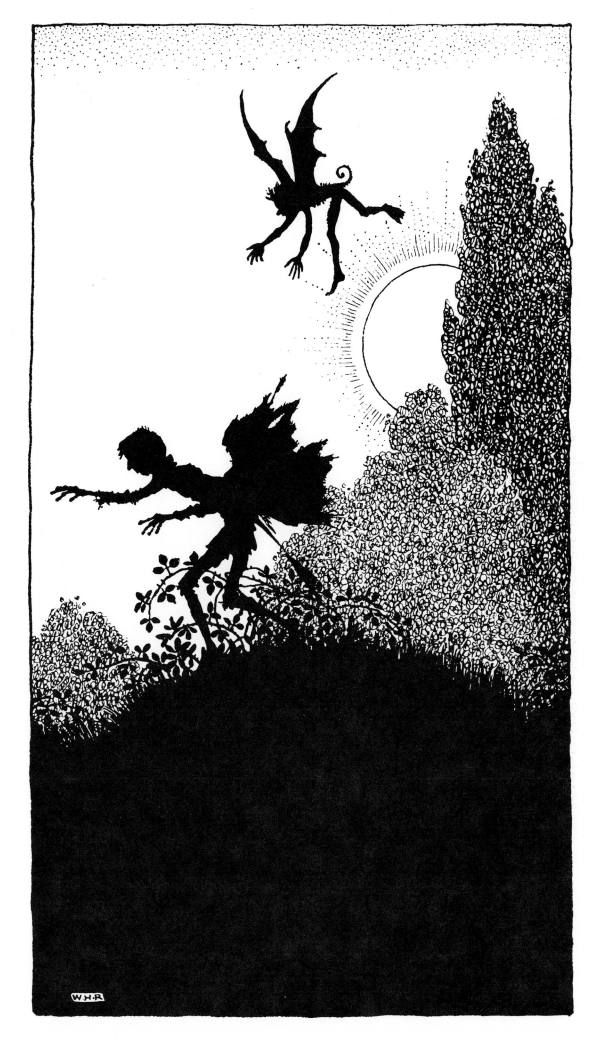

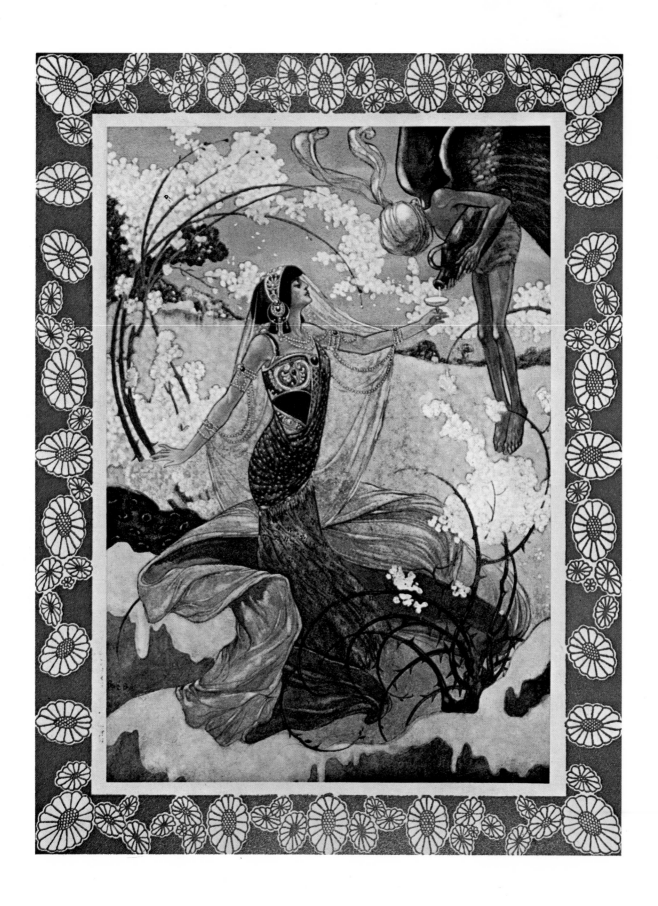

RENÉ BULL
Come fill, the cup, and in the Fire of Spring
The Winter Garment of Repentance fling:
The Bird of Time has but a little way
To fly—and Lo! The bird is on the wing.
From Quatrain VII, of *The Rubá'iyát of Omar Khayyám*,
translated by Edward Fitzgerald (Hodder & Stoughton, 1913)

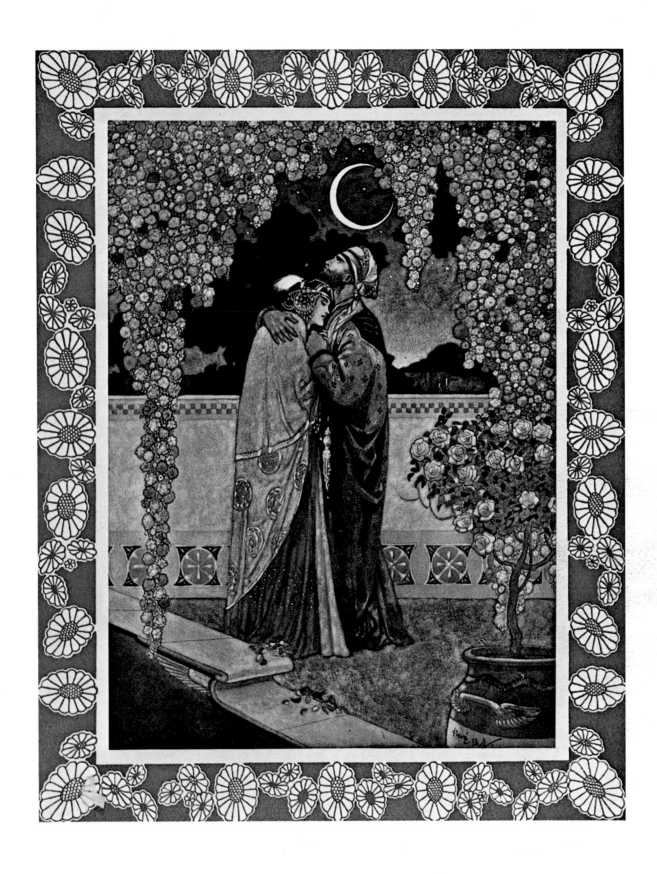

RENÉ BULL
Ah Love! could thou and I with Fate conspire
To grasp this sorry scheme of Things entire,
Would not we shatter it to bits—and then
Re-mould it nearer to the Heart's Desire.
From Quatrain LXXII of *The Rubá'iyát of Omar Khayyám*,
translated by Edward Fitzgerald (Hodder & Stoughton, 1913)

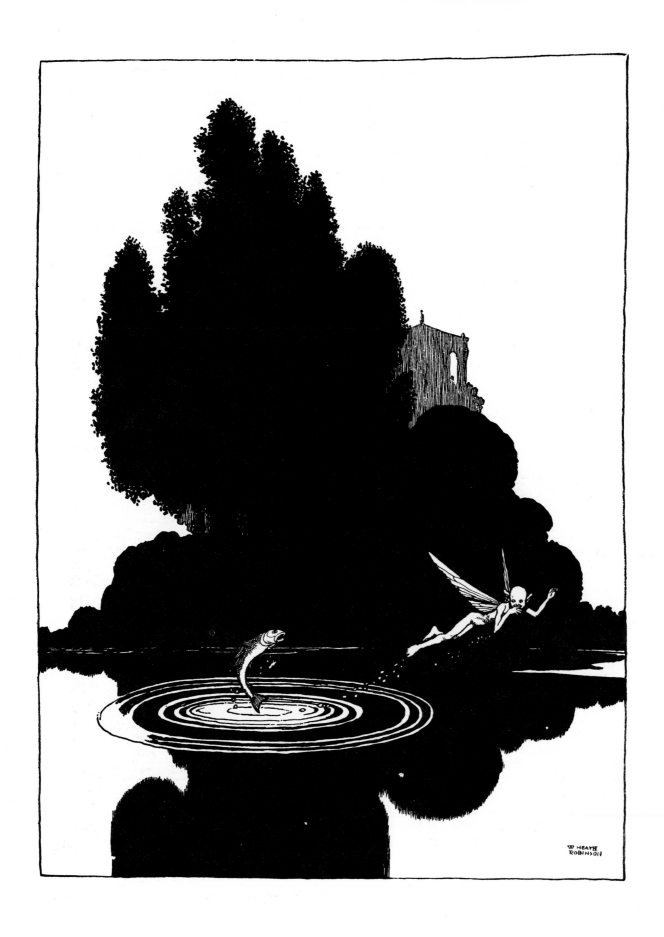

W. HEATH ROBINSON Page introducing Act IV from
A Midsummer Night's Dream by William Shakespeare
(Constable, 1914).

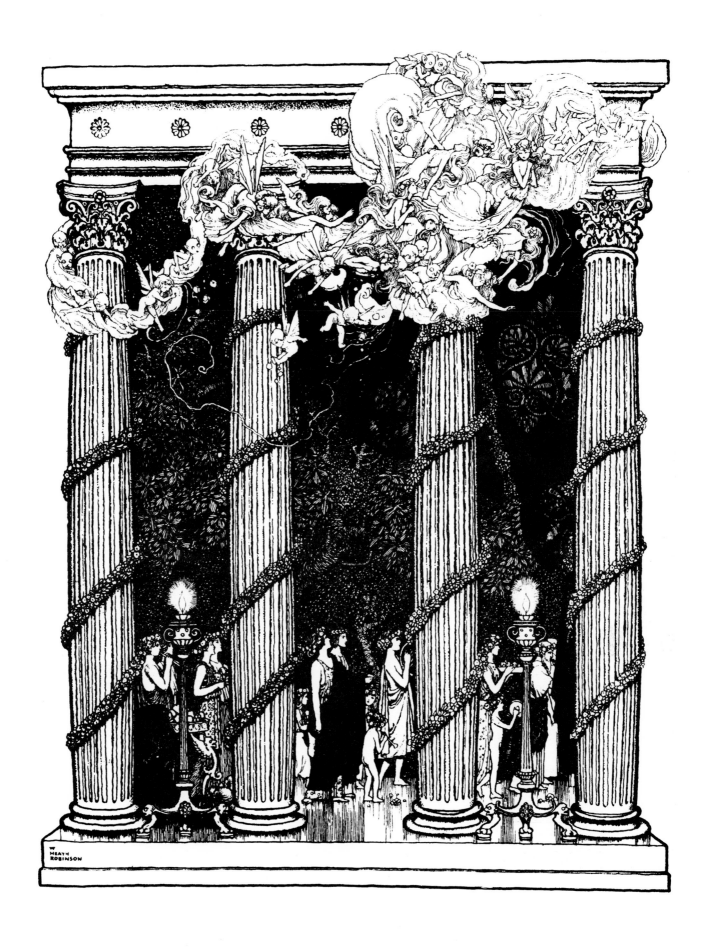

W. HEATH ROBINSON Page introducing Act V from *A Midsummer Night's Dream* by William Shakespeare (Constable, 1914).

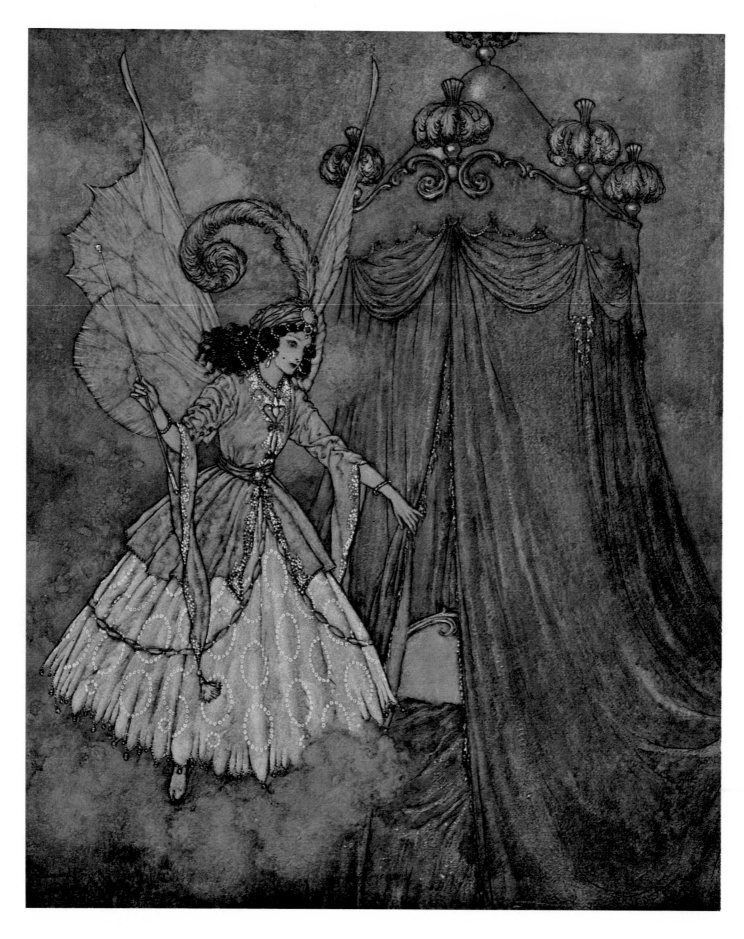

EDMUND DULAC 'She found herself face to face with a
stately and beautiful lady.' Original drawing for *Beauty and
the Beast*, p. 104, *The Sleeping Beauty and other Fairy Tales*,
retold by Sir Arthur Quiller-Couch (Hodder & Stoughton,
1910).

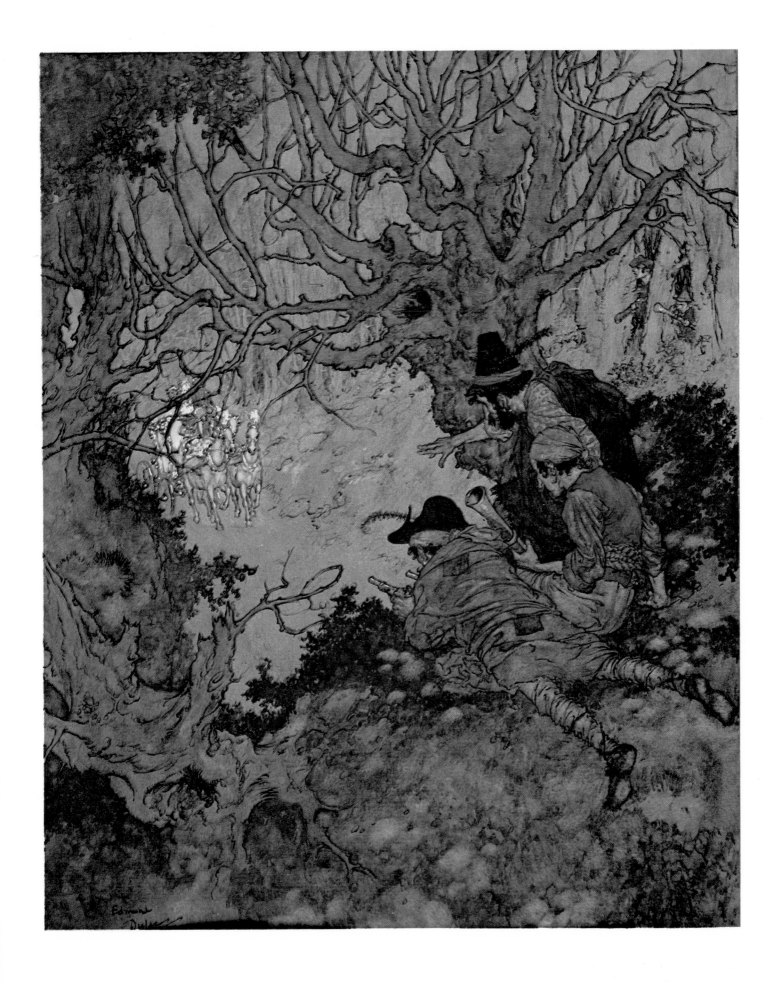

EDMUND DULAC ' "It is gold, it is gold" they cried.'
Original watercolour for *The Snow Queen* in *Stories from Hans
Andersen* (Hodder & Stoughton, 1911).

THE ANCIENT MARINER

W. HEATH ROBINSON Chapter title page to *The Ancient Mariner* and endpiece for *The King of Troy* (*right*) from his *Bill the Minder* (Constable, 1912).

THE MUSICIAN

W. HEATH ROBINSON Titlepage (*above*) and endpiece (*left*) to *The Musician* and a decoration (*top left*) from his *Bill the Minder.* (Constable, 1912).

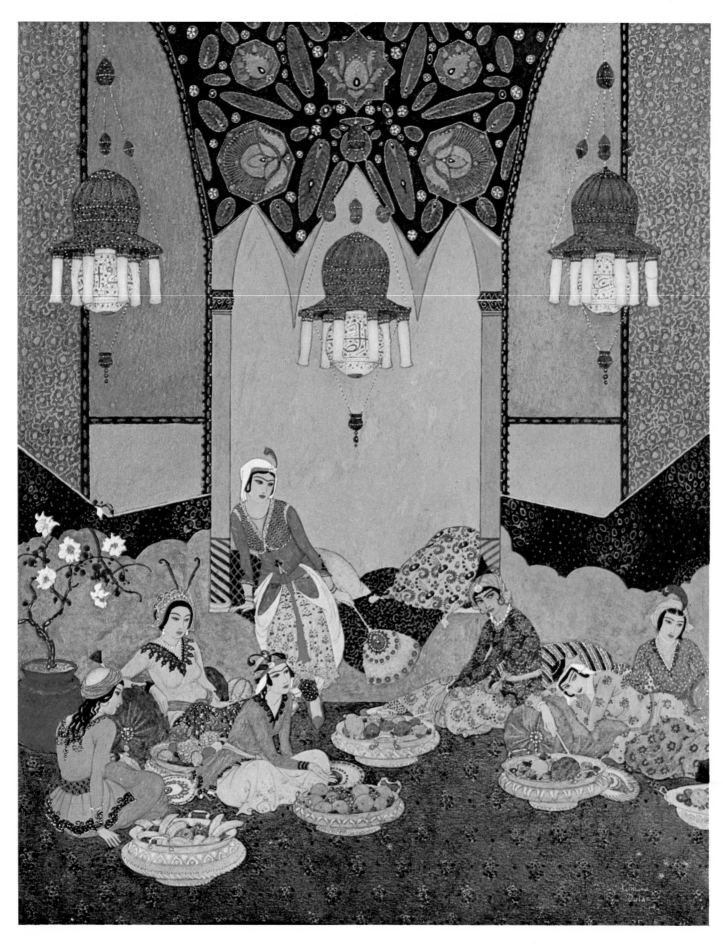

EDMUND DULAC 'The Room of Fruits prepared for
Abu-l-Hasan', original for illustration to *The Sleeper Awakened*
from *Sinbad the Sailor and other stories from the Arabian Nights*
(Hodder & Stoughton, 1914).

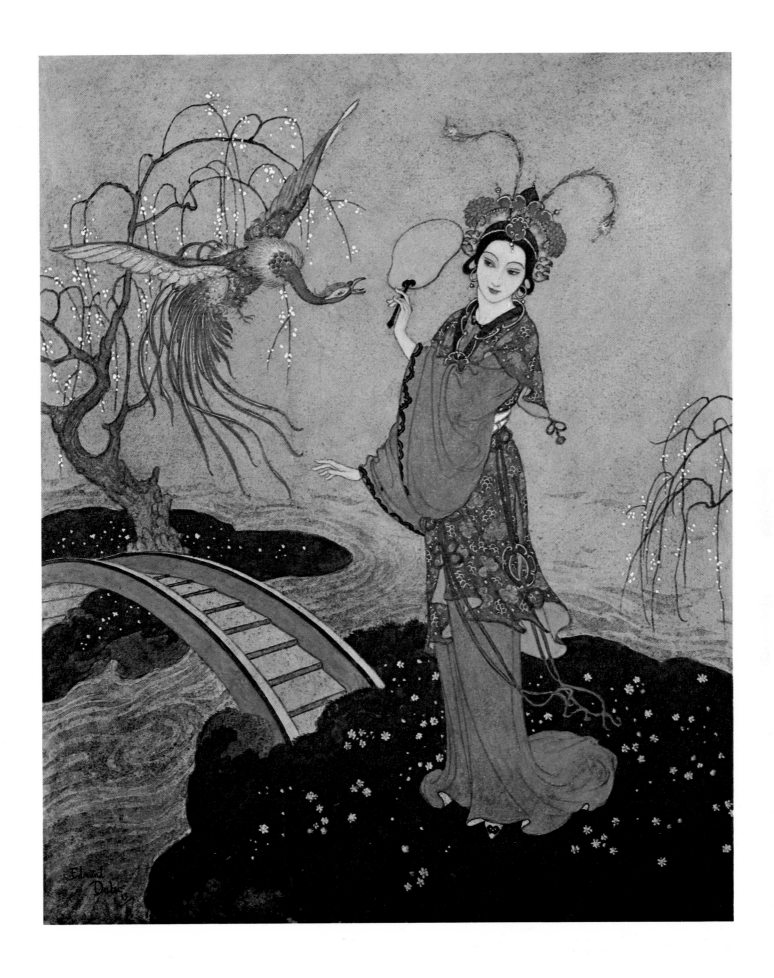

EDMUND DULAC Original watercolour for frontispiece
illustration to *Princess Badoura*, *A Tale from the Arabian
Nights*, retold by Laurence Housman (Hodder & Stoughton,
1913).

Top left W. HEATH ROBINSON
Chapter headpiece to *The Ancient Mariner* from his *Bill the Minder*
(Constable, 1912).

W. HEATH ROBINSON Endpiece to
List of Adventures (*above*) and 'The
Candle and the Iceberg' (*left*), illustration
to *Fourth Adventure* from his *Uncle
Lubin* (Grant Richards, 1902).

Top left W. HEATH ROBINSON
Detail drawing from his *Bill the Minder*
(Constable, 1912).

Above W. HEATH ROBINSON
Chapter heading to *The Crocodile & The
Monkey* from *The Giant Crab & Other
Tales from Old India*, retold by W. H. D.
Rouse (David Nutt, 1897).

Left W. HEATH ROBINSON
Illustration to *Fifth Adventure, the
Sea-Serpent* from his *Uncle Lubin* (Grant
Richards, 1902).

Below W. HEATH ROBINSON
Endpiece to *Poems of Edgar Allan Poe*
(George Bell & Sons, 1900).

EDMUND DULAC 'Great was the astonishment of the Vizier and the Sultan's escort.' Original for illustration to *The Story of the King of the Ebony Isles* from *Stories from the Arabian Nights*, retold by Laurence Housman (Hodder & Stoughton, 1907).

EDMUND DULAC Untitled and unpublished original watercolour of characters from popular nursery rhymes.

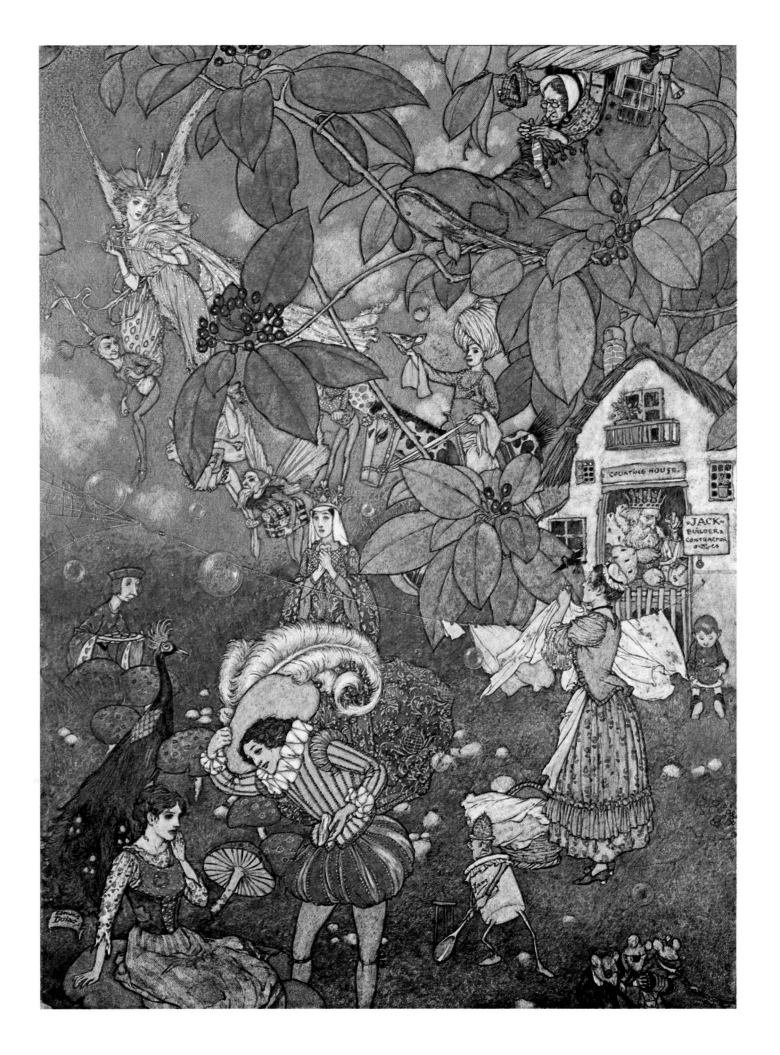

Opposite HAROLD NELSON 'How Robert the Devyll rode to his moder the Duchesse of Normandye, beyinge in the Castell of Darques: she was come to a feste' from *Early English Prose Romances I—Robert the Devyll* by W. H. Thoms (Otto Schulz, 1903).

Above W. HEATH ROBINSON Illustration to *Second Adventure, the Air Ship* from his *Uncle Lubin* (Grant Richards, 1902).

Right W. HEATH ROBINSON Illustration to *The Goblin City* from *The Giant Crab & Other Tales*, retold by W. H. D. Rouse (David Nutt, 1897).

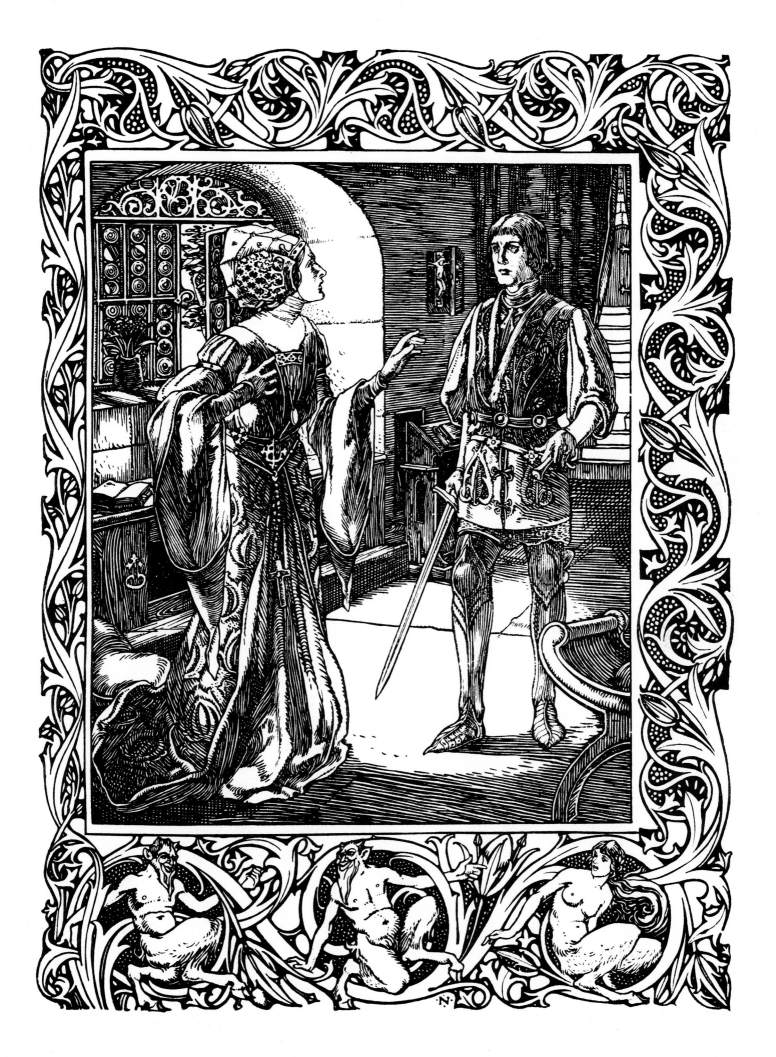

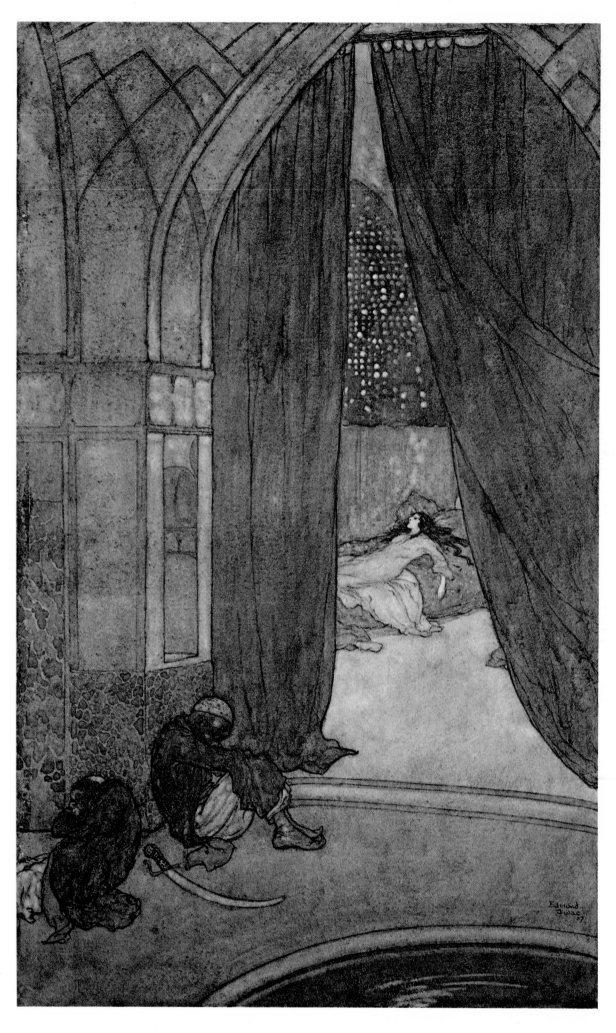

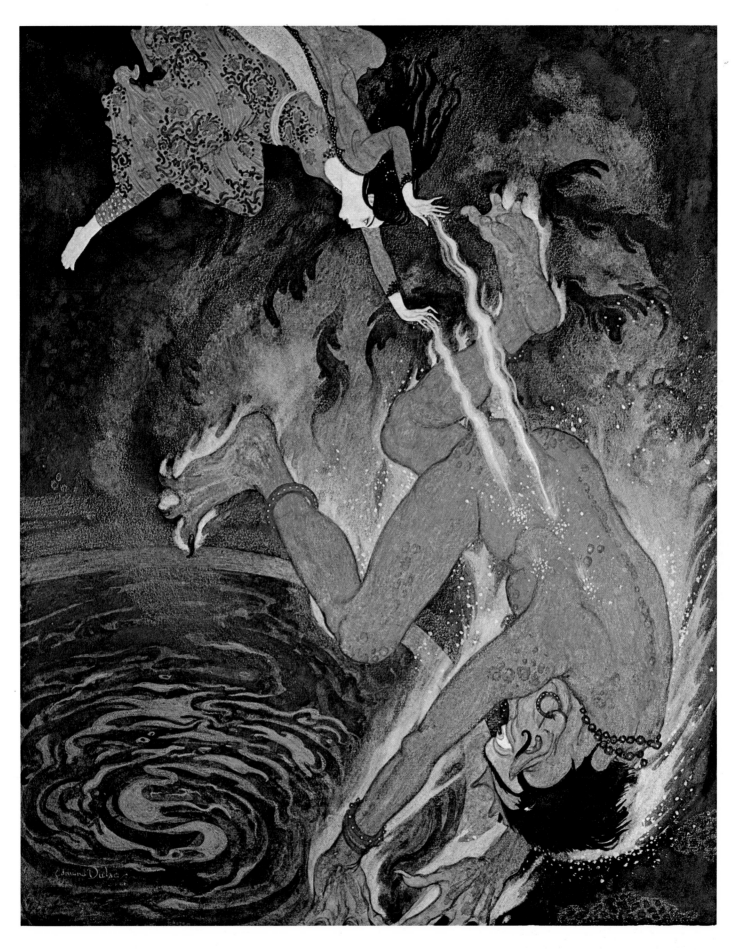

Left EDMUND DULAC 'He saw black eunuchs lying asleep.'
Original for illustration to *The Story of the Magic Horse* in
Stories from the Arabian Nights, retold by Laurence Housman
(Hodder & Stoughton, 1907).

Above EDMUND DULAC 'The Princess burns the Elfrite to
death', original for illustration to *The Story of the Three
Calenders* from *Sinbad the Sailor and other Stories from the
Arabian Nights* (Hodder & Stoughton, 1914).

Left HAROLD NELSON Endpieces
from *Early English Prose Romances I
—Robert the Devyll* by W. H. Thoms
(Otto Schulz, 1903).

H. R. MILLAR 'The monster lizard slipped heavily into the water.' From *The Enchanted Castle* by E. Nesbit (Fisher & Unwin, 1907).

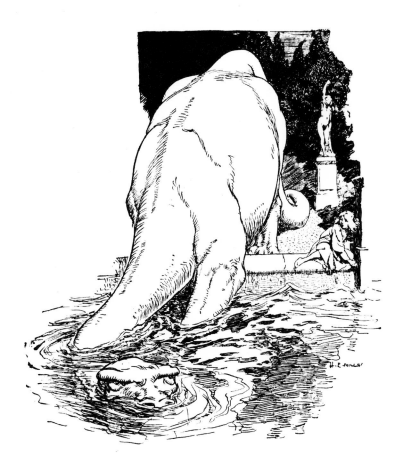

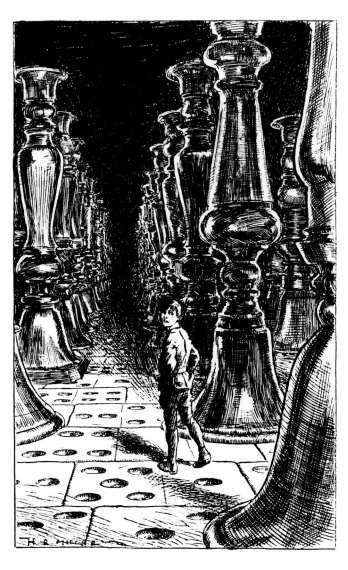

H. R. MILLAR 'He walked on and on and on.' From *The Magic City* by E. Nesbit (Macmillan, 1910).

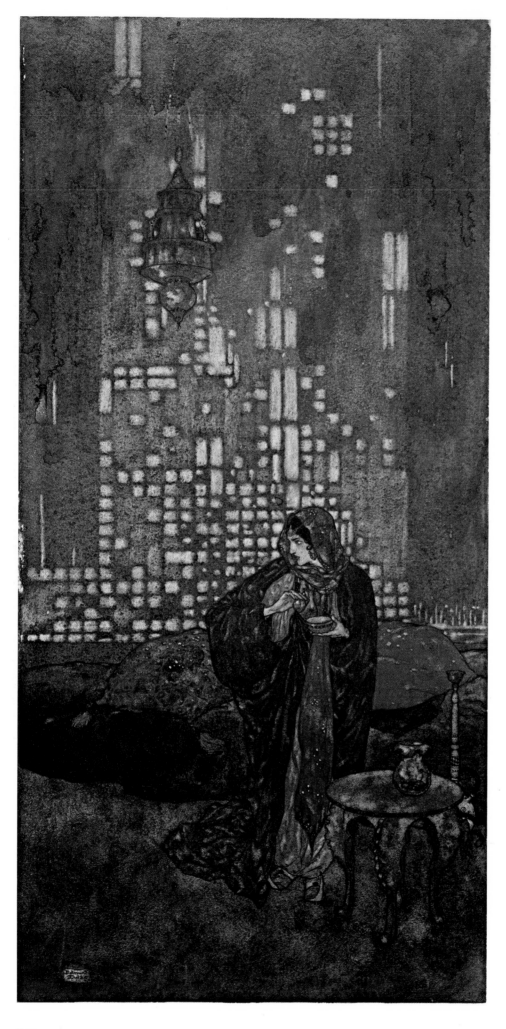

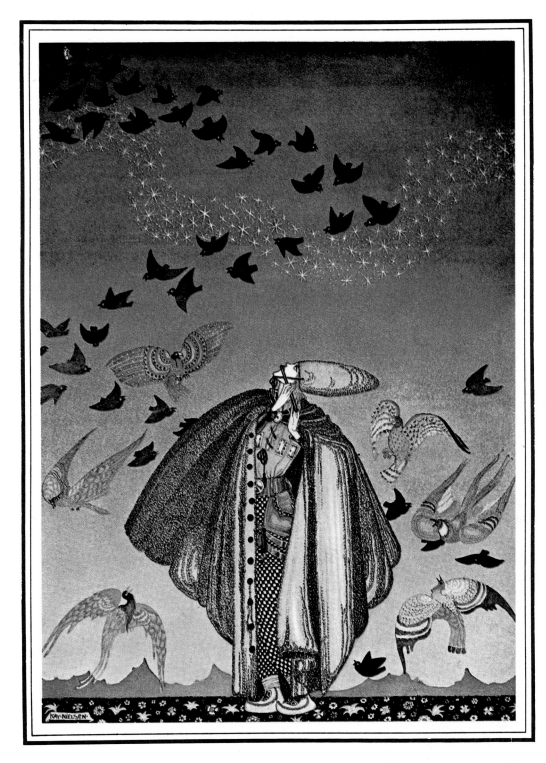

KAY NIELSEN 'No sooner had he whistled than he heard a whizzing and a whining from all quarters, and such a flock of birds swept down that they blackened all the field in which they settled.' Illustration to *The Princess in the Blue Mountain* from *East of the Sun and West of the Moon, Old Tales from the North* by P. C. Asbjörnsen and J. I. Moe (Hodder & Stoughton, 1914).

Left EDMUND DULAC 'The cup of wine which she gives him each night contains a sleeping draught.' Original illustration to *The Story of the King of the Ebony Isles* from *Stories from The Arabian Nights*, retold by Laurence Housman (Hodder & Stoughton, 1907).

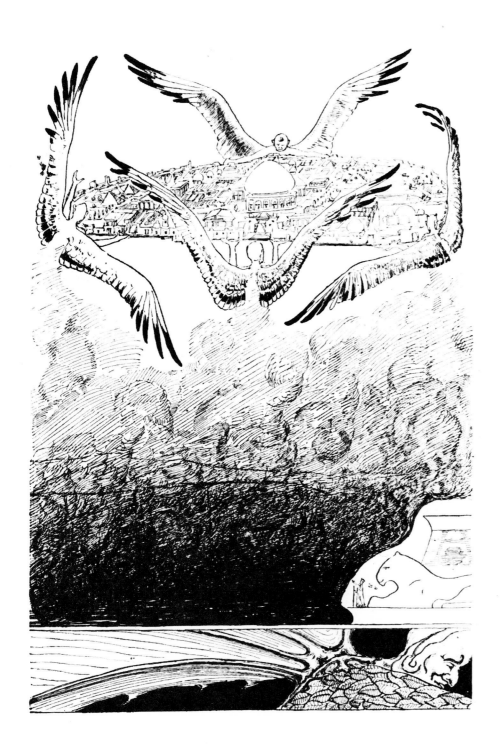

RUDYARD KIPLING 'This is the picture of the four
gull-winged Djinns lifting up Suleiman-bin-Daoud's Palace
the very minute after the Butterfly had stamped . . .'
Illustration to *The Butterfly That Stamped* from *Just So Stories*
by Rudyard Kipling (Macmillan, 1902).

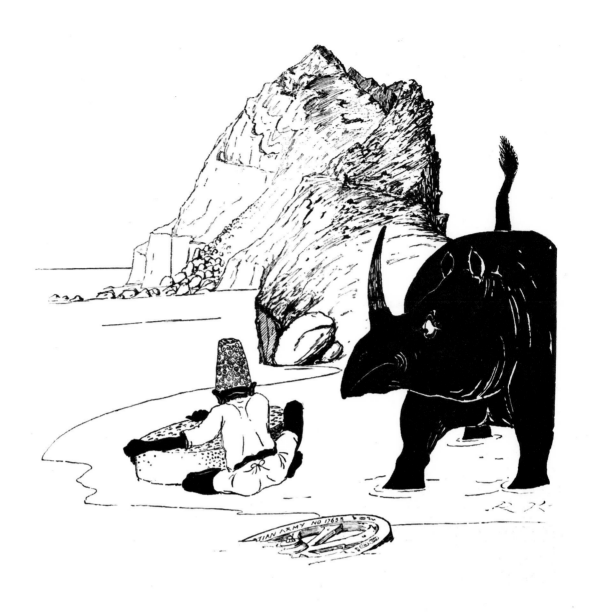

RUDYARD KIPLING 'This is a picture of the Parsee beginning to eat his cake on the Uninhabited Island in the Red Sea on a very hot day; and of the Rhinoceros coming down from the Altogether Uninhabited Interior, which, as you can truthfully see, is all rocky . . .' Illustration to *How the Rhinoceros Got His Skin* from *Just So Stories* by Rudyard Kipling (Macmillan, 1902).

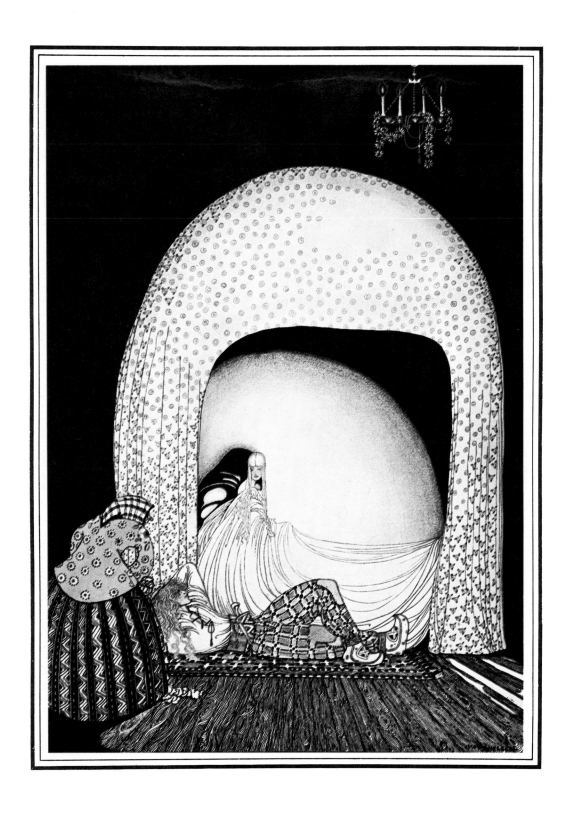

KAY NIELSEN 'And this time she whisked off the wig, and
there lay the lad, so lovely, and white and red, just as the
Princess had seen him in the morning sun.' Illustration for
The Widow's Son from *East of the Sun and West of the Moon,
Old Tales of the North* by P. C. Asbjörnsen and J. I. Moe
(Hodder & Stoughton, 1914).

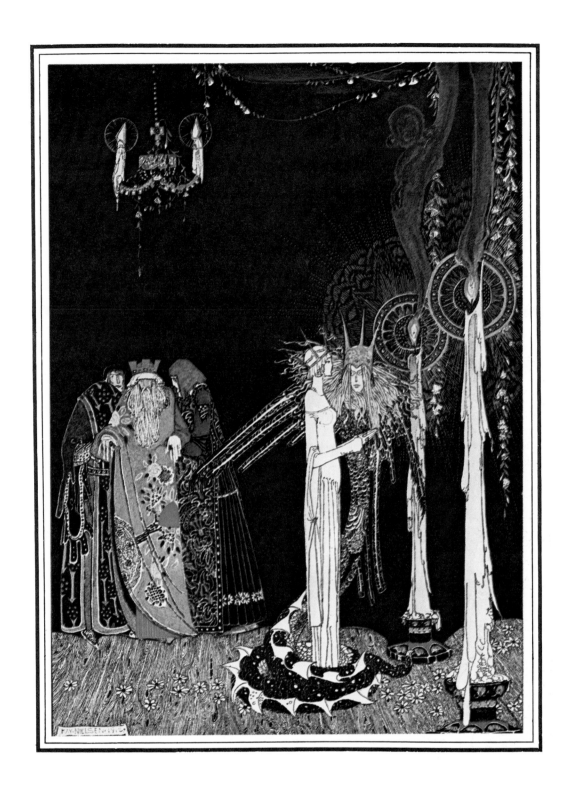

KAY NIELSEN 'She saw the Lindworm for the first time as he came and stood by her side.' Illustration to *Prince Lindworm* from *East of the Sun and West of the Moon, Old Tales from the North* by P. C. Asbjörnsen and J. I. Moe (Hodder & Stoughton, 1914).

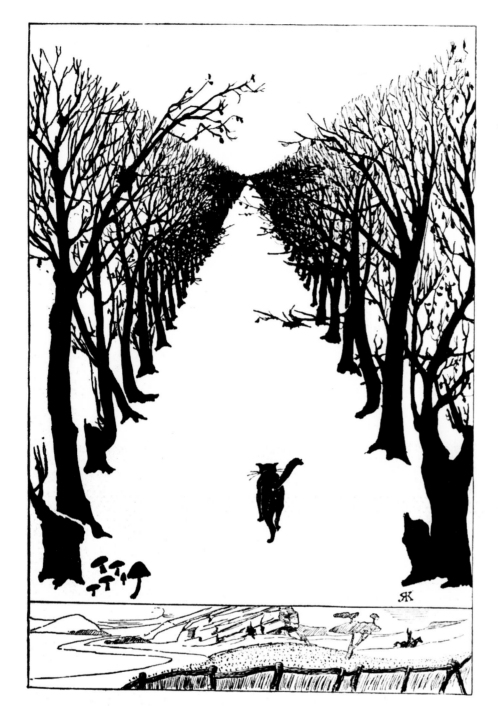

RUDYARD KIPLING 'This is the picture of the Cat that Walked by Himself, walking by his wild lone through the Wet Wild Woods and waving his wild tail . . .' Illustration to *The Cat That Walked By Himself* from *Just So Stories* by Rudyard Kipling (Macmillan, 1902).

RUDYARD KIPLING 'This is the picture of Pan Amma the Crab rising out of the sea as tall as the smoke of three volcanoes . . .' Illustration to *The Crab That Played* from *Just So Stories* by Rudyard Kipling (Macmillan, 1902).

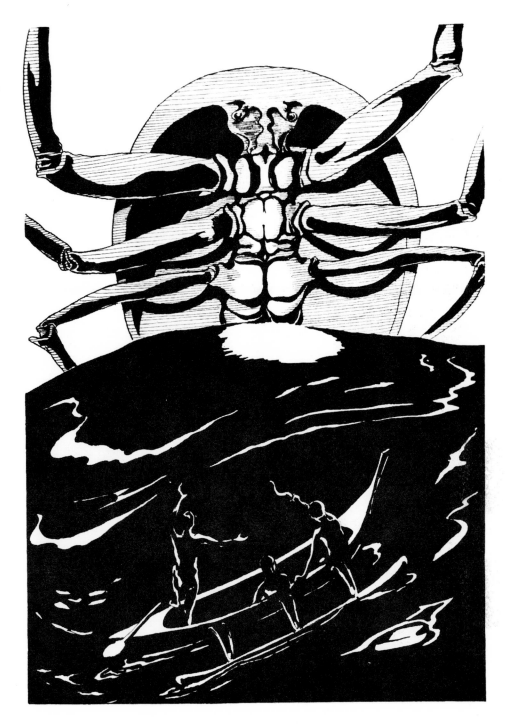

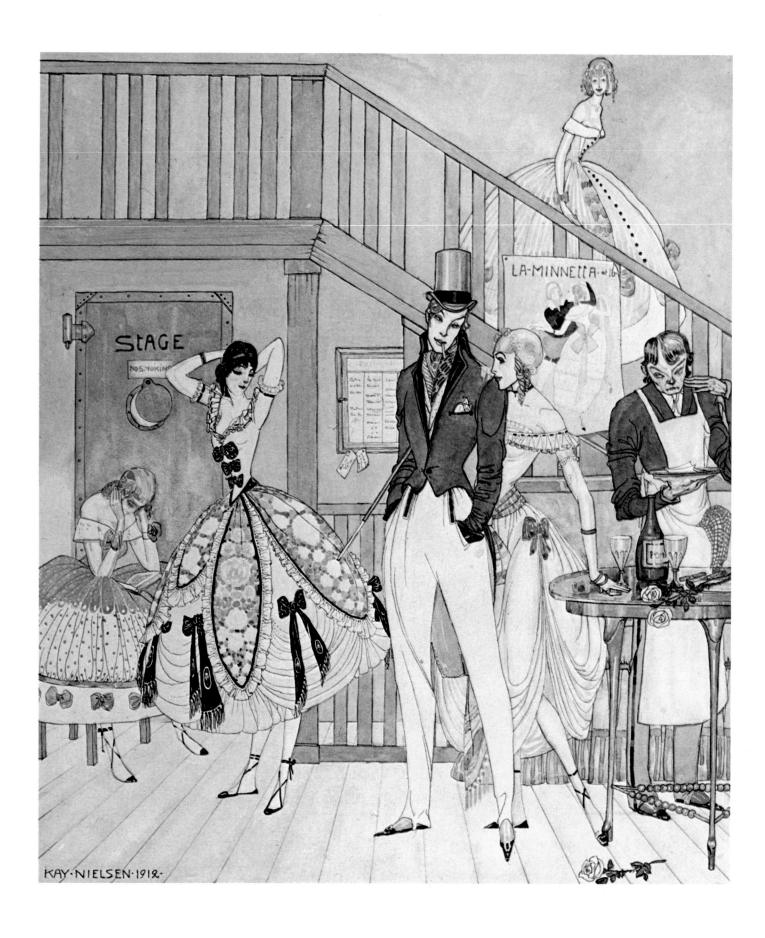

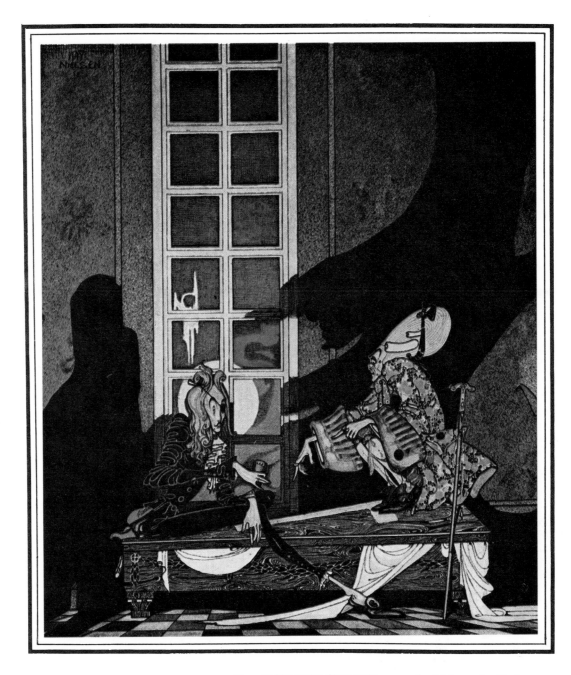

Above KAY NIELSEN ' "Your soul—! My soul—!" they kept saying in hollow tones, according as they won or lost.' Illustration to *John and the Ghosts* from *In Powder and Crinoline, Old Fairy Tales*, retold by Sir Arthur Quiller-Couch (Hodder & Stoughton, 1913).

Left KAY NIELSEN Unpublished illustration to *The Man that never Laughed* for *In Powder and Crinoline, Old Fairy Tales*, retold by Sir Arthur Quiller-Couch (Hodder & Stoughton, 1913).

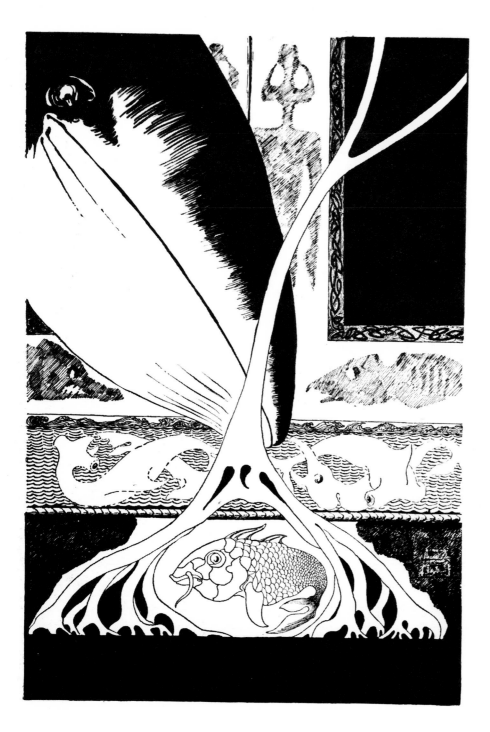

RUDYARD KIPLING 'Here is the Whale looking for the little 'Stute Fish, who is hiding under the Doorsills of the Equator . . .' Illustration to *How The Whale Got His Throat* from *Just So Stories* by Rudyard Kipling (Macmillan, 1902).

RUDYARD KIPLING 'This is the picture of the Animal that came out of the sea and ate up all the food that Suleiman-bin-Daoud had made ready for all the animals in all the world . . .' Illustration to *The Butterfly That Stamped* from *Just So Stories* by Rudyard Kipling (Macmillan, 1902).

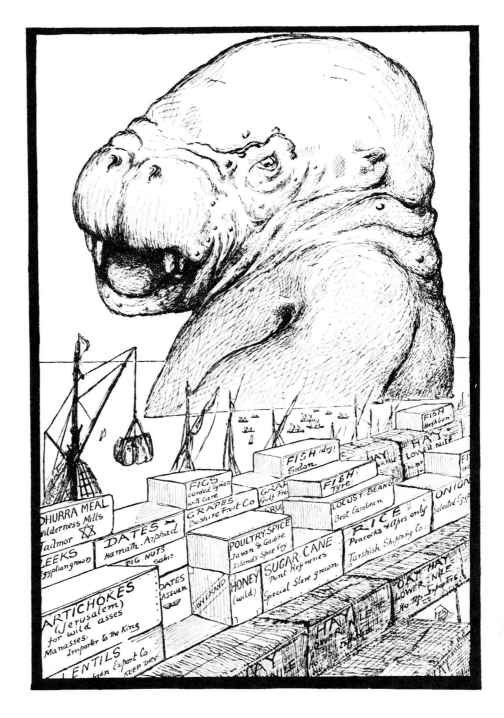

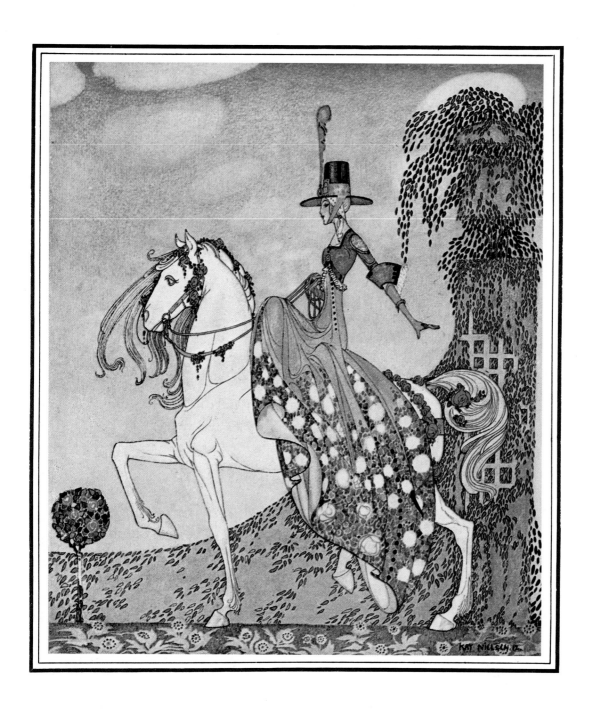

KAY NIELSEN 'Princess Minon-Minette rides out in the
world to find Prince Souci.',Illustration to *Minon-Minette*
from *In Powder and Crinoline, Old Fairy Tales*, retold by Sir
Arthur Quiller-Couch (Hodder & Stoughton, 1913).

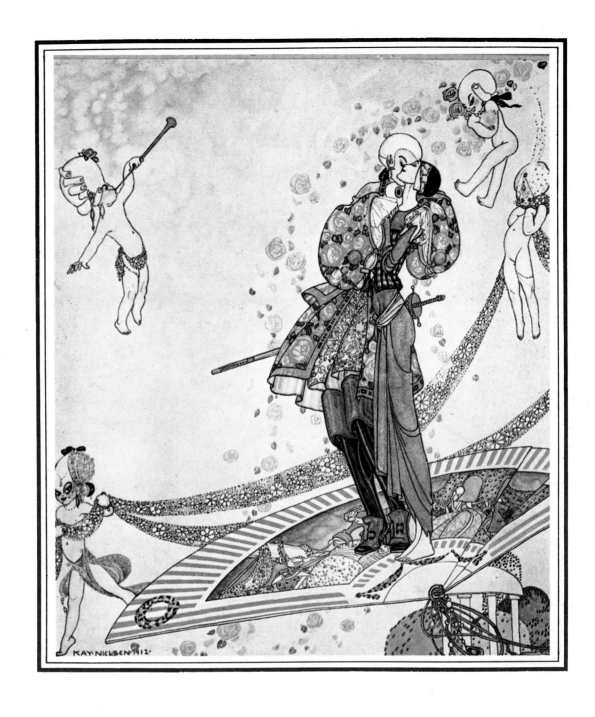

KAY NIELSEN 'Prince Souci and Princess Minon-Minette
on the fan with a cupid.' Illustration to *Minon-Minette* from
In Powder and Crinoline, Old Fairy Tales, retold by Sir Arthur
Quiller-Couch (Hodder & Stoughton, 1913).

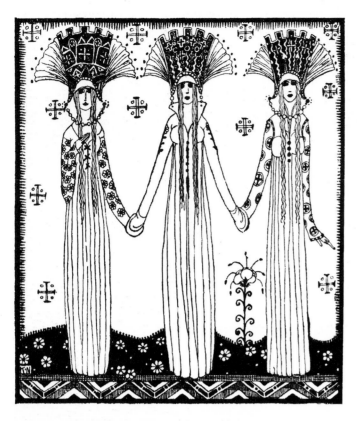 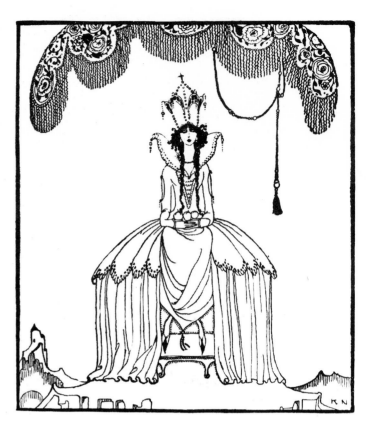

KAY NIELSEN 'The Three Princesses' tor *Soria Maria Castle* (*above*) and 'The Princess on the Glass Hill' for *The Giant who had no heart in his body* (*above right*). From *East of the Sun and West of the Moon, Old Tales from the North* by P. C. Asbjörnsen and J. I. Moe (Hodder & Stoughton, 1914).

Left KAY NIELSEN Headpiece to list of illustrations for *In Powder and Crinoline, Old Fairy Tales*, retold by Sir Arthur Quiller-Couch (Hodder & Stoughton, 1913).

Opposite VERNON HILL 'Alison Gross' from *Ballads Weird & Wonderful* by R. P. Chope (John Lane, 1912).

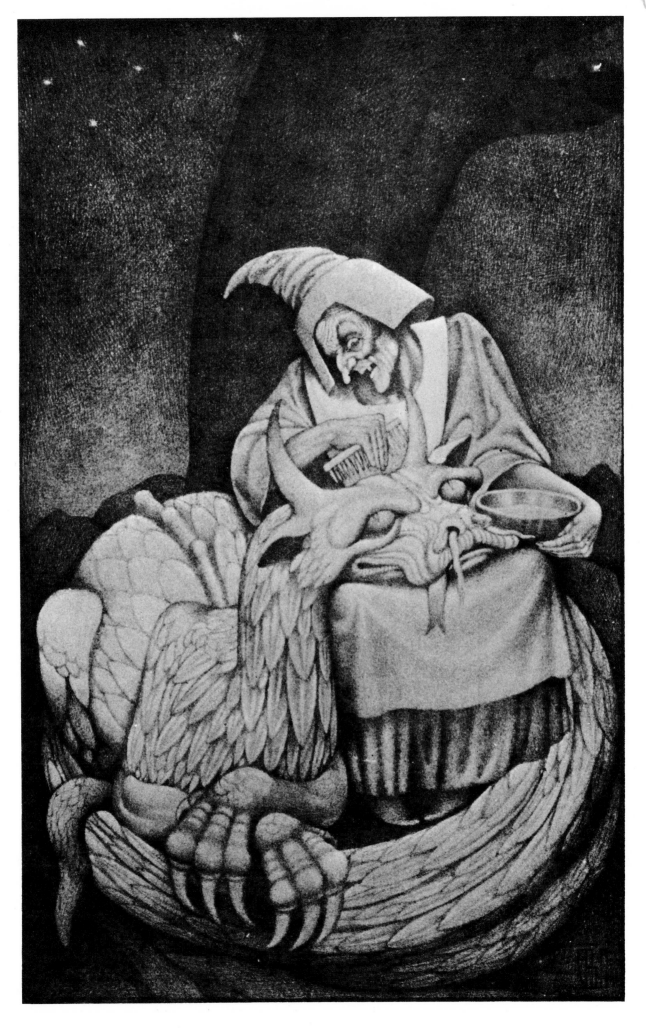

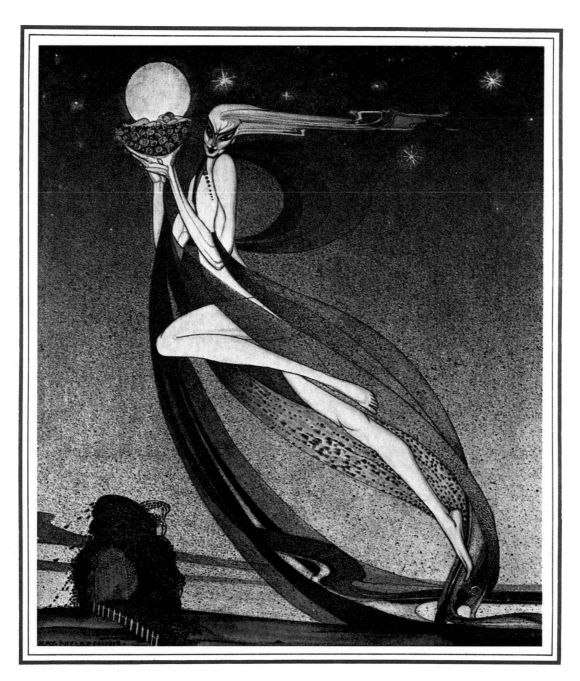

KAY NIELSEN 'This good fairy placed her own baby in
the cradle of roses and gave command to the zephyrs to
carry him to the tower.' Illustration to *Felicia* from *In Powder
and Crinoline*, *Old Fairy Tales*, retold by Sir Arthur Quiller-
Couch (Hodder & Stoughton, 1913).

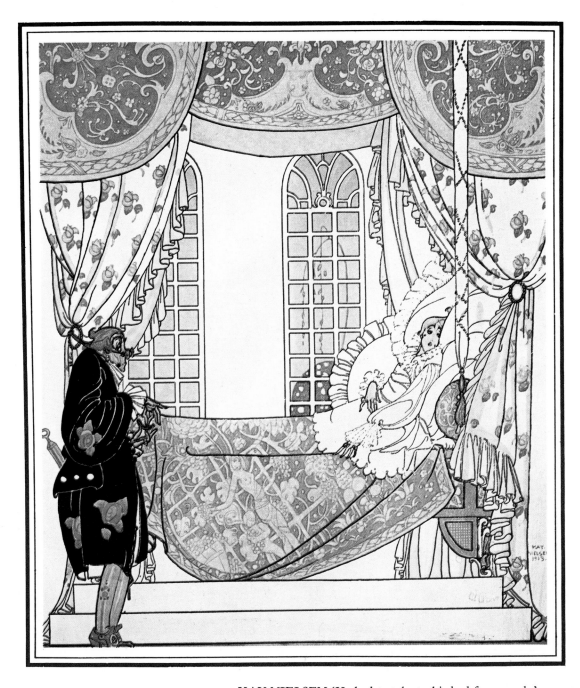

KAY NIELSEN 'He had to take to his bed for a week.'
Illustration to *Minon-Minette* from *In Powder and Crinoline,*
Old Fairy Tales, retold by Sir Arthur Quiller-Couch (Hodder
& Stoughton, 1913).

Overleaf, p 158
VERNON HILL
Hither are brought, or hither of free will
Spirits repair·who still by old desires
And sensual yearnings to the earth are bound
With difficulty to divest themselves and pain.
Illustration to Canto vii, *The New Inferno* by Stephen
Phillips (John Lane, 1911).

Overleaf, p 159
VERNON HILL
On passing to an open space we came.
Where flared a raging fire, and one within
Burned, and in flickering flame writhed to and fro,
Around him spirits danced in furious glee.
Illustration to Canto viii, *The New Inferno* by Stephen
Phillips (John Lane, 1911).

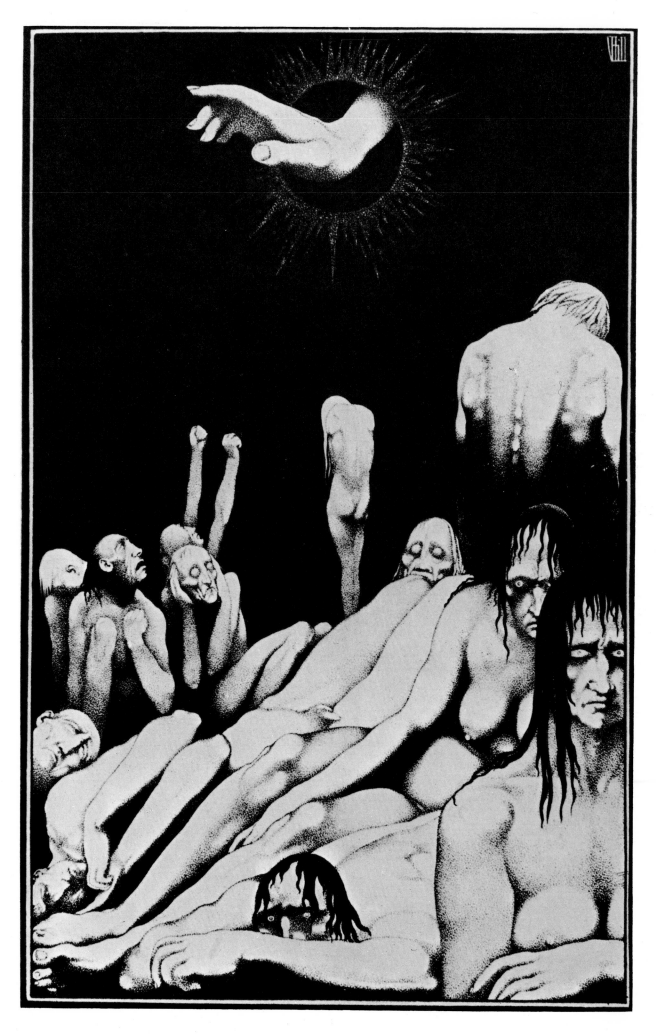

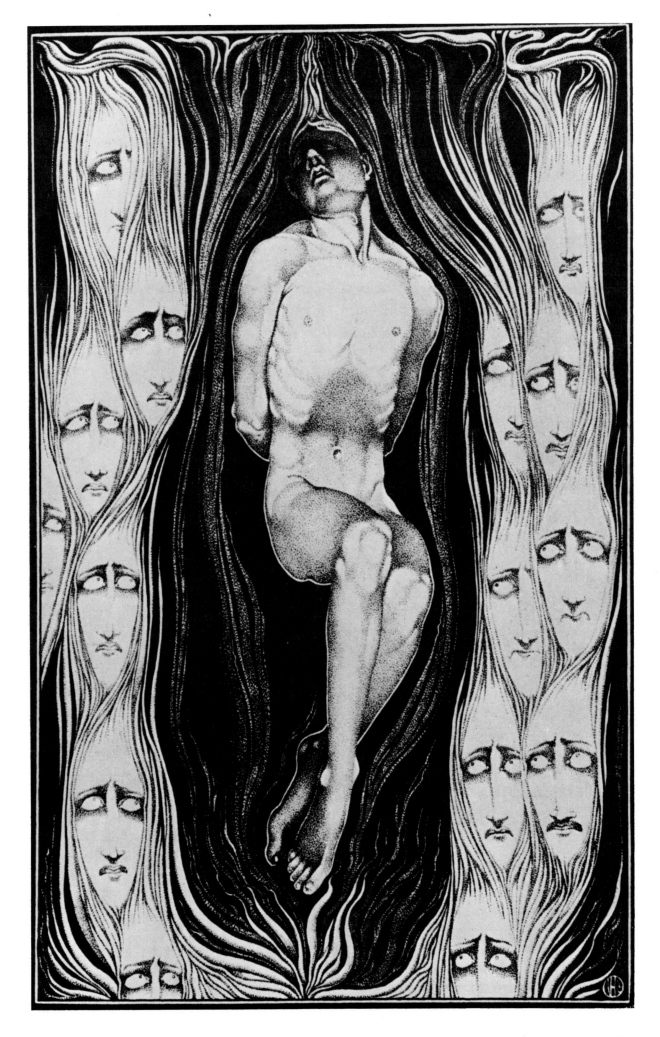

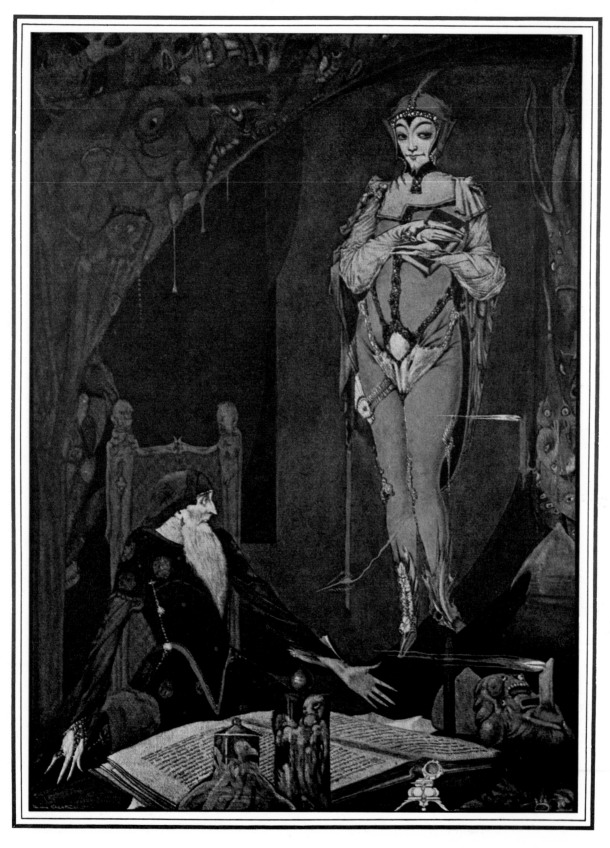

HARRY CLARKE 'Is there anything in my poor power to serve you?' From *Faust* by J W. von Goethe, translated by John Anster (Harrap, 1925).

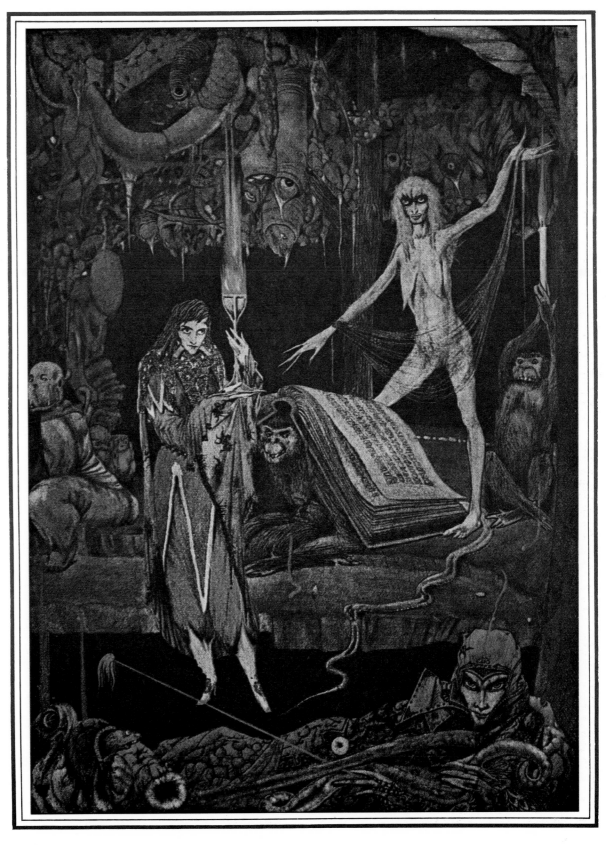

HARRY CLARKE 'Methinks, a million fools in choir/
Are raving and will never tire.' From *Faust* by J. W. von
Goethe, translated by John Anster (Harrap, 1925).

Overleaf VERNON HILL 'The Demon Lover' (*left*) and
'The Merman' from *Ballads Weird & Wonderful* by R. P.
Chope (John Lane, 1912).

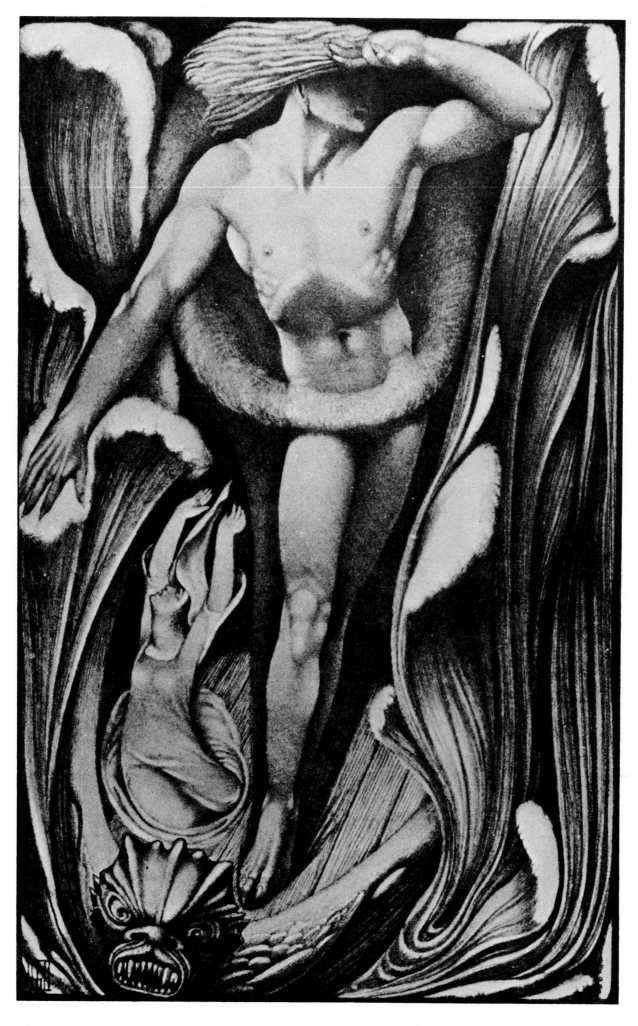

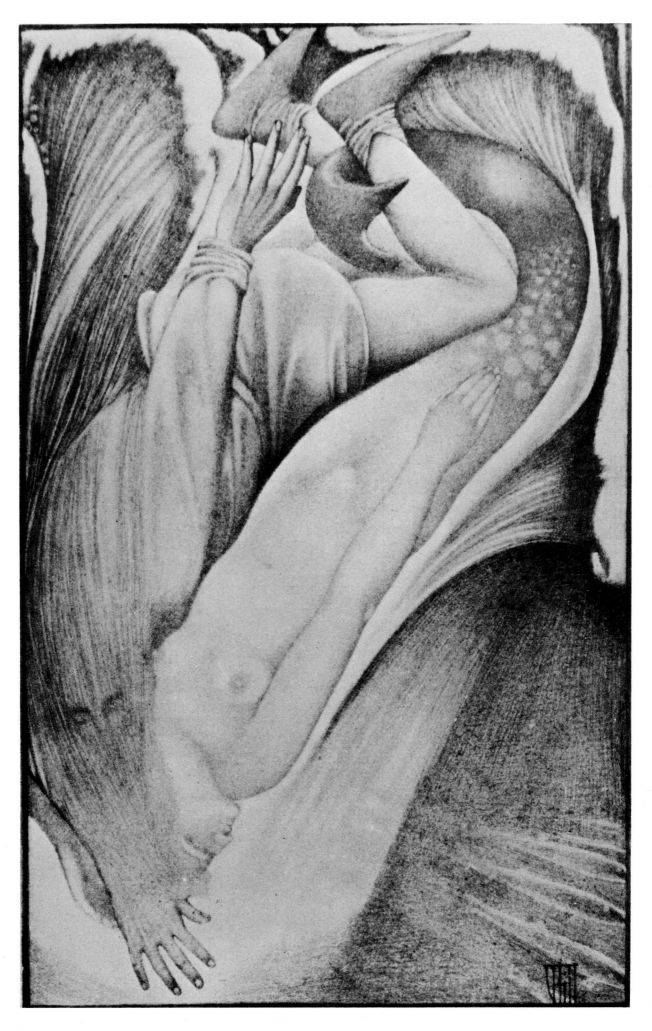

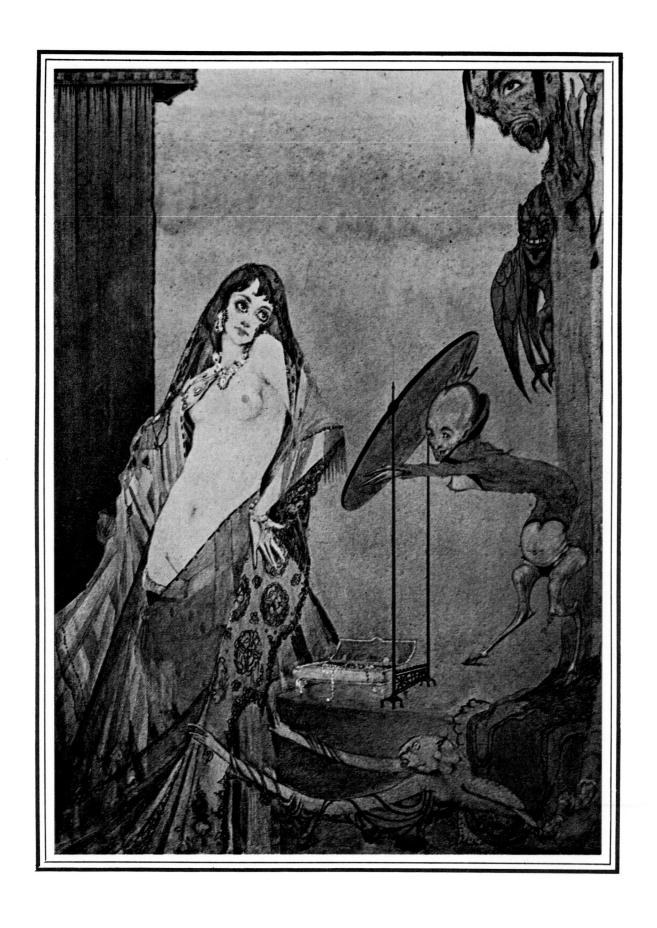

HARRY CLARKE 'Drest thus, I seem a different creature!'
From *Faust* by J. W. von Goethe, translated by John
Anster (Harrap, 1925).

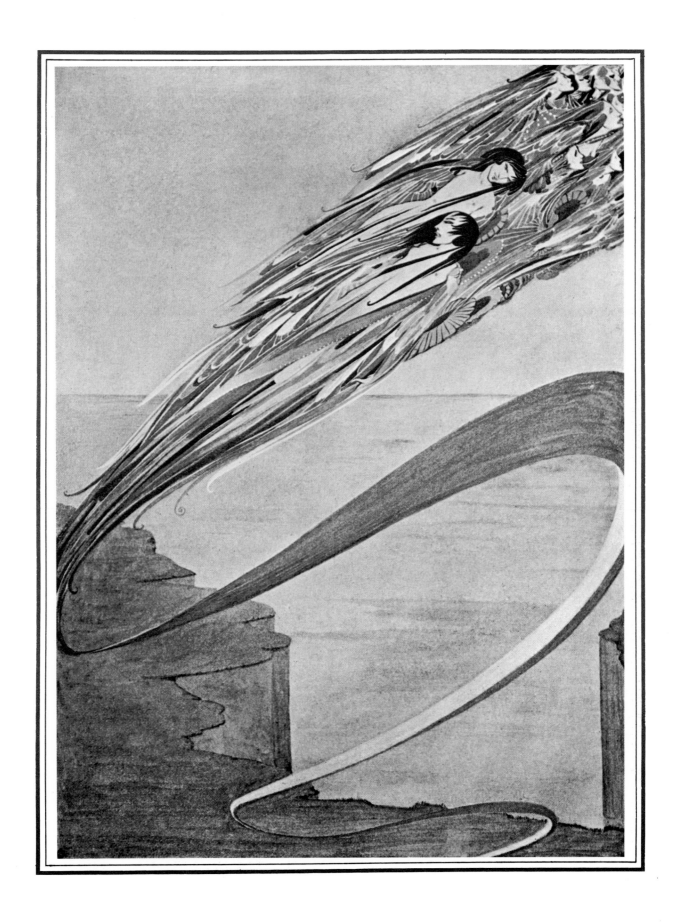

HARRY CLARKE 'I am born of a thousand storms, and grey with rushing rains.' Illustration to *All is Spirit and Part of Me* by L. D'O. Walters from *The Year's at the Spring*, an anthology of poems compiled by Lettice D'O. Walters (Harrap, 1920).

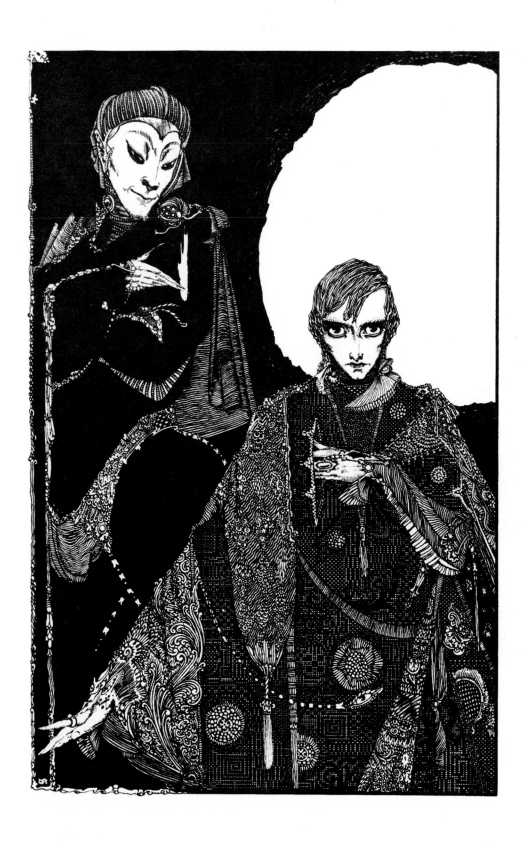

HARRY CLARKE 'I wish you had something else to do than thus torment me when I am quiet.' From *Faust* by J. W. von Goethe, translated by John Anster (Harrap, 1925).

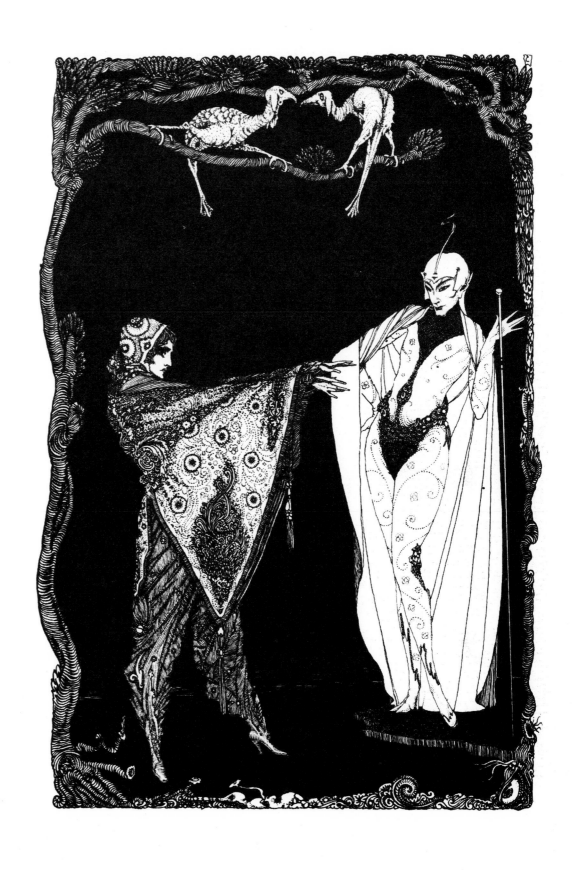

HARRY CLARKE 'Ay! Roll the devil eyes furiously round in thy head!' From *Faust* by J. W. von Goethe, translated by John Anster (Harrap, 1925).

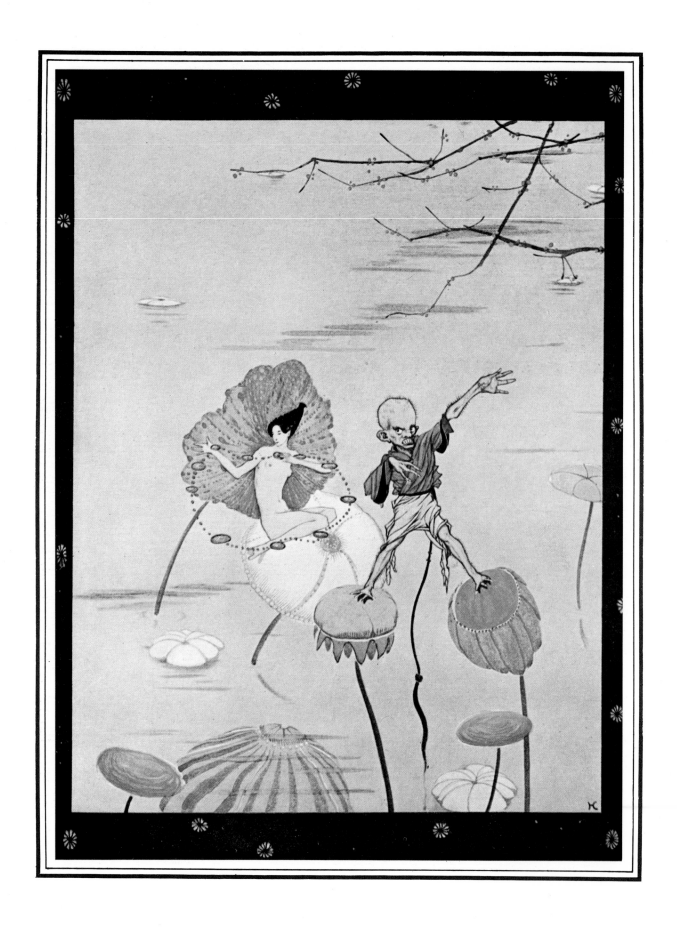

HARRY CLARKE ' "Give me your beads. I desire them."
"No." ' Illustration to *Overheard on a Saltmarsh* by Harold
Monro from *The Year's at the Spring*, an anthology of poems
compiled by Lettice D O. Walters (Harrap, 1920).

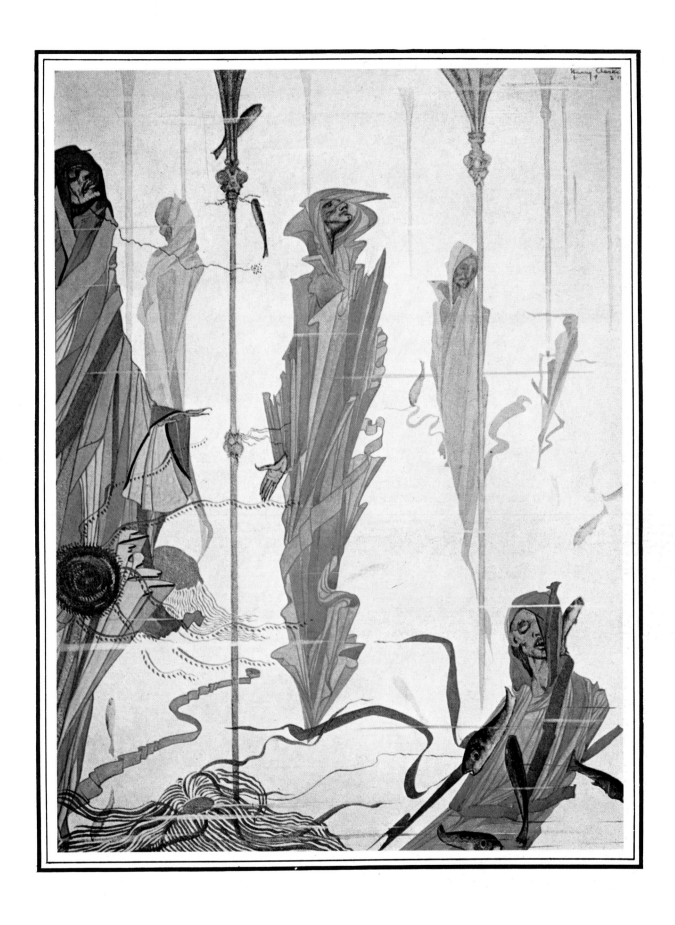

HARRY CLARKE 'And the dead robed in red and sea-lilies overhead sway when the long winds blow.' Illustration to *The Dying Patriot* by James Elroy Flecker from *The Year's at the Spring*, an anthology of poems compiled by Lettice D'O. Walters (Harrap, 1920).

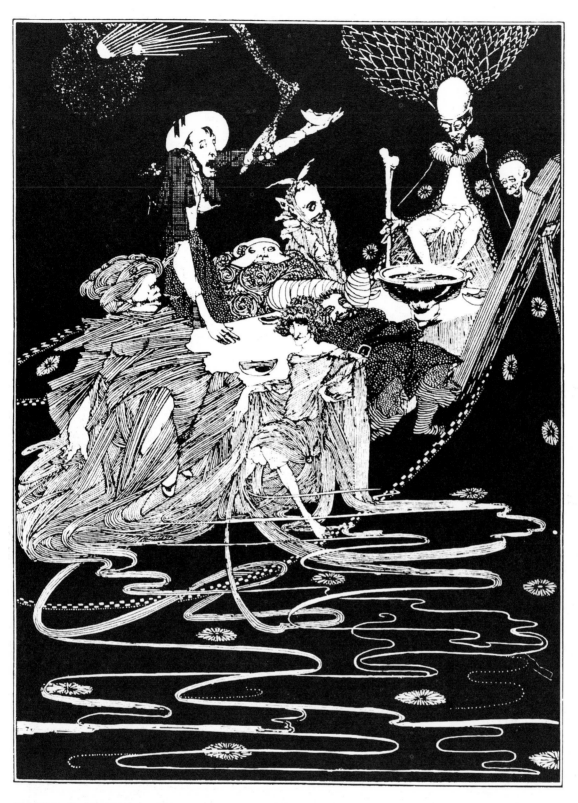

HARRY CLARKE 'Avast there a bit, I say, and tell us who the devil ye all are.' Illustration to *King Pest* from *Tales of Mystery & Imagination*

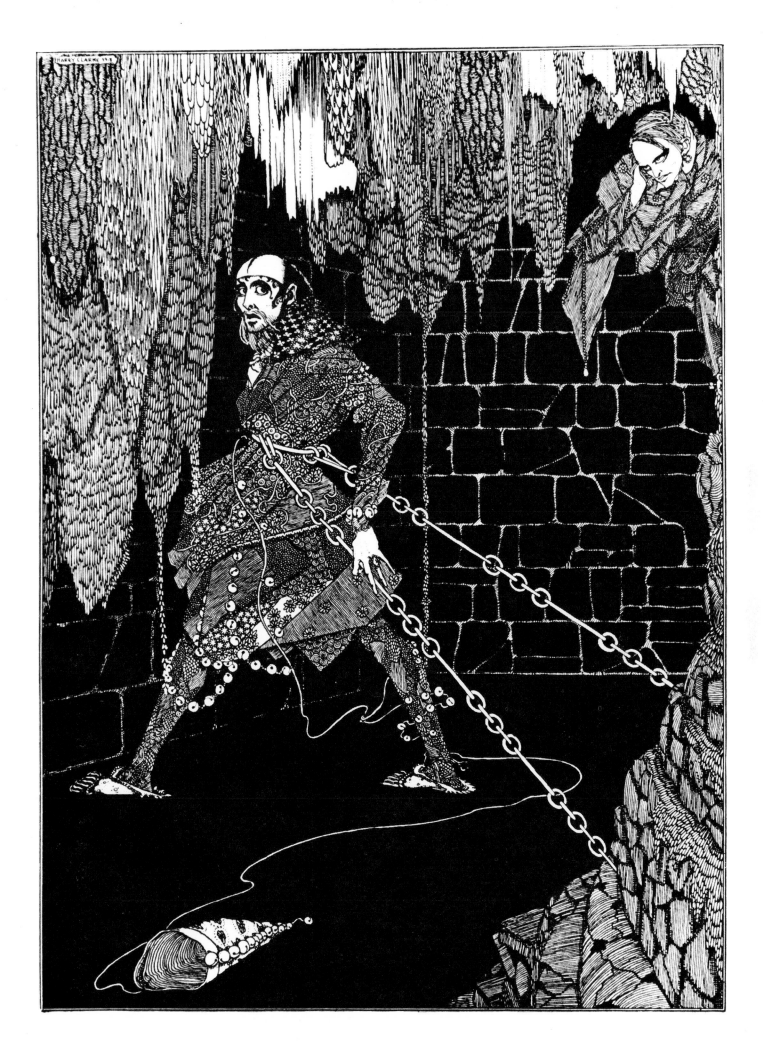

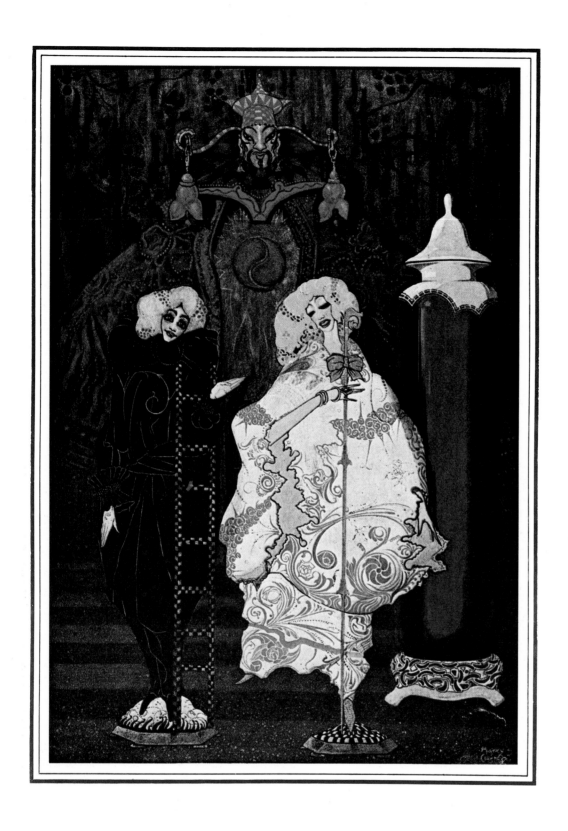

HARRY CLARKE 'The whole day they flew onward
through the air.' Illustration to *The Wild Swans* from *Fairy
Tales* by Hans Andersen (Harrap, 1916).

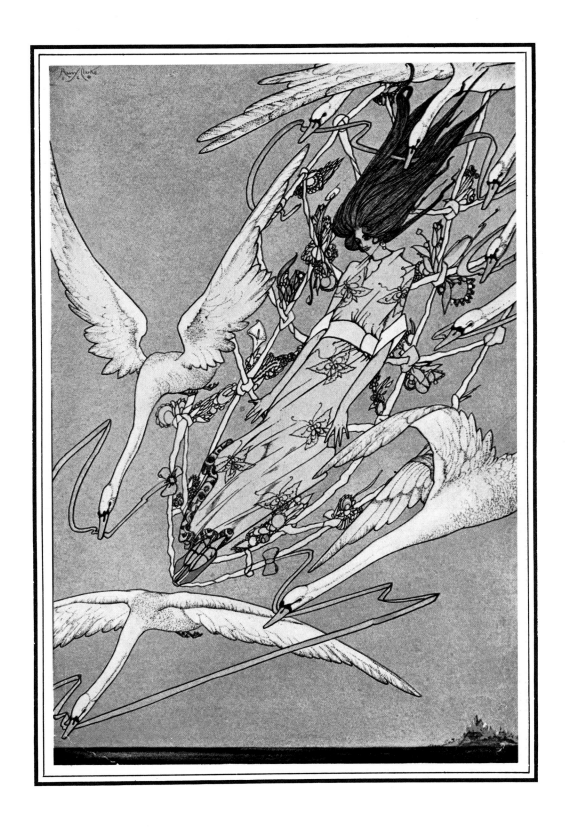

HARRY CLARKE ' "Have you really the courage to go into
the wide world with me?" asked the chimney-sweeper.'
Illustration to *The Shepherdess and the Chimney-sweeper* from
Fairy Tales by Hans Andersen (Harrap, 1916).

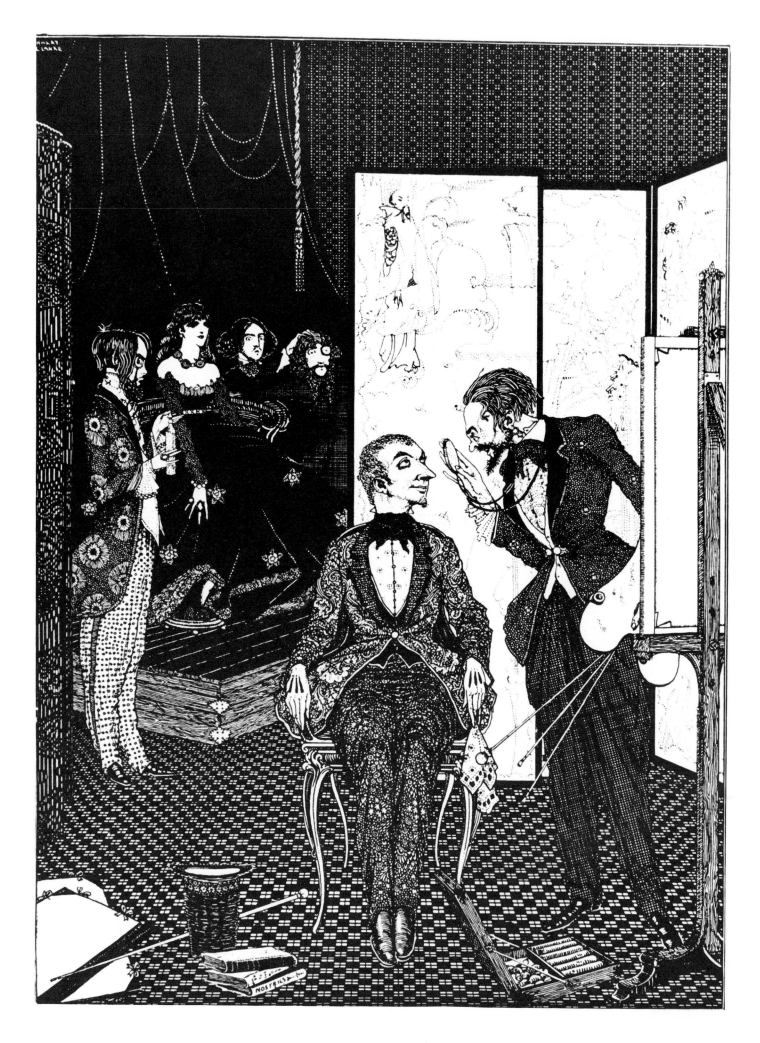

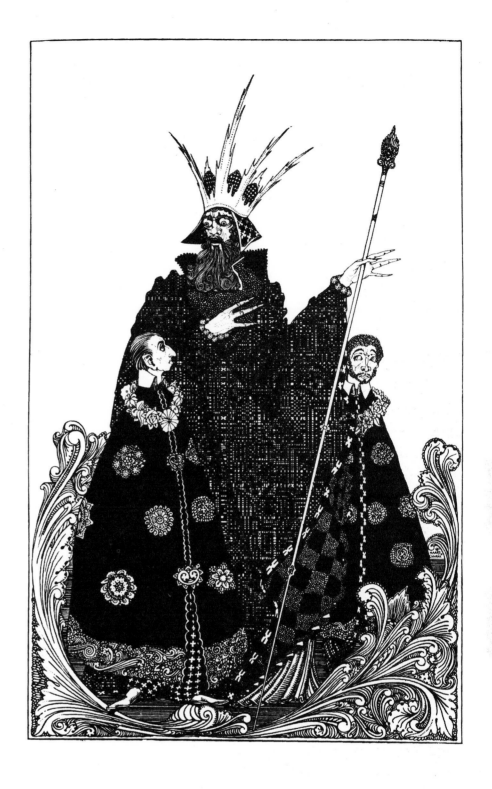

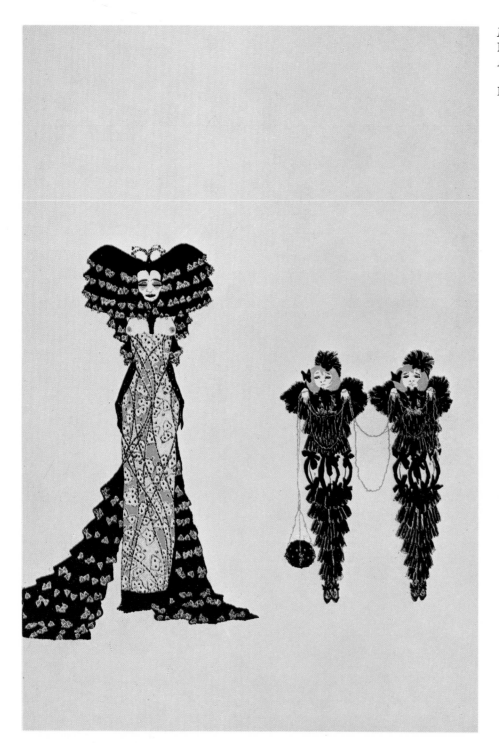

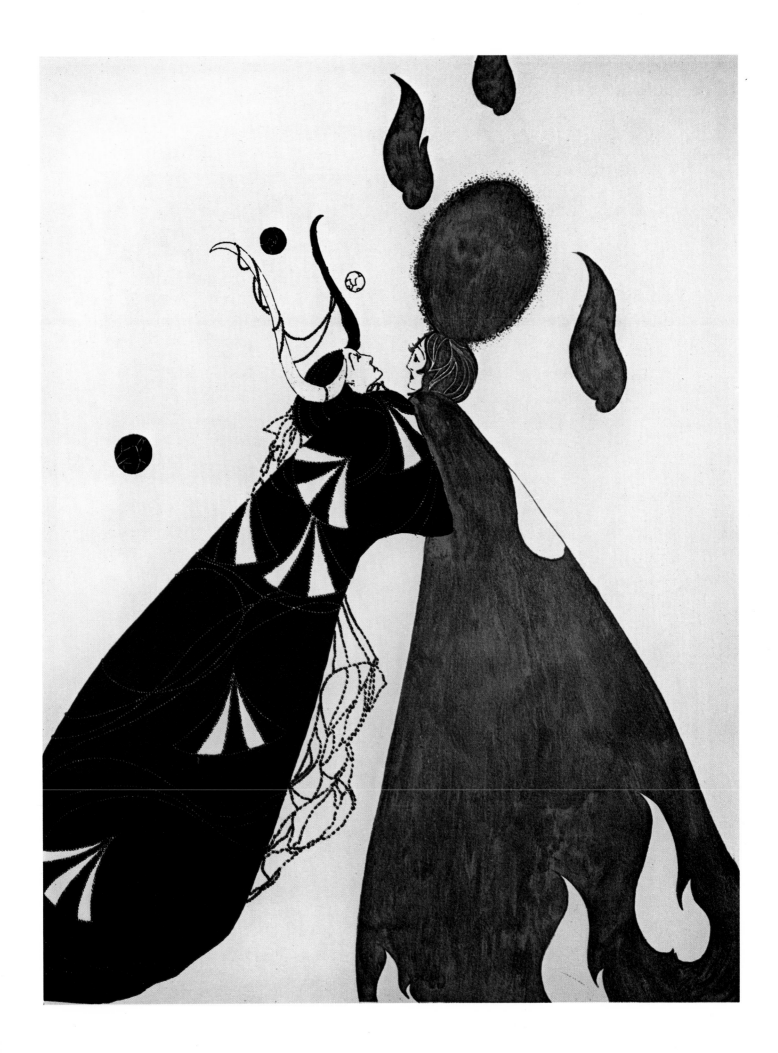

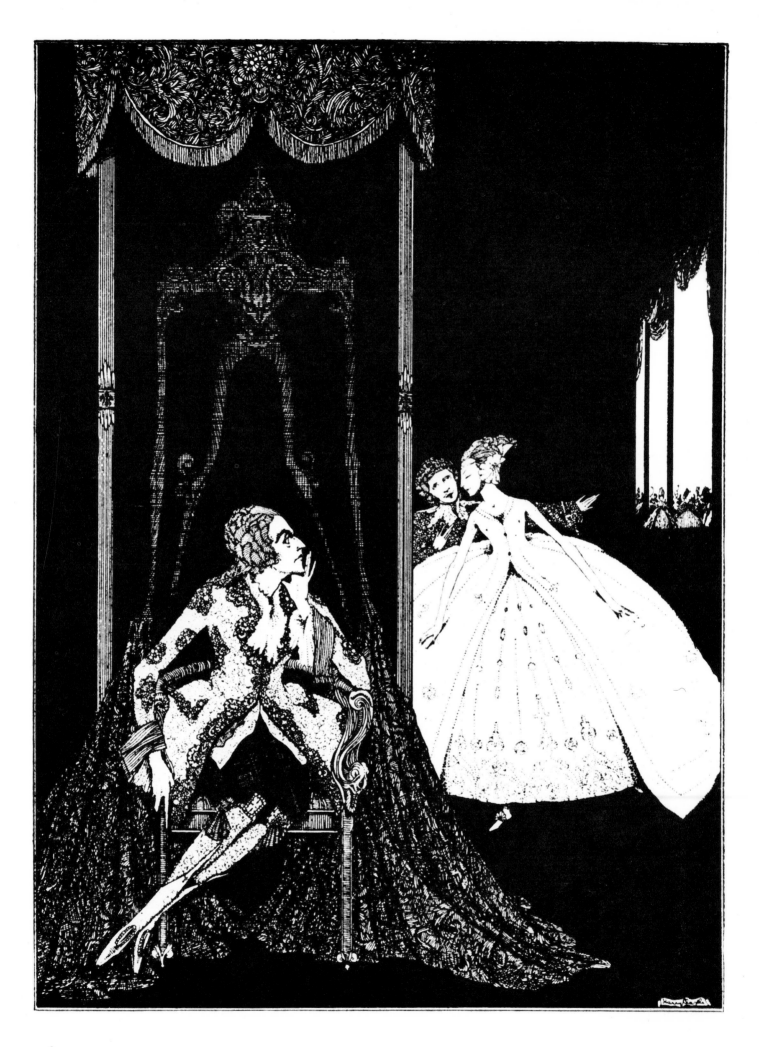

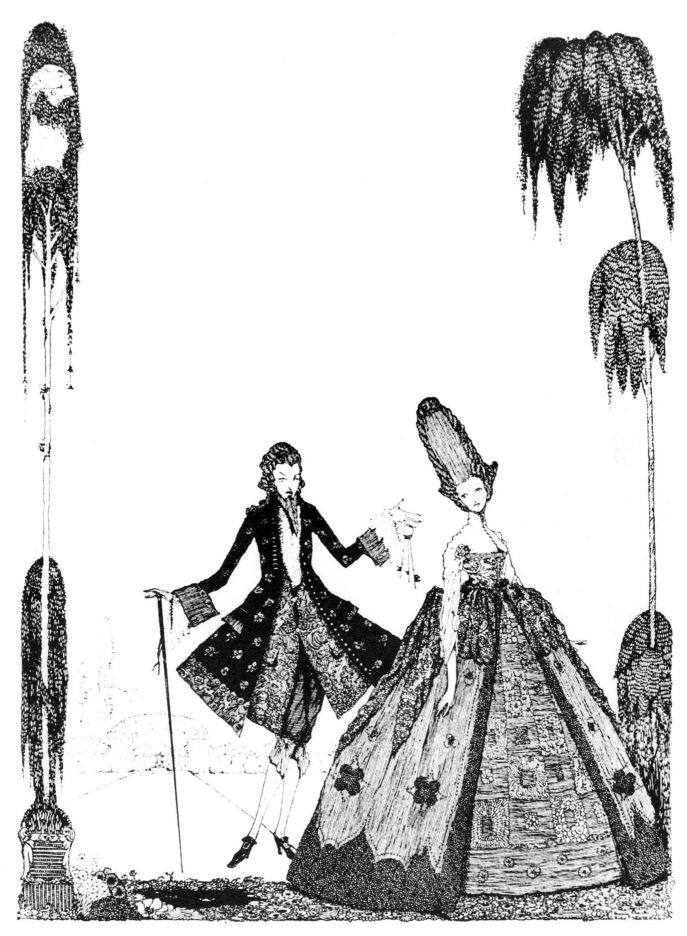

HARRY CLARKE 'He thought the Princess was his Queen'
for *Donkeyskin* (*left*) and 'What, is not the key of my closet
among the rest?' for *Bluebeard* (*above*). From *Fairy Tales of
Charles Perrault* with an introduction by Thomas Bodkin
(Harrap, 1922).

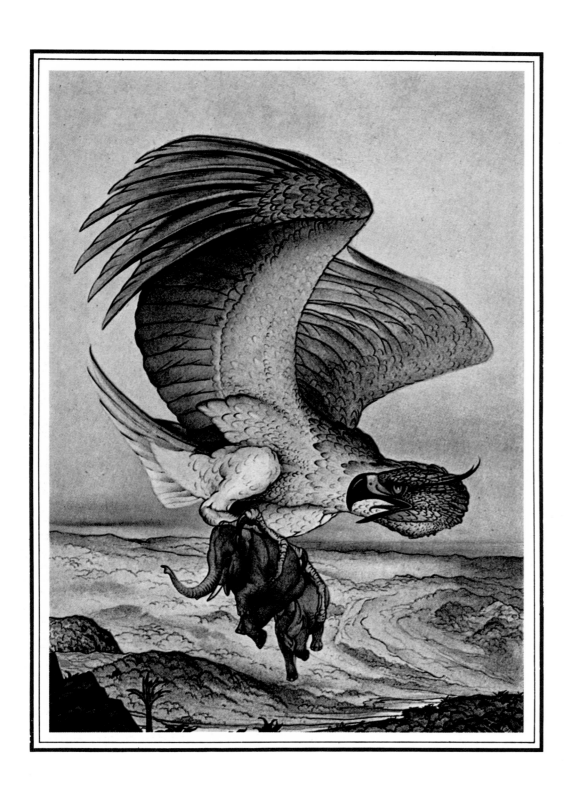

E. J. DETMOLD 'The Rukh which fed its young on
elephants.' Illustration to *The Second Voyage of Sinbad the
Sailor* from *The Arabian Nights* (Hodder & Stoughton, 1924).

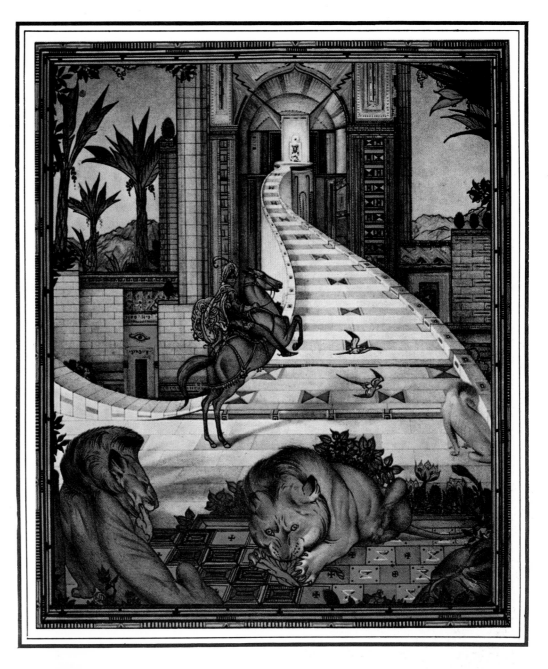

E. J. DETMOLD 'Whilst they were yet devouring the meat, he hastily filled his flagon.' Illustration to *The Story of Prince Assad* from *The Arabian Nights* (Hodder & Stoughton, 1924)

ALASTAIR 'The Young Widow', illustration to *Erdgeist* by Frank Wedekind. From *Forty Three Drawings*, with a note of exclamation by Robert Ross (John Lane, 1914).

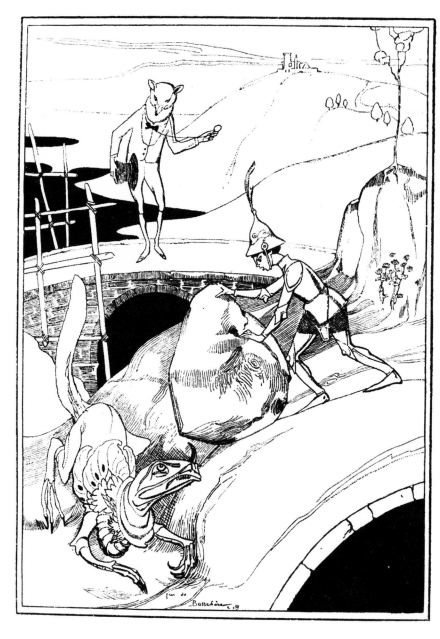

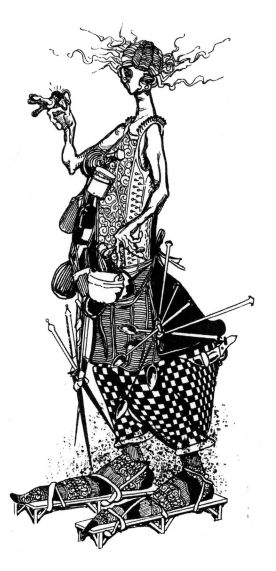

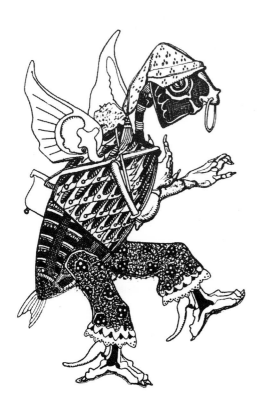

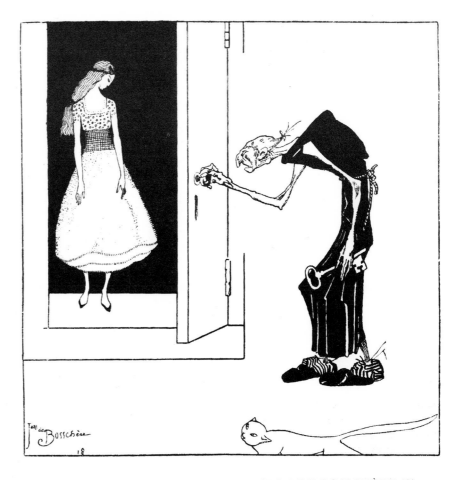

JEAN DE BOSSCHÈRE 'The Elder of the Fishes' from *The City Curious*, retold in English by F. Tennyson Jesse (Heinemann, 1920).

Above JEAN DE BOSSCHÈRE 'She meant to keep her there until she had grown bigger and fatter.' Illustration to *The Witch's Cat* from *Beasts and Men, Folk Tales Collected in Flanders* (Heinemann, 1918).

Below JEAN DE BOSSCHÈRE 'An Extremely Curious Fish' from *The City Curious*, retold in English by F. Tennyson Jesse (Heinemann, 1920).

Above JEAN DE BOSSCHERE 'An immense dragon lying by the water-side.' Illustration to *The Reward of the World* from *Beasts and Men, Folk Tales Collected in Flanders* (Heinemann, 1918).

Right JEAN DE BOSSCHÈRE 'Mistigris' from *The City Curious*, retold in English by F. Tennyson Jesse (Heinemann, 1920).

Notes on Illustrators

Titles marked with an asterisk are written by the illustrator.

ALASTAIR (pseudonym of Hans Henning Voight)
Of English, Spanish and Russian extraction. Lived mostly in Germany. Self-taught draughtsman. According to Robert Ross, was born c1889. In *Dreamers of Decadence*, Philippe Jullian claims that he 'lived to nearly a hundred'. Avowed Decadent, interested in black magic and transvestism.
Forty-three Drawings by Alastair, with a note of exclamation by Robert Ross, 1914
The Sphinx, Oscar Wilde, 1920
Sebastian van Storck, Walter Pater, 1927
Manon Lescaut, A. F. Prévost d'Exiles, 1928 (with others)
Dangerous Acquaintances, P. A. F. Choderlos de Laclos, 1933

BATTEN, John Dickson (1860–1932)
Born in Plymouth, Devon. Studied under Alphonse Legros at Slade School of Fine Art, London. Exhibited at Royal Academy, 1891–98. Painter of genre and historical subjects in tempera (influenced by 14th-century Italians, especially Carlo Crivelli), murals (e.g. at Christ Church, Lichfield); etcher, poet, and authority on man-powered flight.
Oedipus the Wreck, Owen Seamen, 1888 (with L. Speed)
English Fairy Tales, 1890, *Celtic Fairy Tales*, *Indian Fairy Tales*, 1892, ed. Joseph Jacobs
Fairy Tales from the Arabian Nights, ed. E. Dixon, 1893
More English Fairy Tales, *More Celtic Fairy Tales*, ed. Joseph Jacobs, 1894
More Fairy Tales from the Arabian Nights, ed. E. Dixon, 1895
A Masque of Dead Florentines, Maurice Hewlett, 1895
A Book of Wonder Voyages, ed. Joseph Jacobs, 1896
The Saga of the Sea-Swallow and Greenfeather the Changeling, M. Dickson, 1896.
Dante's Inferno, Spencerian Stanza version by George Musgrave, 1933.

BEARDSLEY, Aubrey Vincent (1872–98)
Born and educated in Brighton, Sussex. Clerk in City of London, 1888–92. Encouraged by Edward Burne-Jones to train as a professional artist. Attended evening classes at Westminster School of Art briefly in 1891. Work featured in first issue of *The Studio*, 1893. Art editor of *The Yellow Book* (published by John Lane), 1894–95; dismissed after arrest of Oscar Wilde. Co-founder (with Arthur Symons) of *The Savoy* (published by Leonard Smithers) in 1896. Rapid deterioration in health from 1896. Died at Menton, France.
Le Morte D'Arthur, Sir Thomas Malory, 1893
Bon-Mots, 1893
Salomé, Oscar Wilde, 1894
The Rape of the Lock, Alexander Pope, 1896
The Lysistrata of Aristophanes, 1896
A Book of Fifty Drawings, 1897
The Pierrot of the Minute, Ernest Dowson, 1897
Mlle de Maupin, Théophile Gautier, 1898
Volpone, or the Foxe, Ben Jonson, 1898

BEDFORD, Francis Donkin (b. 1864)
Born in London. Trained as architect at South Kensington and Royal Academy Architectural Schools. Articled to Sir Arthur Blomfield RA. Turned to illustration in 1880s. Exhibited at Royal Academy, 1892. Landscape painter and topographical illustrator.
The Battle of the Frogs and the Mice, trans. J. Barlow, 1894
Old English Fairy Tales, S. Baring-Gould, 1895
A Book of Nursery Rhymes, 1897
The Vicar of Wakefield, Oliver Goldsmith, 1898
Henry Esmond, W. M. Thackeray, 1898
The Book of Shops, E. V. Lucas, 1899
Four and Twenty Toilers, E. V. Lucas, 1905
'Original Poems' and others, A. and J. Taylor, 1903
Two are Company, Louise Field, 1905
Old Fashioned Tales, E. V. Lucas, 1905

*A Night of Wonders**, 1906
Forgotten Tales of Long Ago, E. V. Lucas, 1906
A Book of Verses for Children, E. V. Lucas, 1907
Runaways and Castaways, E. V. Lucas, 1908
Peter Pan and Wendy, J. M. Barrie, 1911
The Magic Fishbone, Charles Dickens, 1921
Billy Barnicote, Greville MacDonald, 1923
At the Back of the North Wind, George MacDonald, 1924
The Princess and the Goblin, George MacDonald, 1926
A Cricket on the Hearth, Charles Dickens, 1927
Count Billy, Greville MacDonald, 1928
A Christmas Carol, Charles Dickens, 1931

BELL, Robert Anning (1863–1933)
Initially articled to architect. Studied art at Westminster School of Art and Royal Academy Schools. Studied under Aimé Morot in Paris, and Sir George Frampton. Visited Italy. Taught at Liverpool University from 1894, Glasgow School of Art from 1911. Professor of Design at Royal College of Art, 1918–24. Exhibited at Royal Academy from 1885; ARA 1914, RA 1922. Master of Art Workers' Guild, 1921. Figure paintings, gesso reliefs, designs for stained glass, and mosaics (e.g. in Westminster Cathedral). Friend of architect, C. F. A. Voysey.
Jack the Giant Killer, *The Sleeping Beauty* and *Cinderella* (three titles in the Dent Banbury Cross series), 1894
A MidsummerNight's Dream, William Shakespeare, 1895
Poems by John Keats, 1897
English Lyrics from Spenser to Milton, 1898
The Pilgrim's Progress, John Bunyan, 1898
Lamb's Tales from Shakespeare, 1899
The Tempest, William Shakespeare, 1901
The Odes of John Keats, 1901
Grimm's Household Tales, 1901
Isabella and *St Agnes' Eve*, John Keats, 1902
Poems by Percy Bysshe Shelley, 1902
Ruba'iyat of Omar Khayyam, 1902
Shakespeare's Heroines, A. B. Jameson, 1905
Palgrave's Golden Treasury, 1907
English Fairy Tales, ed. Ernest Rhys, 1913 (with H. Cole)

BOSSCHERE, Jean de (1881–1953)
Born at Uccle, Belgium. Peripatetic, lengthy stays in England from 1915. Friend of French Symbolist poets, Paul Claudel and Paul Valéry, and of Ezra Pound and T. S. Eliot. Illustrations show influence of Symbolism. Etcher, wood engraver, writer and poet.
*Christmas Tales of Flanders**, 1917
*The Closed Door**, trans. F. S. Flint, 1917
*Beasts and Men**, 1918
Gulliver's Travels, Jonathan Swift, 1920
*The City Curious**, trans. F. T. Jesse, 1920
*Weird Islands**, 1921
The History of Don Quixote, 1922
The Golden Asse, Lucius Apuleius, 1923
Uncanny Stories, May Sinclair, 1923
*Job le Pauvre**, 1923
The Love Books of Ovid, 1925
The Fairies Up to Date, E. and J. Anthony, 1925
Ten Droll Tales, Honoré de Balzac, 1926
The Decameron, G. Boccaccio, 1930

BOYLE, Eleanor Vere (E. V. B.) (1825–1916)
Hon. Mrs Richard Boyle (*née* Gordon). Exhibited at Grosvenor Gallery and Dudley Gallery. Figure paintings, books on gardens.
*A Children's Summer**, 1853
The May Queen, Alfred, Lord Tennyson, 1861

Woodland Gossip, 1864 (with others)
The Story without an End, F. W. Carov, 1868
*A Dream Book**, 1870
Hans Anderson's Fairy Tales, 1872
*Beauty and the Beast**, 1875
The Magic Valley, Eliza Keary, 1877
*Child's Play**, 1880
A Book of Heavenly Birthdays, Elliot Stock, 1894

BULL, René (d. 1942)
Born in Ireland.
Fables, J. de la Fontaine, 1905 (with Carton Moore Park)
Uncle Remus, J. C. Harris, 1906
The Arabian Nights, 1912
The Russian Ballet, A. E. Johnson, 1913
Ruba'iyat of Omar Khayyam, 1913
Carmen, P. Merimée, 1916
Gulliver's Travels, J. Swift, 1928

BURNE-JONES, Sir Edward Coley, Bt (1833–98)
Born in Birmingham. Exeter College, Oxford (with view to entering the Church) from 1852. Studied painting under Dante Gabriel Rossetti from 1855. Collaborated with Rossetti, William Morris, Arthur Hughes and others on murals in Oxford Union depicting scenes from Thomas Malory's *Le Morte D'Arthur* in 1857. Visited Italy, 1859, and again with John Ruskin, 1862. Co-director of Morris, Marshall, Faulkner & Co., established 1861. Exhibited regularly at Grosvenor Gallery and subsequently at New Gallery. ARA, 1885; exhibited at Royal Academy only in 1886 (resigned in 1893). *Légion d'Honneur*. Baronet, 1894. Paintings using oil and water-based media on same canvas, tapestry and stained glass designs, furniture decorations.
Fairy Family, MacLaren, 1857
King Poppy, Earl of Lytton, 1892
The Queen who Flew, J. L. Hueffer, 1894
The Works of Geoffrey Chaucer, 1896 (Kelmscott Press)
The Well at the World's End, William Morris, 1896
Love is Enough, William Morris, 1897
The Story of Sigurd the Volsung etc., William Morris, 1898
The High History of the Holy Graal, Perceval le Gallois, 1898
Letters to Katie, introd. W. Graham Robertson, 1925
(Also illustrations published in *Good Words*.)

CLARKE, Harry (1890–1931)
Born in Dublin. Apprenticed to father (controller of large firm of stained glass workers) at 16. Dublin Metropolitan School of Art, 1910–13. Awarded three gold medals and two scholarships (one to study cathedral windows in Île de France). Set up independent, one-man, stained glass workshop in Dublin; designed and executed numerous windows for churches in England, Ireland, and elsewhere; also secular commissions. Designed textiles. Died of tuberculosis in Switzerland.
Fairy Tales, H. C. Andersen, 1916
Tales of Mystery and Imagination, Edgar Alan Poe, 1919
The Year's at the Spring, Lettice D'O. Walters, 1920
The Fairy Tales of Charles Perrault, 1922
Faust, J. W. von Goethe, 1925
Selected Poems, A. C. Swinburne, 1928

CRANE, Walter (1845–1915)
Born in Liverpool. Apprenticed to wood engraver, W. J. Linton, at 13. Joined Socialist League, 1883. First President of Art Workers' Guild, 1884. President of Arts & Crafts Exhibition Society, 1888–90. Principal, Royal College of Art, 1898–99. Exhibited at Royal Academy in 1862 and 1872, Grosvenor Gallery, etc. Painter of portraits, landscapes and allegorical subjects. Designed textiles, wallpapers, tiles, costumes for masques, etc.
Walter Crane's Toy Books, 1865–76
The Magic of Kindness, H. and A. Mayhew, 1869
Twelve titles by Mrs Molesworth, 1875–89 (Macmillan)
The Quiver of Love, 1876 (with Kate Greenaway)
The Baby's Opera, 1877
The Baby's Bouquet, 1879
The Necklace of Princess Fiorimonde, Mary De Morgan, 1880
The First of May, J. R. Wise, 1881
Household Stories, from the Brothers Grimm, trans. Lucy Crane, 1882
Pan Pipes. A book of Old Songs, Theo Marzials, 1883
Walter Crane's New Series of Picture Books, 1885–86

The Golden Primer, J. M. D. Meiklejohn, 1885
Folk and Fairy Tales, C. C. Harrison, 1885
*The Sirens Three**, 1886
The Baby's Own Aesop, 1886
Echoes of Hellas, introd. Professor George Warr, 1887
*Legends for Lionel**, 1887
The Happy Prince & other Tales, Oscar Wilde, 1888 (with Jacomb Hood)
The Book of Wedding Days, K. E. J. Reid etc., 1889
*Flora's Feast. A Masque of Flowers**, 1889
The Turtle Dove's Nest, 1890 (with others)
*Renascence. A Book of Verse**, 1891
*Queen Summer, or the Tourney of the Lily and the Rose**, 1891
A Wonder Book for Girls and Boys, Nathaniel Hawthorne, 1892
The Tempest, William Shakespeare, 1893
The Old Garden, Margaret Deland, 1893
The Two Gentlemen of Verona, William Shakespeare, 1894
The Story of the Glittering Plain, William Morris, 1894 (Kelmscott Press)
The Merry Wives of Windsor, William Shakespeare, 1894
The Faerie Queene, ed. T. J. Wise, 1895
A Book of Christmas Verse, ed. H. C. Beeching, 1895
The History of Reynard the Fox, F. S. Ellis, 1897
The Shepheard's Calendar, Edmund Spenser, 1898
The Walter Crane Readers, Nellie Dale, from 1898
*A Floral Fantasy in an Old English Garden**, 1899
Don Quixote of the Mancha, retold by Judge Parry, 1900
A Masque of Days, 1901
The Tempest, William Shakespeare, 1902
*A Flower Wedding. Described by Two Wallflowers**, 1905
The Children's Plutarch, F. J. Gould, 1906
Flowers from Shakespeare's Garden, 1906
The Rosebud and other Tales, Arthur Kelly, 1909
Rumbo Rhymes, or the Great Combine, A. C. Calmour 1911
King Arthur's Knights (2 vols) and *Robin Hood* (2 vols) retold for children by Henry Gilbert, 1911–15
(Also books on design. Designed Womens' Movement, Socialist, and Arts & Crafts pamphlets. Contributed to *Good Words*, *Once a Week*, *The Yellow Book* etc.)

DETMOLD, Edward Julius (b. 1883)
Privately educated by uncle. Early work in collaboration with twin brother Maurice (1883–1908). Exhibited at Royal Academy from 1896. Specialised in natural history subjects. Influenced by Albrecht Dürer and Japanese prints. Etchings, wood engravings, watercolour paintings.
Pictures from Birdland, 1899 (with M. Detmold)
Sixteen Illustrations of subjects from Kipling's 'Jungle Book', 1903 (with M. Detmold)
The Jungle Book, Rudyard Kipling, 1908
The Fables of Aesop, 1909
The Life of the Bee, M. P. M. B. Maeterlinck, 1911
Birds and Beasts, C. Lemonnier, 1911
The Book of Baby Beasts, F. E. Dugdale, 1911 (with others)
The Book of Baby Birds, F. E. Dugdale, 1912 (with others)
Hours of Gladness, M. P. M. B. Maeterlinck, 1912
The Book of Baby Pets, F. E. Dugdale, 1915 (with others)
The Book of Baby Dogs, Charles J. Kaberry, 1915
Our Little Neighbours, Charles J. Kaberry, 1921
Rainbow Houses, A. V. Hall, 1923
Tales from the Thousand and One Nights, 1924

DORÉ, Paul Gustave Louis Christophe (1833–83)
Born in Strasbourg. Studied lithography from age of 11. Moved to Paris; exhibited drawings at *Salon* from 1848, paintings from 1851. Particularly successful in England; Doré Gallery, London, (1868–87) provided permanent showcase for own work. *Légion d'Honneur*, 1879. Painting, lithography, pen drawings and, late in life, sculpture.
The Adventures of St George, W. F. Peacock, 1858
Boldheart the Warrier, G. F. Pardon, 1858
The History of Don Quixote, M. de Cervantes Saavedra, 1863
The Ancient Mariner, S. T. Coleridge, 1865
Days of Chivalry, L'Epine, 1866
The Adventures of Baron Munchausen, 1866
Fables of La Fontaine, 1867
Elaine, Guinevere, Vivien, Enid, and *Idylls of the King*, Tennyson, 1867–68
Popular Fairy Tales, 1871

Poems of Thomas Hood, 1872
(Also *The Bible* (1867), Jerrold's *London* (1872) etc.)

DOYLE, Richard (1824–83)
Born in London. Son and pupil of Irish artist and cartoonist, John Doyle ('HB'). Contributed to *Punch*, 1843–51, and designed cover. Exhibited at Royal Academy in 1868 and 1871, and at Grosvenor Gallery. Watercolours and large oil paintings, landscape and fairy subjects.
The Fairy Ring, the Brothers Grimm, 1846
A Jar of Honey from Mount Hybla, Hunt, 1847
Fairy Tales, Montalba, 1849
The Enchanted Doll, Mark Lemon, 1849
Rebecca and Rowena, W. M. Thackeray, 1850
The King of the Golden River, John Ruskin, 1851
The Story of Jack and the Giants, 1851
The Newcomes, W. M. Thackeray, 1854–55
A Juvenile Calendar and Zodiac of Flowers, Mrs Hervey, 1855
The Scouring of the White Horse, Hughes, 1859
A Selection from the Works of Frederick Locker, 1865
An Old Fairy Tale, Planché, 1865
Irish Biddy, the Visiting Judges, and the Troublesome Priest, 1868
Fairy Tales, Mark Lemon, 1868
In Fairyland, W. Allingham, 1870
The Enchanted Crow, 1871
The Feast of the Dwarves, 1871
Fortune's Favourite, 1871
Snow White and Rosy Red, 1871
The Princess Nobody, A. Lang (not dated)
(Also *Brown, Jones & Robinson*, initially in *Punch*, published as book in 1854; *Manners and Customs of Ye Englyshe*, in 1849.)

DULAC, Edmund (1882–1953)
Born in Toulouse, France. Studied Law (unwillingly) at Toulouse University. Attended Toulouse Art School for three years, and Académie Julien, Paris, for three weeks. Exhibited annually at Leicester Galleries, London, 1907–18. Naturalized British subject, 1912. Art and music lectures, portraits, mural paintings, wood engravings, caricatures and caricature dolls, medal and stamp designs, stage sets and costumes. 1908–18, illustrated mostly for publishers Hodder & Stoughton. Friend of Ricketts and de Bosschère.
Stories from the Arabian Nights, 1907
*Lyrics Pathetic and Humourous from A–Z**, 1908
The Tempest. William Shakespeare, 1908
The Ruba'iyat of Omar Khaiyam, 1909
The Sleeping Beauty and other Fairy Tales, 1910
Fairies I have met, M. M. Stawell, 1910
Alibaba and Other Stories, 1911
Stories from Hans Andersen, 1911
The Bells, and other poems, Edgar Allan Poe, 1912
My Days with the Fairies, M. M. Stawell, 1913
Princess Badoura, a tale from the Arabian Nights, retold by Laurence Housman, 1913
Sinbad the Sailor and other stories from the Arabian Nights, 1914
Edmund Dulac's Picture Book for the French Red Cross, 1915
*Edmund Dulac's Fairy Book**, 1915
Tanglewood Tales, Nathaniel Hawthorne, 1918
The Kingdom of the Pearl, L. Rosenthal, 1920
The Green Lacquer Pavilion, H. de V. Beauclerk, 1926
Treasure Island, R. L. Stevenson, 1927
A Fairy Garland, 1928

FORD, Henry Justice (1860–1940)
Won Scholarship to Cambridge University; first class Classical Tripos. Subsequently studied art at the Slade School of Fine Art, London. Exhibited at Royal Academy, 1892–1903. Painter of portraits, landscape, and subject pictures. Friend of Edward Burne-Jones.
Aesop's Fables, Arthur Brookfield, 1888
The Blue Fairy Book, ed. Andrew Lang, 1889 (with G. P. Jacomb Hood). The first of the Coloured Fairy Book series, i.e. *Red*, 1890 (with L. Speed); *Green*, 1892; *Yellow*, 1894; *Pink*, 1897; *Grey*, 1900; *Violet*, 1901; *Crimson*, 1903; *Brown*, 1904; *Orange*, 1906; *Olive*, 1907; *Lilac*, 1910.
When Mother Was Little, S. P. Yorke, 1890
A Lost God, F. W. Bourdillon, 1891
The Blue Poetry Book, ed. Andrew Lang, 1891 (with L. Speed)
The True Story Book, ed. Andrew Lang, 1893 (with L. Bogle); followed by

The Blue True Story Book, 1896 (with Lucien Davis), and *The Red True Story Book*, 1897
The Animal Story Book, ed. Andrew Lang, 1896; followed by *The Red Book of Animal Stories*, 1900
The Arabian Nights Entertainment, Andrew Lang, 1898
Early Italian Love Stories, Una Taylor, 1899
The Disentanglers, Andrew Lang, 1902
The Red Romance Book, ed. Andrew Lang, 1905
Tales of King Arthur, 1905
Tales of Troy and Greece, Andrew Lang, 1907
The Luck-Flower and other verses, George Walker, 1907
The Book of Princes and Princesses, Leonora B. Lang, 1908
The Marvellous Musicians and other stories, Andrew Lang, 1909
The All Sorts of Stories Book, Leonora B. Lang, 1911
The Book of Saints and Heroes, Leonora B. Lang, 1912
The Strange Story Book, Leonora B. Lang, 1913
Pilot and other stories, Harry P. Greene, 1916
The Book of the Happy Warrior, Sir H. Newbolt, 1917
David Blaize and the Blue Door, Edward F. Benson, 1918
The Pilgrim's Progress, John Bunyan, 1921

GASKIN, Arthur J. (1862–1928)
Studied at Birmingham School of Art and later became head of Jewellery and Metalwork Department. Active in Birmingham Guild of Handicraft. Exhibited at Royal Academy in 1889 and 1890. Paintings in oil and tempera, wood engravings, metalwork and enamelling.
A Book of Pictured Carols, 1893 (with others)
Stories and Fairy Tales, Hans Andersen, 1893
A Book of Fairy Tales, retold by S. Baring-Gould, 1894 (Methuen)
Good King Wenceslas, J. M. Neale, 1895
The Shepheard's Calendar, Edmund Spenser, 1896 (Kelmscott Press)

HILL, Vernon (b. 1887)
Born in Halifax, Yorkshire. Apprenticed to trade lithographer at 13. As student teacher at 18, taught mill hands in night school. At 21, worked under poster artist and illustrator, John Hassall. Examples of work in British Museum, Victoria & Albert Museum, and New York Public Library. Sculpture in bronze, wood and ivory, lithographs, etchings.
The Arcadian Calendar for 1910, 1909
The New Inferno, Stephen Phillips Jr, 1911
Ballads Weird and Wonderful, Richard Chope, 1912
Tramping with a Poet in the Rockies, Stephen Graham, 1922

HORTON, William T. (1864–1919)
Born in Brussels. Educated Brussels and Brighton, Sussex. Articled to Brighton architect. Student at Royal Academy Architectural Schools in 1887. Abandoned architecture in disgust, c1894, turning to literature and mysticism (e.g. novel, *The Mystic Will*). Joined army as private in Artists' Corps. Member of 'The Brotherhood of New Life'. Graphic work inspired by William Blake and Aubrey Beardsley.
*'Whispers', A Magazine for Surrey Folk** (4 numbers), 1893
A Book of Images, introd. by W. B. Yeats, 1898
The Raven. The Pit and the Pendulum, Edgar Allan Poe, 1899
*The Grig's Book**, 1900
*The Way of the Soul, A Legend in Line and Verse**, 1910
(4 drawings published in *The Savoy* magazine.)

HOUGHTON, Arthur Boyd (1836–75)
Studied at Leigh's Art School. Exhibited at Royal Academy, 1860–70. Visited America. Oil paintings and watercolours.
Dalziel's Arabian Nights, 1863–65
Idyllic Pictures, 1865 (with others)
Home Thoughts and Home Scenes, 1865, (reprinted as *Happy-Day Stories*, 1875)
A Round of Days, 1866 (with others)
Adventures of Don Quixote, M. de Cervantes Saavedra, 1866
Ballad Stories of the Affections, Robert Buchanan, c1866 (with others)
Poetical Works, Longfellow, c1866
The Arabian Nights, 1866
Poems by Jean Ingelow, 1867 (with others)
'North Coast' and other poems, Robert Buchanan, 1868
Kridof and his Fables, 1869
Picture Posies, 1874 (with others)
(Illustrations published in *Once a Week, Good Words, London Society, Quiver, Good Words for the Young, The Graphic*, etc.)

HOUSMAN, Laurence (1865–1959).
Born in Bromsgrove, Warwickshire. Studied at Lambeth and South Kensington Schools of Art. Gave up illustration in 1901 because of failing sight. Art critic on *The Manchester Guardian*, 1895–1911. Brother of author and scholar, A. E. Housman; lived with sister, Clemence (wood engraver, authoress and suffragette). Pioneer Socialist. Became Pacifist during World War I. Wrote plays (often about Queen Victoria, usually censored by Lord Chamberlain), pamphlets and novels.
Jump-to-Glory Jane, George Meredith, 1892
Goblin Market, Christina Rossetti, 1893
Wierd Tales from North Seas, trans. J. Lie, 1893
The End of Elfin-Town, Jane Barlow, 1894
*A Farm in Fairyland**, 1894
*The House of Joy**, 1895
Poems, Francis Thompson, 1895
Sister Songs, Francis Thompson, 1895
*Green Arras**, 1896
*All-Fellows**, 1896
The Were-Wolf, Clemence Housman, 1896
The Sensitive Plant, P. B. Shelley, 1898
*The Field of Clover**, 1898
*Seven Young Goslings**, 1899
*The Little Land**, 1899
At the Back of the North Wind, George MacDonald, 1900
The Princess and the Goblin, George MacDonald, 1900

HUGHES, Arthur (1832–1915)
Studied under Alfred Stevens, and, from 1847, at Royal Academy Schools. Met members of Pre-Raphaelite Brotherhood (Dante Gabriel Rossetti, William Holman Hunt and John Everett Millais), soon subscribing to their ideals. In 1852, exhibited first major Pre-Raphaelite picture, 'Ophelia'; collaborated (1857) with Rossetti, Edward Burne-Jones, etc. on Oxford Union murals depicting scenes from Thomas Malory's *Le Morte D'Arthur*. From 1860, lived quietly in south London suburbs. Exhibited at Royal Academy from 1849, and at Grosvenor and New Galleries.
The Music Master, W. Allingham, 1855 (with D. G. Rossetti)
Enoch Arden, Alfred, Lord Tennyson, 1866
Dealings with the Fairies, George MacDonald, 1867
Five Days' Entertainment at Wentworth Grange, F. T. Palgrave, 1868
Tom Brown's Schooldays, Thomas Hughes (no relation), 1869
Mother Goose, 1870 (with A. B. Houghton and others)
At the Back of the North Wind, George MacDonald, 1871
Ranald Bannerman's Boyhood, George MacDonald, 1871
The Princess and the Goblin, George MacDonald, 1872
Parables and Tales, T. Gordon Hake, 1872
Sing Song, Christina Rossetti, 1872
Sindbad the Sailor, 1873
Speaking Likenesses, Christina Rossetti, 1873
Gutta-Percha Willie, George MacDonald, 1873
Babies' Classics, 1904
The Magic Crook, Greville MacDonald, 1911
Trystie's Quest, Greville MacDonald, 1912
Jack and Jill, Greville MacDonald, 1913
(Illustrations published in *Good Words*, *Cornhill Magazine*, *London Society Sunday Magazine*, *Good Words for the Young*, etc.)

HUNT, William Holman (1827–1910)
Born in London. Studied at Royal Academy Schools from 1844; met John Everett Millais. In 1848, with Millais, Dante Gabriel Rossetti and others, formed the Pre-Raphaelite Brotherhood. Extensive travels in Middle East. Exhibited at Royal Academy, Grosvenor and New Galleries. Order of Merit, 1905. Buried in St Paul's Cathedral. Paintings in oil and watercolour.
Poems, Alfred, Lord Tennyson ('Moxon Tennyson'), 1858 (with others)
(Contributed single illustrations to various works and anthologies; also to *Once a Week* and *Good Words*.)

JONES, Alfred Garth
Born in Manchester. Studied at Westminster School of Art, Slade School of Fine Art, Académie Julien and South Kensington School of Art. Visiting master in Design at Lambeth and Manchester Schools of Art. Exhibited at Royal Academy. Designs for mosaics and stained glass windows, also advertisements.

The Tournament of Love, W. T. Peters, 1894
The Minor Poems of John Milton, Bell, 1898
Contes de Haute-Lisse, Jerome Doucet, 1899
Contes de la Fileuse, Jerome Doucet, 1900
The Essays of Elia, Charles Lamb, 1901
Queen Mab's Fairy Realm, 1901 (with others)
In Memoriam, Alfred, Lord Tennyson, 1901

KING, Jessie Marion (later Taylor) (1876–1949)
Studied at Glasgow School of Art. Won a travelling Scholarship to France and Italy: influenced by Botticelli. Gold Medal at Turin International Exhibition of Modern Decorative Art, 1902. Jewellery designs, mural decorations for schools, batik (from 1915).
Jephtha, G. Buchanan, 1902
The High History of the Holy Graal, trans. S. Evans, 1903
The Defence of Guinevere and other poems, William Morris, 1904
Comus, John Milton, 1906
Songs of the Ettrick Shepherd, James Hogg, 1912
Isabella. The Pot of Basil, John Keats, 1914
A House of Pomegranates, Oscar Wilde, 1915
*The Little White Town of Never-Weary**, 1917
Good King Wenceslas, 1919
(also numerous landscape and flower books)

KIPLING, Rudyard (1865–1936)
Born in Bombay, India. Educated in England, spending Christmas vacations at home of Edward Burne-Jones. Journalist in India, 1882–89. In 1890s, made visits to United States with American wife; finally settled in Sussex, England. Awarded Nobel Prize in 1907. Author of short stories, novels and poems.
*Just So Stories**, 1902

KNOWLES, Reginald Lionel
Illustrated books in collaboration with brother Horace. From 1905, designer for Dent's Everyman's Library.
Legends from Fairyland, Holme Lee. 1908
Norse Fairy Tales, P. C. Asborjörnsen and J. I. Moe, 1910
Marie de France, Old World Love Stories, 1913

LEAR, Edward. (1812–88)
Born in London, youngest in a family of 21 children. Cared for by eldest sister until age of 50; epileptic, asthmatic, and bronchitic. Largely self-taught as scholar and artist. Draughtsman at London Zoological Gardens, 1831. Drawing master to Queen Victoria in 1846. Travelled extensively in Southern Europe and the Middle East. Topographical drawings and paintings (watercolours and oils). Natural History illustrations. Stories, letters, and verse.
*A Book of Nonsense**, 1846
*Nonsense Songs, Stories, Botany and Alphabets**, 1871
*More Nonsense, Pictures, Rhymes, Botany** etc. 1872
*Laughable Lyrics, a fourth Book of Nonsense**, 1877

MILLAIS, John Everett (1829–96)
Born Jersey, Channel Islands. Studied at Royal Academy Schools from 1840, forming friendship with William Holman Hunt. 1848, founded the Pre-Raphaelite Brotherhood with Holman Hunt, Dante Gabriel Rossetti etc. Exhibited at Royal Academy from 1846 (at 16); ARA 1853, RA 1863. Also exhibited at Grosvenor Gallery etc. 1885, first English artist to be made Baronet.
Poems, Alfred, Lord Tennyson ('Moxon Tennyson'), 1858 (with others)
The Poets of the Nineteenth Century, 1858 (with others)
Lilliput Levée, 1864; followed by *Lilliput Lectures*, 1871, and *Lilliput Legends*, 1872.
Little Songs for me to sing, 1865
A Thousand and One Gems of English Poetry, ed. C. Mackay, 1867 (with others)
Little Valentine and other tales, 1878 (with others)
(Also *The Parables of Our Lord*, 1863 (Dalziel's edition), illustrations to the novels of Anthony Trollope, first appearing in *Cornhill* magazine, and contributions to *Once a Week*, *Good Words*, *London Society*, etc.)

MILLAR, Harold R. (active 1891–1935)
Lived at Upper Tooting, London. Exhibited illustrations at Royal

Academy, 1892, 1899 and 1903. Graphic style shows influence of Franco-Spanish artist Daniel Vierge.
The Golden Fairy Book, George Sand etc., 1894
Fairy Tales Far and Near, 1895
The Adventures of Hajji Baba and Isaphan, James Morier, 1895
The Silver Fairy Book, Sarah Bernhardt etc., 1895
Headlong Hall, and Nightmare Abbey, Thomas Love Peacock, 1896
Booklets by Count Tolstoi 1895-7
The Diamond Fairy Book, Isabel Bellerby, etc. 1897
Untold Tales of the Past, Beatrice Harraden, 1897
Eothen, A. W. Kinglake, 1898
Phroso, Anthony Hope, 1897
The Book of Dragons, E. Nesbit, 1900
Nine Unlikely Tales for Children, E. Nesbit, 1901
The Story of the Bold Pecopin, Victor Hugo, 1902
The Phoenix and the Carpet, E. Nesbit, 1904
The New World Fairy Book, 1904
Oswald Bastable and others, E. Nesbit, 1905
Kingdom Curious, Myra Hamilton, 1905
Puck of Pook's Hill, Rudyard Kipling, 1906
The Enchanted Castle, E. Nesbit, 1907
The Magic City, E. Nesbit, 1910
The Wonderful Garden, E. Nesbit, 1911
Wet Magic, E. Nesbit, 1913
*The Dreamland Express**, 1927
Hakluyt's Voyages, 1929
(also: novels by Captain Marryat. Macmillan's Infant Readers, etc.)

MUCKLEY, Louis Fairfax
Born in Stourbridge, Worcestershire. Studied at Manchester School of Art. Associated with Birmingham Guild of Handicraft. Exhibited at Grosvenor Gallery, 1887, Royal Academy, 1890, 1891 and 1901. Presumably related to well known flower painter, William Jabez Muckley (1837-1905), sometime teacher at Manchester School of Art, and to Angelo Fairfax Muckley, who exhibited portraits and subject pictures at Royal Academy in 1890s. Landscape and genre paintings, wood engravings.
Fringilla, R. D. Blackmore, 1895
The Faerie Queene, Edmund Spenser, 1897

NELSON, Harold Edward Hughes (b. 1871)
Studied at Lambeth School of Art and at Central School of Arts and Crafts, London. Member of Art Workers' Guild. Lecturer. Exhibited at Royal Academy, 1899. Posters and advertisements, etchings, bookplates, heraldry.
Undine and Aslauga's Knight, F. H. C. de La Motte Fouqué, 1901
Early English Prose Romances, W. J. Thoms, 1904
(Also drawings for *The Graphic, Sphere, Queen, Ladies' Field*, etc.)

NIELSEN, Kay (1886-1957)
Born in Denmark. Studied art in Paris at Académies Julien and Colarossis, 1904-11. Worked in London, 1911-16, exhibiting at Leicester Galleries. Exhibited in New York, 1917. Designed stage sets for Theatre Royal in Copenhagen, 1918-22. Emigrated to United States; lived in California from 1939, working as actor and designer in Hollywood.
In Powder and Crinoline, Sir Arthur Quiller-Couch, 1912
East of the Sun, West of the Moon, P. C. Asbjörnsen and J. I. Moe, 1914
Old Tales from the North, 1919
Fairy Tales by Hans Andersen, 1924
Hansel and Gretel, the Brothers Grimm, 1925
Red Magic, Romer Wilson, 1930

PATON, Joseph Noel (1821-1901)
Born in Dunfermline, Scotland. Studied at Royal Academy Schools. Returned to Scotland. Exhibited at Royal Academy, 1856-69, and at Royal Scottish Academy. Knighted in 1866. Lifelong friend of John Everett Millais; sympathised with aims of Pre-Raphaelite Brotherhood. Writer and poet. Sculpture, paintings of fairy, historical and, after 1870, religious subjects.
Compositions from Shakespeare's 'Tempest', 1845
Compositions from Shelley's 'Prometheus Unbound', 1845
Silent Love, James Wilson 1845
Coleridge's Rime of the Ancient Mariner, 1863
Lays of the Scottish Cavaliers, W. E. Aytoun, 1863
The Water Babies, Charles Kingsley, 1869

The Story of Wandering Willie, 1870
The Princess of Silverland and other tales, E. Strivelyne, 1874
Rab and his Friends, John Brown M.D., 1878

RACKHAM, Arthur (1867-1939)
Born in Lewisham, London. Studied at Lambeth School of Art, 1884. Worked as clerk in insurance office, 1885-92. Contributed to various illustrated papers from 1884. Joined staff of *Westminster Budget*, 1892. Exhibited at Royal Academy from 1888, Leicester Galleries from 1905. Master of Art Workers' Guild, 1919. Watercolour paintings (landscapes and mythological subjects), oil paintings from c1922, stage designs.
Tales of a Traveller, Washington Irving, 1895
The Sketch Book, Washington Irving, 1895 (with others)
The Money Spinner and other character notes, Merriman and Tallintyre, 1896
The Zankiwank and the Bletherwitch, S. J. Adair, 1896
Two Old Ladies, Two Foolish Fairies, and a Tom Cat, Maggie Browne, 1897
Charles O'Malley, Charles Lever, 1897
The Grey Lady, Henry Seton Merriman, 1897
Evelina, Fanny Burney, 1898
The Ingoldsby Legends, H. R. Barham, 1898
Feats on the Fjords, Harriet Martineau, 1899
Tales from Shakespeare, Charles and Mary Lamb, 1899
Fairy Tales of the Brothers Grimm, trans. Mrs Edgar, 1900
Gullivers Travels, Jonathan Swift, 1900
The Argonauts of the Amazon, C. R. Kenyon, 1901
The Greek Heroes, Niebuhr, 1903
The Grey House on the Hill, Hon. Mrs. Green, 1903
Rip Van Winkle, Washington Irving, 1905
Peter Pan in Kensington Gardens, J. M. Barrie, 1906
Alice's Adventures in Wonderland, Lewis Carroll, 1907
A Midsummer Night's Dream, William Shakespeare, 1908
The Ingoldsby Legends, R. H. Barham, 1907
Undine, F. H. C. de La Motte Fouqué, 1909
The Book of Betty Barber, Maggie Browne, 1910
The Rhinegold and the Valkyrie, Richard Wagner, 1910
Siegfried and the Twilight of the Gods, Richard Wagner, 1911
Aesop's Fables, 1912
Mother Goose, The Old Nursery Rhymes, 1913
Arthur Rackham's Book of Pictures, 1913
A Christmas Carol, Charles Dickens, 1915
The Allies' Fairy Book, 1916
Little Brother and Little Sister, the Brothers Grimm, 1917
The Romance of King Arthur and his Knights of the Round Table, abridged from
 Thomas Malory by Alfred Pollard, 1917
English Fairy Tales Retold, Flora Annie Steel, 1918
The Springtide of Life, poems of childhood, A. C. Swinburne, 1918
Cinderella, retold by C. S. Evans, 1919
Snickerty Nick, Rhymes by Whitter Bynner, J. E. Ford, 1919
Some British Ballads, 1919
The Sleeping Beauty, retold by C. S. Evans
Irish Fairy Tales, James Stephens, 1920
A Dish of Apples, Eden Philpotts, 1921
Comus, John Milton, 1921
A Wonder Book, Nathaniel Hawthorne, 1922
Where the Blue Begins, Christopher Morley, 1925
Poor Cecco, Margery Williams Bianco, 1925
The Tempest, William Shakespeare, 1926
The Legend of Sleepy Hollow, Washington Irving, 1928
The Vicar of Wakefield, Oliver Goldsmith, 1929
The Compleat Angler, Izaak Walton, 1931
The Night Before Christmas, Clement C. Moore, 1931
The King of the Golden River, John Ruskin, 1932
Fairy Tales, Hans Andersen, 1932
Goblin Market, Christina Rossetti, 1933
The Pied Piper of Hamelin, Robert Browning, 1934
Tales of Mystery and Imagination, Edgar Allan Poe, 1935
Peer Gynt, Henrik Ibsen, 1936
A Midsummer Night's Dream, William Shakespeare, 1939
The Wind in the Willows, Kenneth Grahame, 1940

RICKETTS, Charles de Sousy (1866-1930)
Born in Geneva. At 16, apprenticed to Roberts, wood engraver at City and Guilds Art School. Studied at Lambeth School of Art. With Charles Shannon, edited *The Dial* (5 issues, 1889-97) devoted to art and literature.

Founded and ran The Vale Press 1896–1904. Painter from 1904. Stage designs (from 1906) anticipated many innovations of Bakst. With Shannon, formed collection of old master drawings and paintings, ancient Egyptian and Greek objects, gems, Japanese drawings, paintings and prints, etc. ARA 1922, RA 1928. Printer, painter, stage designer, writer.

A House of Pomegranates, Oscar Wilde, 1891 (with C. H. Shannon)
Poems, Dramatic and Lyrical, Lord de Tabley, 1893 (with C. H. Shannon)
Daphnis and Chloe, Longus, trans. George Thornley, 1893 (with C. H. Shannon)
The Sphinx, Oscar Wilde, 1894
Hero and Leander, Christopher Marlowe and George Chapman, 1894
Nymphidia and the Muses Elizium, Michael Drayton, 1896
Spiritual Poems, Thomas Gray, 1896
Milton's Early Poems, 1896
Songs of Innocence, William Blake, 1897
Sacred Poems of Henry Vaughan, 1897
The Excellent Narration of the Marriage of Cupid and Psyche, trans. from Lucius Apuleius by William Adlington, 1897
The Book of Thel, Songs of Innocence and Songs of Experience, William Blake, 1897
Blake's Poetical Sketches, 1899
The Rime of the Ancient Mariner, S. T. Coleridge, 1899
Danaë, T. Sturge Moore, 1903
The Parables from the Gospels, 1903
(See also: *Charles Ricketts R. A.* 65 illustrations introduced by T. Sturge Moore, 1933)

ROBINSON, Charles (1870–1937)
Born in London. Apprenticed to lithographer. Studied art at Royal Academy Schools, also at Highbury School of Art, West London School of Art, and Heatherley's. Exhibited water colour paintings at Royal Academy. Brother of Tom and Will Heath Robinson.

Aesop's Fables, 1895
Animals in the Wrong Places, Edith Carrington, 1896
The Child World, Gabriel Setoun, 1896
Make Believe, H. D. Lowry, 1896
A Child's Garden of Verses, R. L. Stevenson, 1896
Dobbie's Little Master, Mrs Arthur Bell (1897)
King Longbeard, or Annals of the Golden Dreamland, B. McGregor, 1898
Lullaby Land, Eugene Field, 1898
Lilliput Lyrics, W. B. Rand, 1899
Fairy Tales from H. C. Andersen, trans. Mrs E. Lucas, 1899 (with T. H. and W. H. Robinson)
Pierrette, Henry de Vere Stacpoole, 1900
Child Voices, W. E. Cule, 1900
The Adventures of Odysseus, 1900
The True Annals of Fairyland, ed. Wm. Canton, 1900
Sintram and his Companions and *Aslauga's Knight*, F. H. C. de La Motte Fouqué, 1900
The Master Mosaic-Workers, George Sand, 1900
The Suitors of Aprille, N. Garstin, 1900
Jack of All Trades, J. J. Bell, 1900
Tales of Passed Times, C. Perrault, 1913
The Mother's Book of Song, J. H. Burn, 1902
Nonsense! Nonsense . . ., W. C. Jerrold, 1902
The Big Book of Nursery Rhymes, W. C. Jerrold, 1903
The Cloud Kingdom, I. H. Wallis, 1905
The Child's Christmas, Evelyn Sharp, 1906
The Story of the Weathercock, Evelyn Sharp, 1907
The Fairies' Fountain, E. Martinengo-Cesaresco, 1908
Annals of Fairyland, 1909
Grimm's Fairy Tales, 1910
The Vanishing Princess, Netta Syrett, 1910
The Secret Garden, Frances Hodgson Burnett, 1911
The True Annals of Fairyland in the Reign of King Herla, 1911
The Big Book of Fairy Tales, W. C. Jerrold, 1911
The Sensitive Plant, P. B. Shelley, 1911
Bee, Princess of the Dwarves, Anatole France, 1912
The Four Gardens, Handasyde, 1912
The Big Book of Fables, W. C. Jerrold, 1912
Alice's Adventures in Wonderland, Lewis Carroll, 1913
Margaret's Book, H. Fielding, 1913
Fairy Tales, C. Perrault, 1913

The Open Window, E. T. Thurston, 1913
The Happy Prince, Oscar Wilde, 1913
Our Sentimental Garden, Agnes and E. Castle, 1914
A Child's Book of Empire, A. T. Morris, 1914
Rip Van Winkle, Washington Irving, 1914
The Story of Prince Ahmed and Fairy Perie Banou, 1915
Robert Herrick (selections), 1915
The Songs and Sonnets of William Shakespeare, 1915
What Happened at Christmas, Evelyn Sharp, 1915
Bridget's Fairies, A. M. Stevenson, 1919
Father Time Stories, J. G. Stevenson, 1921
The Child's Garland of Verse, Grace Rhys, 1921
Once Upon a Time, A. A. Milne, 1925
The Ruba'iyat of Omar Khayyam, trans. Edward Fitzgerald, 1928

ROBINSON, Tom H. (1865–1953)
Born in London. Studied at Royal Academy Schools. Brother of Charles and Will Heath Robinson. Later specialised in boys' story and biblical illustrations.

Old World Japan, Frank Rinder, 1895
Cranford, Mrs Gaskell, 1896
Legends from River and Mountain, Carmen Sylva, 1896
The History of Henry Esmond, W. M. Thackeray, 1896
The Scarlet Letter, Nathaniel Hawthorne, 1897
A Sentimental Journey through France and Italy, L. Sterne, 1897
Hymn on the morning of Christ's Nativity, John Milton, 1897
The Heroes, Charles Kingsley, 1899
A Book of French songs for the Young, Bernard Minssen, 1899
The Scottish Chiefs, Jane Porter, 1900
Robin Hood and his Adventures, P. Creswick, 1902
Heroes of the Norselands, K. F. Boult, 1903
Una and the Red Cross Knight and other tales from Spencer's Faerie Queene, 1905
A Sentimental Journey, L. Sterne, 1907
The Ruba'iyat of Omar Khayyam, 1907
The Song of Frithiof, Frae kni Fridthjofr, 1912
Tales from the Arabian Nights, 1914 (with Dora Curtis)

ROBINSON, William Heath (1872–1944)
Born Hornsey Rise, London. Islington School of Art, 1887, Royal Academy Schools, 1890. Tried unsuccessfully to earn living as landscape painter, then followed brothers into illustration. Worked for numerous magazines and on advertisements. Noted for humorous contrivances. Designed comic scenery for stage productions, mural decorations for liner, Empress of Britain, and a house for *The Daily Mail* Ideal Home Exhibition. Acknowledged influence of Aubrey Beardsley, Sidney Sime, Walter Crane, Robert Anning Bell, and brother, Charles Robinson, on his work.

Danish Fairy Tales and Legends of Hans Andersen, 1897
Don Quixote, 1897
The Giant Crab and other Tales from Old India, W. H. D. Rouse, 1897
The Pilgrim's Progress, John Bunyan, 1897
The Queen's Story book, ed. G. L. Gomme, 1898
The Talking Thrush and other tales from India, 1899
Fairy Tales from Hans Christian Andersen, 1899 (with his brothers)
Arabian Night's Entertainments, 1899 (with others)
The Poems of Edgar Allan Poe, 1900
Medieval Stories, Professor Schuck, 1902
*The Adventures of Uncle Lubin**, 1902
The Adventures of Don Quixote of La Manche, M. de Cervantes Saavedra, 1902
The Surprising Travels and Adventures of Baron Munchausen, 1902
Tales from Shakespeare, Charles and Mary Lamb, 1902
*The Child's Arabian Nights**, 1903
Rama and the Monkeys, 1903
The Works of Rabelais, Vols I & II, 1904
The Monarchs of Merry England, 1904
The Merry Multifleet and the Mounting Multicorps, H. H. Kennedy, 1904
Told to the Children Series, ed. Louey Chisholm. *Stories from Chaucer, The Iliad*, and *The Odyssey*, 1906 etc.
Twelfth Night, William Shakespeare, 1908
A Song of the English, Rudyard Kipling, 1909
Collected Verse of Rudyard Kipling, 1910
The Dead King, Rudyard Kipling, 1910
*Bill the Minder**, 1912
Hans Andersen's Fairy Tales, 1913
A Midsummer Night's Dream, William Shakespeare, 1914

The Water Babies, Charles Kingsley, 1915
Some Frightful War Pictures, 1915
*Hunlikely**, 1916
Peacock Pie, Walter de la Mare, 1916
The Saintly Hun, a book of German virtues, 1917
Flypapers, 1919
Get on with it, 1920
The Home-made Car, 1921
Old Time Stories, C. Perrault, trans. A. E. Johnson, 1921
*Peter Quip in search of a friend**, 1921
Humours of Golf, introd. Bernard Darwin, 1923
Topsy Turvey Tales, Elsie Smeaton, 1923
The Incredible Adventures of Professor Branestawm, Norman Hunter, 1933
Absurdities, A Book of Collected Drawings, 1934
Heath Robinson's Book of Goblins, 1934
How to live in a Flat, with K. R. G. Browne, 1936
How to be a Perfect Husband, with K. R. G. Browne, 1937
How to Make a Garden Grow, with K. R. G. Browne, 1938
*My Line of Life** (autobiography), 1938 ·
How to be a Motorist, with K. R. G. Browne, 1939
Let's Laugh, with K. R. G. Browne, 1939
Mein Rant, Richard F. Patterson, 1940
How to Make the Best of Things, with H. Cecil Hunt, 1940
How to Build a New World, with H. Cecil Hunt, 1941
Heath Robinson at War, 1942
How to run a Communal Home, with H. Cecil Hunt, 1943
Once Upon a Time, Liliane M. C. Clopet, 1944
(Also numerous advertising booklets and several almanacks.)

ROSSETTI, Dante Gabriel (1828–82)
Born in London. Studied at Royal Academy Schools, 1845–47. Formed Pre-Raphaelite Brotherhood with John Everett Millais, William Holman Hunt in 1848. Collaborated (1857) with Edward Burne-Jones, William Morris, Arthur Hughes, etc. on Oxford Union murals depicting scenes from Thomas Malory's *Le Morte D'Arthur*. Participated in founding of Morris, Marshall, Faulkner & Co., 1861. Shared tenancy of Kelmscott Manor, Gloucestershire, with William Morris, 1871–74. Paintings, in watercolour and oils, of medieval scenes (in 1850s) and, later, half-length allegorical female portraits; drawings; designs for stained glass, tiles and furniture; book bindings; translations of Dante, and poetry.
The Music Master, William Allingham, 1855 (with Millais and Hughes)
Poems, Alfred, Lord Tennyson ('Moxon Tennyson'), 1858 (with others)
Goblin Market, Christina Rossetti, 1862
The Prince's Progress and other poems, Christina Rossetti, 1866

SANDYS, Frederick (1832–1904)
Studied at Royal Academy Schools. In late 1850s, met Dante Gabriel Rossetti, A. C. Swinburne and their circle. Exhibited at Royal Academy, 1851–86. Oil paintings of female heads and half-lengths, dramatic allegorical portraits, portrait drawings. About 30 illustrations, almost all published in periodicals e.g. *The Cornhill Magazine*, *Once a Week* (12 illustrations), *Good Words*.

SHAW, John Byam Liston, usually known as Byam Shaw (1872–1919)
Studied at Royal Academy Schools, winning several awards. Exhibited at Royal Academy from 1893. Large figure compositions in oils, and academic drawings.
Poems by Robert Browning, 1897
Tales from Boccaccio, Joseph Jacobs, 1899
The Chiswick Shakespeare, 1899
Tales from Shakespeare, Charles and Mary Lamb, 1903
The Pilgrim's Progress, John Bunyan, 1904
The Blessed Damozel, D. G. Rossetti
Tennyson, Selected poems by Prof. H. J. C. Grierson, 1907
Selected Tales of Mystery, Edgar Allan Poe, 1909
Stories from Wagner, 1909
The Adventures of Akbar, Flora Steel, 1913
The Garden of Kama, Lawrence Hope, 1914

SIME, Sidney H. (1867–1941)
Born in Manchester. Trained at Liverpool School of Art. In 1890s, contributed to numerous periodicals; sometime co-editor of *The Idler* and *Eureka*. Subsequently worked in relative isolation. Exhibited at the St George's Gallery, 1924 and 1927. Paintings (mostly watercolours, some oils), etchings, portrait caricatures.
The Gods of Pegana, Edward, Lord Dunsany (E. J. M. D. Plunkett), 1905
The Book of Wonder, Edward, Lord Dunsany, 1912
Time and the Gods, Edward, Lord Dunsany, 1922
The King of Elfland's Daughter, Edward, Lord Dunsany, 1924
(Contributed to *The Illustrated London News*, *The Sketch*, *Pick-me-Up*, *The Idler*, *Eureka*.)

STRANG, William (1859–1921)
Born in Dumbarton, Scotland. Studied under Alphonse Legros. Exhibited at Royal Academy from 1883; ARA 1908. Poetry, paintings, etchings.
*The Earth Fiend**, 1892
*Death and the Ploughman's Wife**, Ballad, 1894
Nathan the Wise, G. E. Lessing, trans. W. Jacks, 1894
The Pilgrim's Progress, John Bunyan, 1895
The Surprising Adventures of Baron Munchausen, 1895 (with J. B. Clark)
Paradise Lost, John Milton, 1896
Sinbad the Sailor, & Ali Baba and the Forty Thieves, 1896 (with J. B. Clark)
A Book of Ballads, Alice Sargant, 1898
*A Book of Giants**, 1898
Western Flanders, Laurence Binyon, 1899
A series of 30 etchings, illustrating subjects from . . . Kipling, 1901
The Praise of Folie, Erasmus, trans. Sir Thomas Chaloner, 1901
A series of 30 etchings illustrating subjects from Don Quixote, 1902.
The Compleat Angler, Izaak Walton, 1902
(Also children's books published in 20th century by Nelson.)

SULLIVAN, Edmund Joseph (1869–1933)
Taught to draw by father Michael Sullivan ARCA. Joined staff of the Daily Graphic, 1868. Subsequently, lecturer on book illustration and lithography at Goldsmith's College of Art. President of Art Workers' Guild. Admired Boyd Houghton and Albrecht Dürer; friend of Arthur Rackham. Writer on art; etchings, lithographs, and watercolour paintings.
The Rivals and School for Scandal, R. B. Sheridan, 1896
Lavengro, George Borrow, 1896
The Compleat Angler, Izaak Walton, ed. Andrew Lang, 1896
Tom Brown's School-Days, T. Hughes, 1896
Sartor Resartus, Thomas Carlyle, 1898
The Pirate, Sir Walter Scott, 1898
The Natural History of Selbourne and *A Garden Kalandar*, Gilbert White, 1900 (with others)
A Dream of Fair Women, Alfred, Lord Tennyson, 1900
The Pilgrim's Progress, John Bunyan, 1901
Poems by Robert Burns, 1901
A Citizen of the World, Oliver Goldsmith, 1904
A Modern Utopia, H. G. Wells, 1905
Sintram and his companions, F. H. C. de La Motte Fouqué, 1908
The French Revolution, Thomas Carlyle, 1910
The Ruba'iyat of Omar Khayyam, trans. Edward FitzGerald, 1913
The Vicar of Wakefield, Oliver Goldsmith, 1914
Legal and other Lyrics, George Outram, 1916
Maud, Alfred, Lord Tennyson, 1922
(Also contributed to *The Daily Graphic*, *Good Words*, *The Pall Mall Budget*, *The Pall Mall Magazine* etc. and *The Yellow Book*.)

TENNIEL, John (1820–1914)
Self-taught, except for some lessons at Royal Academy Schools. Joined staff of *Punch* in 1850, succeeding John Leech as chief political cartoonist, 1864; retired, 1901. Knighted (by government of W. E. Gladstone), 1893. Exhibited at Royal Academy, 1837–80. Paintings, cartoons.
Undine, F. H. C. de La Motte Fouqué, 1845
Aesop's Fables, ed. Thomas James, 1848
L'Allegro and Il Pensoroso, John Milton, 1848 (with others)
The Poetical Works of E. A. Poe, 1858 (with others)
The Silver Cord, Shirley Brooks, 1860
The Gordian Knot, Shirley Brooks, 1860
Lalla Rookh, Thomas Moore, 1861
Puck on Pegasus, H. Cholmondeley-Pennell, 1861
The Ingoldsby Legends, R. H. Barham, 1864 (with others)
Dalziels' Arabian Nights Entertainments, 1865 (with Houghton, etc.)
Alice's Adventures in Wonderland, Lewis Carroll, 1865
Through the Looking Glass, Lewis Carroll, 1872
(Contributions to *Punch*, *Once a Week* and *Good Words*.)

Index

Page numbers in italic indicate illustrations.

Académie Julien, Paris 21
Aesthetic Movement 13
Alastair 7; *Forty Three Drawings* 176, 181; *The Sphinx* 177
Allen, George 13, 40, 79
Ancient Mariner, The 26, 27, 38, 126, 130
Andersen, Hans Christian, *Fairy Tales* 8, 87, 89, 125, 172, 173, 175
'Ape' 18
'April Love' 12
Arabian Nights (including individual stories) 18, 56, 69, 116, 117, 128, 129, 132, 136, 137, 140, 180, 181; Dalziel edition 10, 12, 34
Art Deço 17
Art Nouveau 16–18, 21, 22
Arts & Crafts Movement 14, 16, 17
Art Union 26, 27

Ballantyne, R. M. 7
Batten, John D. 19–20; *Celtic Fairy Tales* 59; *English Fairy Tales* 19, 59; *Indian Fairy Tales* 59
Beardsley, Aubrey 8, 14, 16, 18, 21, 22; *The Birth, Life and Acts of King Arthur* 14, 15, 42, 43, 44, 45; *The Rape of the Lock* 15, 22, 46, 47, 48; *Salome* 43, 48, 49
Beardsley, Mabel 18
Bedford, F. D. 7; *The Battle of the Frogs and Mice* 91; *Old English Fairy Tales* 91
Beerbohm, Max 18
Bell, George & Sons 17, 68, 94, 98, 131
Bell, Robert Anning *The Tempest* 94, 95
Birmingham Guild of Handicraft 17
Blake, William 7, 18
Bosch, Hieronymus 21
Boyle, Eleanor Vere 8, 11; *Beauty and the Beast* 57, 60; *The Story Without an End* 8, 57, 60
Brophy, Brigid 10
Bull, René *The Arabian Nights* 116, 117; *The Rubá'iyát of Omar Khayyam* 120, 121
Burne-Jones, Edward 11, 13, 14, 18, 20; *King Poppy* 40; *the Well at the World's End* 39
Byam Shaw, J. 20; *Poems by Robert Browning* 94

Caldecott, Randolph 10
Carové 8, 57, 60
Carroll, Lewis 7, 10, 28
Cassell, Petter & Galpin 35, 36, 37, 72, 73
Chamberlain, Joseph 15
chromolithography 8
Clarke, Harry 21–22; *Fairy Tales by Hans Christian Andersen* 172, 173, 175; *Fairy Tales of Charles Perrault* 178, 179; *Faust* 21–22, 22, 160, 161, 164, 166, 167; *Tales of Mystery & Imagination* 170, 171, 174; *The Year's at the Spring* 22, 165, 168, 169
colour printing 8, 21
Constable 84, 116, 117, 118, 119, 122, 123, 126, 127, 130, 131, 192
Cornish 41
Crane, Walter 8, 10, 11, 13–14, 17, 18, 20; *Toy Books* 8, 13; *Aladdin's Picture Book* 69; *The Faerie Queene* 13, 79; *Flora's Feast* 72, 73; *The Sirens Three* 82, 83; *Crane's New Series of Picture Books* 86
Cruikshank, George 9, 10, 11, 17, 20

Dalziel Bros 8, 10, 12, 13, 29, 30, 34
Darwin, Charles 10
Dean & Son 9, 64
de Bosschère, Jean 7, 18; *Beasts and Men* 182, 183, 184; *The City Curious* 182, 183, 184
Dent, J. M. 14, 15, 17, 42–45, 62, 63, 66, 87, 89, 105, 114
Detmold, E. J. *The Arabian Nights* 180, 181
Dickens, Charles 9
Don Quixote 12, 99
Doré Gallery 38
Doré, Gustave 12; *Adventures of Baron Munchausen* 35, 36, 37; *The Rime of the Ancient Mariner* 38; *Paradise Lost* 12
Doyle, Richard 9, 11, 20; *The Doyle Fairy Book* 9, 64; 'Girls combing beards of goats' 61; *In Fairyland* 65, 68; 'The Knight and the Spectre' 61
Duckworth 76, 77
Dulac, Edmund 7, 21, 133; *Princess Badoura* 129; *Sinbad the Sailor* 128, 137; *The Sleeping Beauty* 124; *Stories from Hans Andersen* 125; *Stories from the Arabian Nights* 132, 136, 137, 140
Du Maurier, George 12
Dunsany, Lord (E. J. M. D. Plunkett) 18, 20, 71, 78
Dürer, Albrecht 11, 16

Eureka 18, 75
Evans, Edmund 8, 13, 69

Faerie Queene, The 13, 62, 63, 66, 79
Fisher & Unwin 139
Ford, H. J. 19–20; *The Olive Fairy Book* 58; *The Pink Fairy Book* 19, 20, 58; *The Red Romance Book* 58
Foster, Birket 8
Freeman, S. T. 108, 109, 110–111
Freemantle & Co 94, 95
Freud, Sigmund 19

Gaskin, A. J. 14, 17; *Good King Wenceslaus* 41; *Stories by Hans Christian Andersen* 40
Gillray, James 9, 21
Glasgow style 17
Goblin Market 11, 16, 30, 54
Good Words 7
Grant Richards 130, 131, 134
Graphic, The 7, 12
Greenaway, Kate 7, 8, 14
Grimms' Fairy Tales 18

halftone printing 8; in colour 9, 20
Hamilton Adams 38
Hardy, Thomas 7
Harrap, George 7, 160, 161, 164, 165, 166, 167, 168, 169, 170, 171, 172, 173, 174, 175, 178, 179
Heinemann, William 81, 92, 93, 96, 97, 98, 99, 102, 103, 104, 106, 107, 182, 183, 184
Henry, H. 67
Hill, L. Raven 20
Hill, Vernon 7, 18; *Ballads Weird & Wonderful* 155, 162, 163; *The New Inferno* 158, 159
Hodder & Stoughton 85, 88, 89, 120, 121, 124, 125, 128, 129, 132, 136, 137, 140, 141, 144, 145, 148, 149, 152, 153, 154, 156, 157, 180, 181
'Home from the Sea' 12
Horton, W. T. 18; *The Book of Images* 18, 50
Houghton, A. Boyd 10, 11, 12; *Dalziel's Arabian Nights* 34; *Don Quixote* 12
Housman, Clemence 16
Housman, Laurence 7, 13, 16, 129, 132, 136, 137, 140; *The End of Elfintown* 54, 55; *Goblin Market* 54
Hughes, Arthur 11, 12, 12, 13; 'My Heart' 12, 12; *Dealings with the Fairies* 13; *The Music Masters* 29
Hunt, William Holman 11; *Poems by Tennyson* 29

Idler, The 18
Illustrated London News, The 7

Japanese art 13, 15, 18
Jones, A. Garth 17; *The Minor Poems of John Milton* 17, 68; *The Parade* 67

Keene, Charles 8
Kelmscott Press 14, 16, 17, 39
King, Jessie M. 17, 113; *Defence of Guenevere* 2; *The High History of the Holy Graal* 114, 115; *A House of Pomegranates* 112
Kipling, Rudyard 7, 101; *Just So Stories* 7, 142, 143, 146, 147, 150, 151
Knowles, Horace 17
Knowles, Reginald 17; *Norse Fairy Tales* 108, 109, 110, 111

Lambeth School of Art 20
Lane, John 2, 3, 90, 155, 158, 159, 162, 163, 176, 177, 181; see also Mathews, Elkin, & John Lane
Lang, Andrew 19, 19, 20, 58
Lawrence & Bullen 56
Lear, Edward 7, 9–10, 18; *The Book of Nonsense* 25
letterpress printing 8
Linton, W. J. 8
Longmans Green 19, 20, 40, 58, 65, 68
Low, Sampson 57, 60

MacDonald, George 12, 13
MacDonald (Mackintosh), Margaret 17
Mackintosh, Charles Rennie 17
Mackmurdo, A. H. 16
Macmillan 11, 28, 30, 54, 55, 82, 83, 139, 142, 143, 146, 147, 150, 151
Malory, Thomas 14, 15, 42, 43, 44, 45
Mantegna 15
Mathews, Elkin, & John Lane 16, 48, 49, 51, 52, 53
medieval style 14
Methuen & Co. 91, 112
Millais, John Everett 11; *Poems by Tennyson* 29
Millar, H. R. 7; *The Enchanted Castle* 139; *The Magic City* 139
Moreau, Gustave 22
Morris, William 2, 14, 16, 17, 39, 41
Moxon, Edward 11, 29, 30
Muckley, Louis Fairfax 17; *The Faerie Queene* 62, 63, 66

Nelson, Harold *Early English Prose Romances* 135, 138

Newnes, George 99
Nielsen, Kay 7, 21–22; *East of the Sun and West of the Moon* 21, 141, 144, 145, 154; *In Powder and Crinoline* 148, 149, 152, 153, 154, 156, 157,
Nutt, David 19, 59, 131, 134

Once a Week 7, 12, 32, 33

Pater, Walter 13
Paton, J. Noel 11; *Coleridge's Rime of the Ancient Mariner* 26, 27
Pennell, Joseph 11
Phillips, Stephen 18, 158, 159
'Phiz' 11
photogravure 8, 70, 71, 78
photomechanical reproduction ('process') 8, 20
Poe, Edgar Allan 10, 131, 170, 171, 174
Potter, Beatrix 7, 10
Pre-Raphaelites 11, 19
'process' see photomechanical reproduction
Punch 7, 9, 10, 20
Putnam's 70, 71, 78

Rackham, Arthur 7, 20, 22, 100; *Comus* 20, 96, 97, 107; *Dymchurch Flit (Puck of Pook's Hill)* 101; *Gulliver's Travels* 105; *A Midsummer Night's Dream* 104; *Mother Goose* 102, 103, 106; *Peter Pan in Kensington Gardens* 85, 88, 89; *The Rhinegold and The Valkyrie* 93; *Siegfried and The Twilight of the Gods* 92
Ricketts, Charles 15–16, 20, 21; *Daphnis and Chloë* 16, 53; *Poems Dramatic & Lyrical* 51; *Poems in Prose* 51; *The Sphinx* 52
Robinson, Charles 8, 16, 17, 80; *Fairy Tales from Hans Christian Andersen* 89; *The Happy Prince* 76, 77; *King Longbeard* 3, 90; *The Secret Garden* 81
Robinson, Thomas *Fairy Tales from Hans Christian Andersen* 87
Robinson, William Heath 7, 8, 16, 17–18; *Bill the Minder* 84, 126, 127, 130, 131, 192; *The Giant Crab* 6, 131, 134; *A Midsummer Night's Dream* 118, 119, 122, 123; *Poems of Edgar Allan Poe* 17, 131; *Uncle Lubin* 130, 131, 134
rococo style 15, 21
Rossetti, Christina 11–12, 11, 16, 30, 31, 54
Rossetti, Dante Gabriel 7, 11, 13, 16, 20; *Goblin Market* 11, 30; *Poems by Tennyson* 30; *The Music Masters* 30
Rothenstein, John 14
Routledge, George 29, 30, 69
Rowlandson, Thomas 9
Ruskin, John 11, 14

Sandys, Frederick 11; 'Amor Mundi' 11–12, 31; 'The Death of King Warwolf' 32; 'Harold Harfagr' 33
Savoy, The 18
Schulz, Otto 135, 138
Shannon, Charles 16, 20
Shilling Magazine 31
Siddall, Elizabeth 11
Sime, Sidney 7, 18; *The Fantasy of Life* 18, 74; *The Legend of the Mandrake* 75; *Time and the Gods* 70, 71, 78
'Sir Isumbras at the Ford' 11
Slade School of Art, London 19
Smithers, Leonard 46, 47, 48
Stevenson, Robert Louis 7
Strang, William *Death and The Ploughman's Wife* 56; *Sinbad the Sailor* 56
Sturge Moore, T. 7
Sullivan, E. J. 8; 'Don Quixote' 99; *The Kaiser's Garland* 98, 99; *The Pilgrim's Progress* 99; *Sartor Resartus* 98
Sunday Magazine 12
Symbolism 15, 18
Symons, Arthur 18

Tatler, The 74
Taylor, John Russell 16
Tenniel, John 7, 10, 11, 12, 17; *Alice's Adventures in Wonderland* 28
Tennyson, Alfred, Lord 11, 29, 30
Thompson, J. 29
Tolkien, J. R. R. 20
Townshend, F. H. 20
tree-animism 20
Trollope, Anthony 11

Unicorn Press 50

Vale Press, The 16
Vizetelly 8
Voysey, C. F. A. 20

Wain, Louis 10
Ward, Lock & Tyler 34
Warne 10, 12, 25
Westminster Budget 20
White, Gleeson 11
Wilde, Oscar 14, 15, 16, 43, 48, 49, 51, 52, 76, 77, 112, 177
wood engraving 8, 20

Yeats, W. B. 18, 50